Days Remembered
Iconic Photography of The Baltimore Sun

The photographs of A. Aubrey Bodine, Robert F. Kniesche, Richard Stacks, Jed Kirschbaum and others chronicle the events big and small that have shaped the lives of Marylanders. The Sun celebrates its 175th year with iconic images of war and peace, triumph and disaster, advancement and failure, our vocations and pastimes, and the familiar faces and places of Baltimore.

Days Remembered
Iconic Photography of The Baltimore Sun

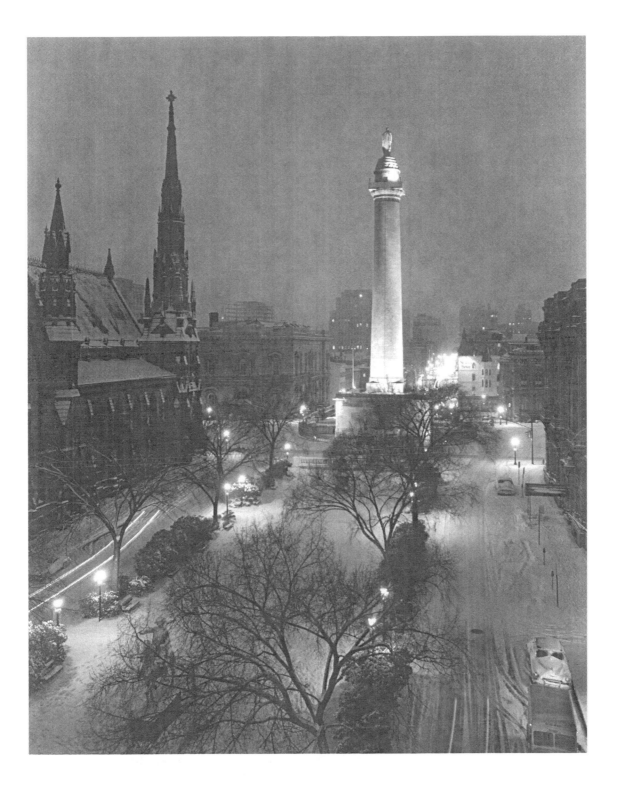

Published by Lightning Source Inc.,
1246 Heil Quaker Boulevard
La Vergne, TN 37086

Library of Congress
Cataloging-in-Publication Data applied for.
ISBN 978-1-893116-23-8

Print edition: 978-1-893116-23-8
Library of Congress Control Number: 2012911674

Cover and title page: The soft glow of evening reflected off the snow made Mount Vernon Place a fitting subject for a holiday greeting card on Christmas Eve 1961. *Photo by A. Aubrey Bodine* AHP-019-BS
Opposite: Going topless is sometimes the only way to beat the heat of a Baltimore summer, as Samantha Robinson, Greg Roy, Kelli Robinson and Sherrie Stancill demonstrated in 1988 when the mercury hit 104 in Pigtown. *Photo by Amy Davis* 12029

Contents

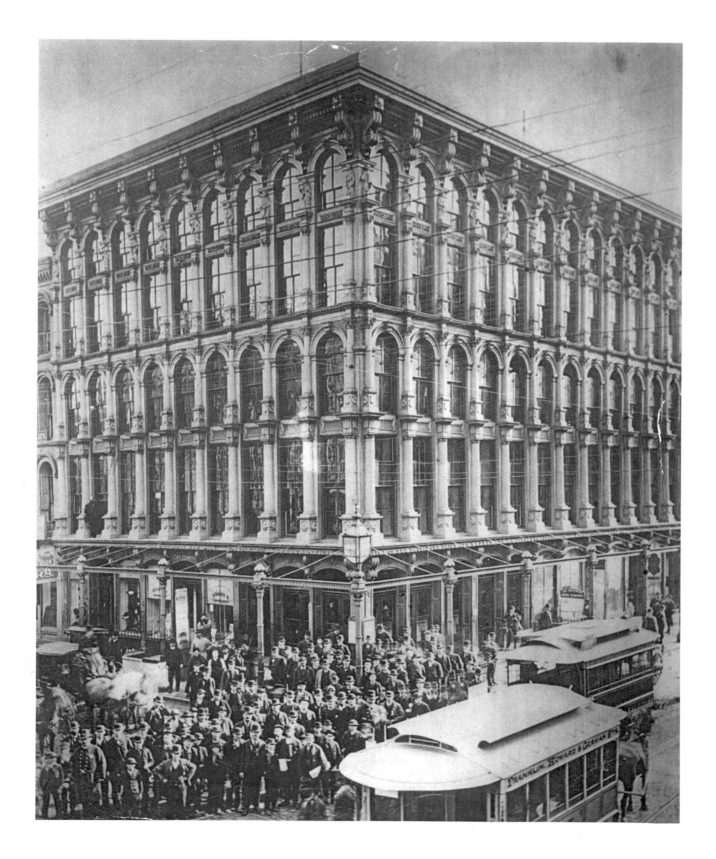

Light for All

For 175 Years, a Tradition of Progress

By Frederick N. Rasmussen
The Baltimore Sun

The Baltimore Sun, whose pages have chronicled Maryland life and institutions for generations, whose reporters covered every government and conflict and glory of the city since well before the Civil War, is celebrating its 175th anniversary in 2012.

Since Volume 1, Number 1 rolled off Arunah S. Abell's press on May 17, 1837, the newspaper has embodied the founder's philosophy that his newspaper would cover the news for all, not just for Baltimore's moneyed, banking, legal or merchant classes, but for the common folk.

Abell, who was born and raised in East Providence, R.I., worked as a shipping clerk before becoming an apprentice printer at the Providence Patriot in 1822. After moving to New York City, he met Azariah H. Simmons and William M. Swain, with whom he formed a business partnership to publish a penny paper. In 1836, they founded the Public Ledger in Philadelphia, and a year later, Abell's partners agreed to back him when he proposed to publish a penny paper in Baltimore, whose population at the time was about 90,000.

"We have resolved upon the experiment of publishing a penny paper, entitled 'The Sun.' ... We shall strive to render it a channel of useful information to every citizen in every department of society . . wheth er literary, professional, mercantile, manufacturing or miscellaneous," Abell and his partners wrote.

The birth of The Sun came at an inauspicious moment, as the nation was reeling from the Panic of 1837, which led to factory closings, bank failures, inflation and unemployment. Abell also faced formidable competition. There were already six daily papers in the city — the American, Chronicle, Gazette, Patriot, Republican and Transcript — that sold for 6 cents a copy. There also were nine weeklies and two monthlies.

Abell departed from the practice of most newspapers then being published in the city, which tended to publish more opinion than news. He assembled a staff of reporters to cover City Hall, the courts, meetings, police and anything else that could be considered the news of the day.

The first issue, whose type had likely been set by Abell himself, came off the hand-operated press in a

Opposite: The Sun's innovative Iron Building, at Baltimore and South streets, had a cast-iron frame that was a forerunner of modern skyscraper construction using steel. It opened in 1851 and was destroyed in the Great Fire of 1904. *Baltimore Sun photo* BLN-262-BS

small building at 21 Light Street that served as the newspaper's first home. It was four tabloid-size pages. On Page 2, in a note to readers, Abell laid out what has remained the newspaper's philosophy and guiding course for 175 years:

"We shall give no place to religious controversy, nor to political discussions of merely partisan character. On political principles, and questions involving the interest or honor of the whole country, it will be free, firm and temperate. Our object will be the common good, without regard to that of sects, factions or parties; and for this object we shall labor without fear or partiality. The publication of this paper will be continued for one year at least, and the publishers hope to receive, as they will try to deserve, a liberal support."

The 15,000 copies from Abell's initial press run went to every corner of the city.

The Sun made history four months later when it printed, in its entirety, President Martin Van Buren's 12,000-word address to Congress. The text had been rushed to Baltimore by courier aboard a Baltimore & Ohio Railroad passenger train. Abell had the text set in type in time for the morning paper; his competition did not get the story until the next day.

On its first anniversary, The Sun's circulation was 12,000, forcing Abell to move to a larger building at Gay and Baltimore streets. In 1840, the motto "Light for All" was added to The Sun's nameplate — words that expressed his philosophy and remain to this day. Abell embraced new technology that he thought would aid in news-gathering and lead to a better paper. It didn't take him long to see the possibilities in Samuel F.B. Morse's telegraph, demonstrated with a message from Washington to Baltimore in 1844. Abell later became a backer and Swain president of the Magnetic Telegraph Co.

Abell's aggressive coverage of the Mexican War placed The Sun on the national stage. In 1846, he and others set up a communication system using a relay of telegraph, railroad, steamboat, stagecoach and pony express to speed war news to Baltimore by land and by sea.

The Sun made history again when Abell had President James K. Polk's message to Congress on the Mexican War telegraphed to Baltimore so it could be published in its entirety.

From its earliest days, The Sun had a Washington correspondent, a postal clerk who doubled as a reporter. By 1872, it had a full-fledged bureau in the capital. Eventually, more than 15 reporters worked there, covering the president and all departments of the federal government.

The invention of the high-speed rotary press by New Yorker Richard Hoe in 1846 enabled the newspaper to print 20,000 copies an hour. The Linotype, first patented by Ottmar Mergenthaler of Baltimore in 1884 and demonstrated at the New York Tribune in 1886, ended the drudgery of setting type by hand and revolutionized the printing industry.

A fleet of 500 carrier pigeons owned by Abell was used in news-gathering, speeding reports to Baltimore from Northern and Southern cities, according to a book about the newspaper's first 150 years written by former Sunday Sun editor Harold A. Williams.

In 1851, Abell moved his paper to a new, cast iron-framed building at Baltimore and South streets that would become known as The Sun Iron Building. The innovative building, designed by New York architect James Bogardus, was the newspaper's home until the Great Baltimore Fire of 1904 destroyed it.

The Civil War would put a great strain on Abell and The Sun. Though he was a Northerner, his sympathies lay with the South. When Union troops occupied Baltimore, he was warned that any pro-Confederate articles could lead to his arrest and charges of sedition.

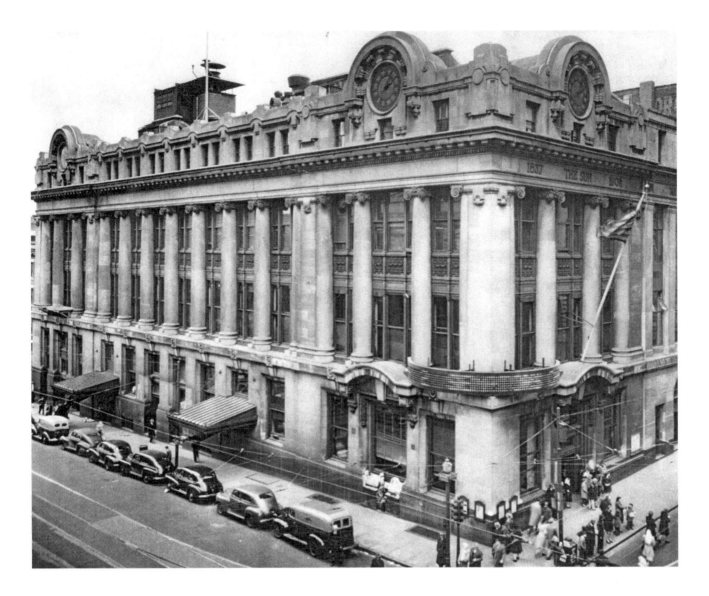

By 1864, he had bought out his original partners. With the end of the Civil War, Abell editorially supported the re-enfranchisement of Southern voters, the acceptance of African-Americans as freemen and President Andrew Johnson's plans for reconstruction of the South.

In the 1880s, Abell introduced telephones in the newsroom and business office of the newspaper, and the first typewriter made its appearance in 1893. No longer did reporters have to write articles in longhand.

Abell lived to celebrate the 50th anniversary of The Sun in 1887, and was 81 when he died at his home at Charles and Madison streets in 1888. His friend Enoch Pratt, a Baltimore businessman who had been an advertiser from the paper's first issue, said, "He has always been foremost in advocating all measures for the good of the city and of his fellow citizens."

After the Great Fire of 1904, The Sun erected a new building on the southwest corner of Baltimore and Charles streets, where it would remain until moving to its present home on North Calvert Street in 1950.

Above: After the Iron Building burned, The Sunpapers moved into a new home at Charles and Baltimore streets in 1906 and would stay till 1950. The city named the crossroads Sun Square. *Baltimore Sun photo* ABD-040-BS

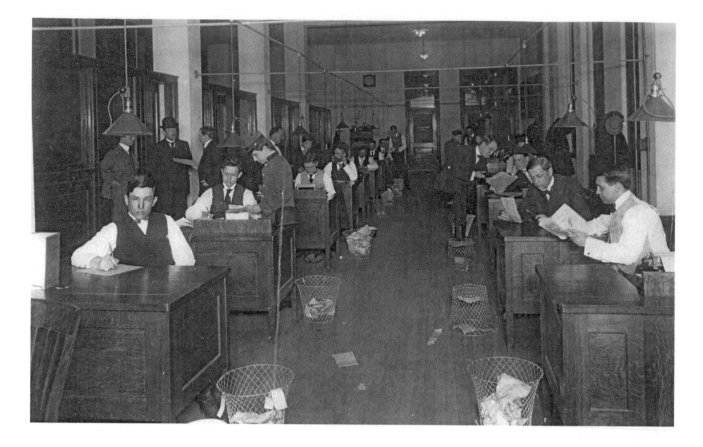

The Sunday Sun was first published on October 6, 1901, and Henry L. Mencken joined The Sun in 1906 as Sunday editor, beginning a nearly 50-year run as columnist, correspondent and adviser to the A.S. Abell Co.

The Sunpapers remained under Abell family control until 1910, when the A.S. Abell Co. was sold to a group headed by Charles H. Grasty, a newspaperman backed by wealthy Marylanders H. Crawford Black, a leading coal mine operator and former Confederate cavalryman; Robert Garrett, a banker and, in 1896, the first American to win an Olympic gold medal; R. Brent Keyser, a copper company president and descendant of the state's first settlers; and John Campbell White, son of a U.S. ambassador. Grasty started The Evening Sun on April 18, 1910.

In 1919, the company was sold to R. Brent Keyser; Walter W. Abell, A.S. Abell's grandson; and Baltimore businessmen Van-Lear Black and Harry C. Black, sons of H. Crawford Black.

In 1931, The Sun's Edmund P. Duffy won a Pulitzer Prize for an editorial cartoon drawn in 1930, the first of 15 awarded to the paper through the years. He would win two more by the end of the decade.

During World War II, Sunpapers correspondents covered the war in Europe and the Pacific. Price Day, later editor in chief from 1960 to 1975, was the only correspondent for an individual newspaper to witness the German surrender at Reims, France, on May 7, 1945. When the Japanese surrendered aboard the battleship USS Missouri on September 2, 1945, three Sunpapers correspondents — Robert B. Cochrane, Thomas J. O'Donnell and Philip Potter — were there to report on the ceremony.

Above: Sun reporters and editors at work in 1908. The building was considered an architectural beauty and completely up to date, but the city room would get so hot in summers that men would work shirtless after women left. *Baltimore Sun photo* ABD-092-BS

After the war, many changes came to the newspaper. The Sunday Sun Magazine, which grew out of a sepia-colored Sunday section known as the Brown Section, was created in 1946 and continued until 1996. After a 14-year absence, it was resumed in 2010.

In 1975, computers entered the newsroom, making The Sun one of the first large metropolitan dailies in the nation to switch from "hot type" to "cold type" printing.

When the paper celebrated its 150th anniversary in 1987, The Sun had news bureaus in Washington, New York and San Francisco and in seven foreign capitals. It had offices in each of the counties surrounding Baltimore and a State House bureau in Annapolis.

In 1988, the company purchased 60 acres in South Baltimore that had formerly been the yards of the Western Maryland Railway. The Hoe offset presses that had printed the three papers at the Calvert Street plant since 1950 fell silent when the printing and packaging operations were moved to Port Covington in 1992.

The Evening Sun rolled off the Port Covington presses for the last time on September 15, 1995. The headline bid Baltimore adieu: "GOOD NIGHT, HON. Thanks for a great 85 years; will you love us in the morning?"

In 1996, the company launched the website Sunspot.net, which was renamed baltimoresun.com in 2004.

Thirty hours after the News American folded on May 26, 1986, the A.S. Abell Co. ceased to exist after 149 years, when it was sold for $600 million to the Times Mirror Co., publisher of the Los Angeles Times and other papers. Times Mirror was acquired in 2000 by the Tribune Co. of Chicago, a multimedia company whose operations include newspapers, television and radio broadcasting, and interactive media. In 2007, Tribune Co. was purchased by real estate tycoon Sam Zell, and The Sun's 171-year-old name was changed the next year to The Baltimore Sun. Many longtime Baltimoreans still refer to the newspaper as the Sunpapers.

Among the many notable figures who have called The Sun and The Evening Sun home are writer Russell Baker, Congresswoman Helen Delich Bentley, author and historian William Manchester, broadcaster Jim McKay, financial journalist and host of "Wall Street Week" Louis Rukeyser and writer David Simon, creator of TV's "The Wire" and "Homicide: Life on the Street."

Since 1837, Sun reporters have reported on governmental matters and chronicled events big and small that have shaped the lives of Marylanders. They have traveled from the shores of the Chesapeake Bay to the corners of the world, at times risking their lives to cover wars, civil unrest and disasters. They have been eyewitnesses to the rise of the civil rights and women's movements. They have reported on assassinations, depressions, advancements in medicine, science, education, entertainment and technology, and every presidential administration from Martin Van Buren's to Barack Obama's.

Sun reporters, editors and photographers have held true to the mission laid down by Arunah S. Abell. After 175 years, The Sun remains Maryland's dominant news organization. Whether in print each morning, online throughout the day, on smartphones, tablets or other mobile devices, more people than ever get their news from The Sun each day.

A Century Opens

The Great Fire devastates Baltimore, and Marylanders are drawn into The Great War

By 1900, the United States had signed a peace treaty ending the Spanish-American War, Baltimore was a growing city of nearly 509,000 and The Sun was supporting Democrat William Jennings Bryan against incumbent Republican William McKinley for president. In 1901, the newspaper began to publish on Sundays, noting, "There should be no day of the week in this era of quick communication upon which the quiet and orderly dissemination of intelligence should be banned." It sold for 2 cents. The Sun ran its first photograph that September. On December 17, 1903, the Wright Brothers made the first flight by a powered airplane at Kitty Hawk, N.C. A stringer for The Sun and the New York Herald reported the news to the two papers, which later boasted of beating others on the story.

On Sunday morning, February 7, 1904, a fire started in the basement of a dry-goods store on what is now Redwood Street in Baltimore. That night the glow of the city in flames was visible for 50 miles. The Sun's Iron Building was evacuated about 11 p.m. and plans were made to print the next day's paper in Washington. The building was engulfed shortly after midnight. The Sun's eight-page paper was back in Baltimore by 5 a.m., describing a conflagration that devastated the business district. The Great Baltimore Fire would rage for 30 hours, consuming 73 blocks and 1,343 buildings, with damage estimated at up to $150 million — nearly $4 billion in today's dollars. Amazingly, no one was killed.

In July 1906, H.L. Mencken went to work for The Sun as Sunday editor. That November, the paper moved to a new, larger building at Charles and Baltimore streets. In December, the city named the intersection Sun Square, and it would become a gathering place in the heart of Baltimore.

Above: Photography debuted in The Sun on September 30, 1901, with the publication of a one-column image of Chief Judge James McSherry of the Maryland Court of Appeals. *Baltimore Sun photo*

In 1910, pitcher Cy Young won his 500th game, Alva Fisher patented the electric washing machine and Gustav Mahler's 8th Symphony premiered in Munich. In Baltimore, where the population had grown to more than 558,000, founder A.S. Abell's heirs sold The Sun to a group led by Charles H. Grasty, a newspaperman backed by wealthy Marylanders H. Crawford Black, Robert Garrett, R. Brent Keyser and John C. White. On April 18, Grasty started The Evening Sun, which he declared would be "orderly in form and reliable in substance." Amid falling circulation, The Sun paid French aviator Hubert Latham to fly over Baltimore — a first — in his 50-horsepower monoplane, Antoinette. A half-million Baltimoreans were said to have witnessed his flight.

On April 15, 1912, The Evening Sun, based on erroneous wire reports, reported the sinking of the liner Titanic. "All Titanic Passengers Are Safe," its headline read. In fact, 1,517 passengers and crew members lost their lives in the disaster.

In 1914, World War I began in Europe. In 1916, Mencken went to Germany as a war correspondent. When the United States declared war in April 1917, The Sun covered the training of Maryland men and the fighting in the trenches. But before the soldiers' triumphant return in 1919, thousands of Baltimoreans would die in a flu epidemic in the fall of 1918.

On the night of November 11, 1918, thousands gathered in Sun Square to celebrate the signing of the armistice ending World War I. Returning Maryland troops were greeted at Camp Stuart in Newport News, Va., in May 1919 with a meal of Maryland fried chicken, soft-shell crabs, asparagus and fresh strawberries provided by the Sunpapers.

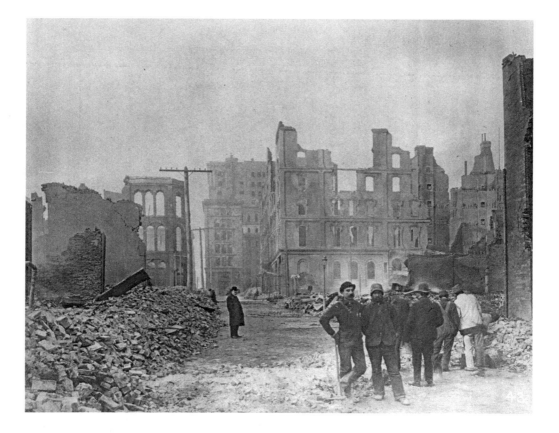

Above: After the Great Fire swept Baltimore on February 7-8, 1904, more than 140 acres and 1,300 buildings lay in ruin. Damage was estimated at up to $150 million, nearly $4 billion in today's dollars. *Baltimore Sun photo* AAS-319-BS

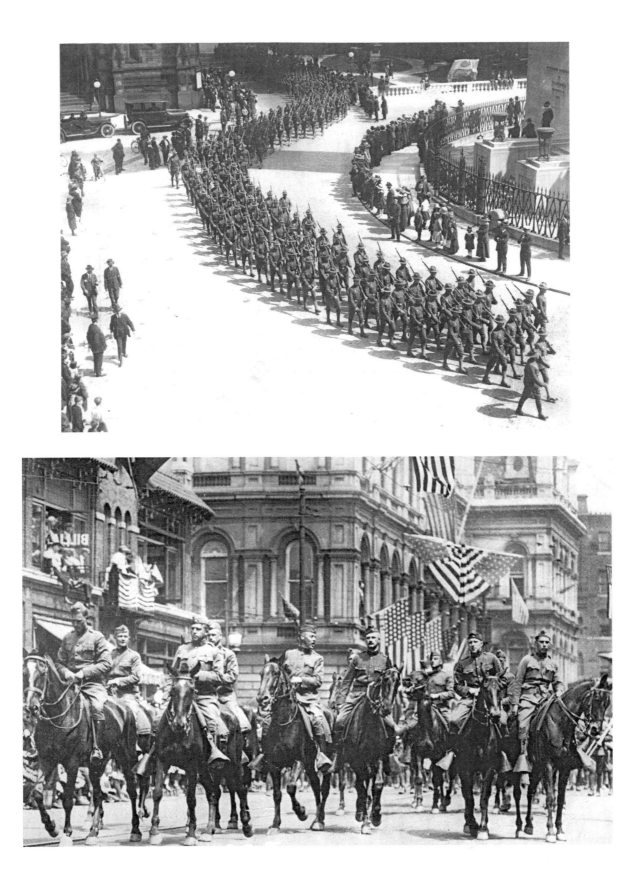

Top: An Armistice Day parade marches smartly by the Washington Monument in Mount Vernon Place on November 11, 1918, marking the end of the "war to end all wars." *Baltimore Sun photo* AHO-607-BS

Above: Col. Milton A. Reckord, left, and officers of the 29th Division welcome home the 115th Infantry at City Hall in June 1919. Reckord was later adjutant general of the Maryland National Guard. *Baltimore Sun photo* 108902

The Twenties

The Sun grows in national stature, and Mencken takes on Prohibition and the 'Monkey Trial'

In 1920, the 18th Amendment went into effect, instituting Prohibition; the 19th Amendment was ratified, giving women the right to vote; Man o' War won the Preakness; and Republican Warren G. Harding was elected president (The Sun backed Democrat James M. Cox). About 734,000 people lived in Baltimore, where The Sun had set a goal of becoming "a newspaper of national distinction." In 1921 and after, the dispatches of respected foreign journalists and U.S. experts appeared in The Sun, the better to inform readers and present a balanced view of events. At home, The Evening Sun fought on for years against Prohibition, playfully advocating secession of the Maryland Free State.

In 1925, the newsstand price of the expanded Sunday Sun rose to 5 cents. Mencken enlisted the

noted lawyer Clarence Darrow to defend John T. Scopes, a Tennessee schoolteacher arrested for teaching Charles Darwin's theory of evolution. The Evening Sun paid his bail and, eventually, his $100 fine. The "Monkey Trial," and Mencken's reporting, became a national sensation, later portrayed in the stage play and film "Inherit the Wind."

In 1928, thousands gathered in Sun Square to hear an account of the Baltimore-bred horse Billy Barton's run in England's Grand National steeplechase. A reporter at Aintree telephoned his description of the race to London, then it was sent by radio to Baltimore — the first time news had been relayed across the Atlantic Ocean that way, according to the phone company.

Above: George Metteo cleans the street in front of City Hall in April 1924. Cattle and pigs were once herded through Baltimore's streets and slop jars and other waste dumped there. *Baltimore Sun photo* ABC-637-BS

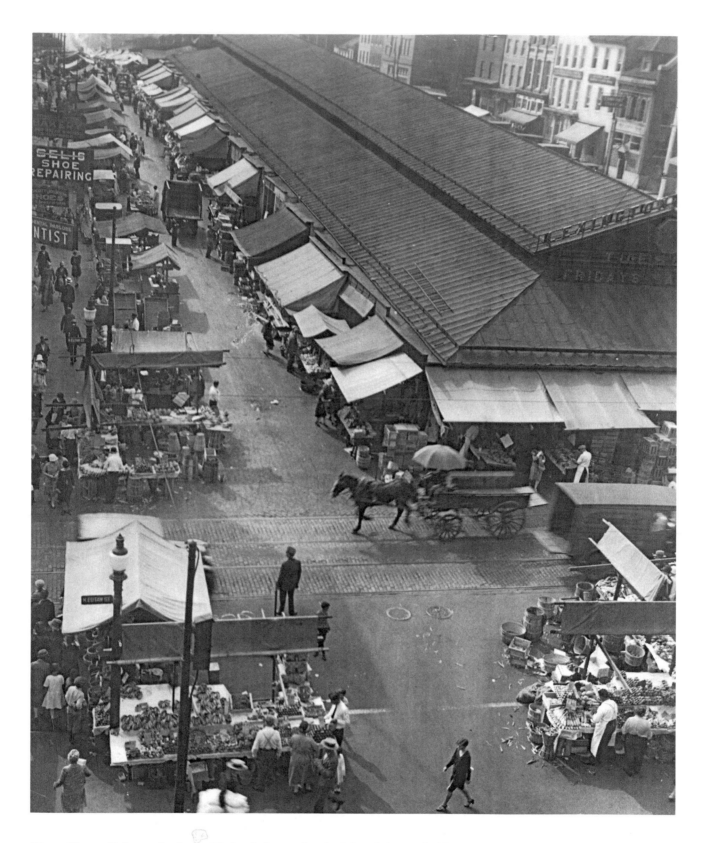

Above: The world-famous Lexington Market, in its wooden shed days, is jammed with shoppers, horse-drawn wagons and trucks in this October 1927 view. *Baltimore Sun photo* ABW-393-BS

Opposite top: Snow removal Roaring '20s-style. A truckload of snow goes over the side into Baltimore harbor on a cold January day in 1925. *Baltimore Sun photo* ABA-728-BS

Opposite bottom: Where Inner Harbor tourists now walk, shop and dine, bay steamers tied up at Light Street wharves waited for passengers and cargo bound for East Coast ports in 1920. *Baltimore Sun photo* ABP-949-BS

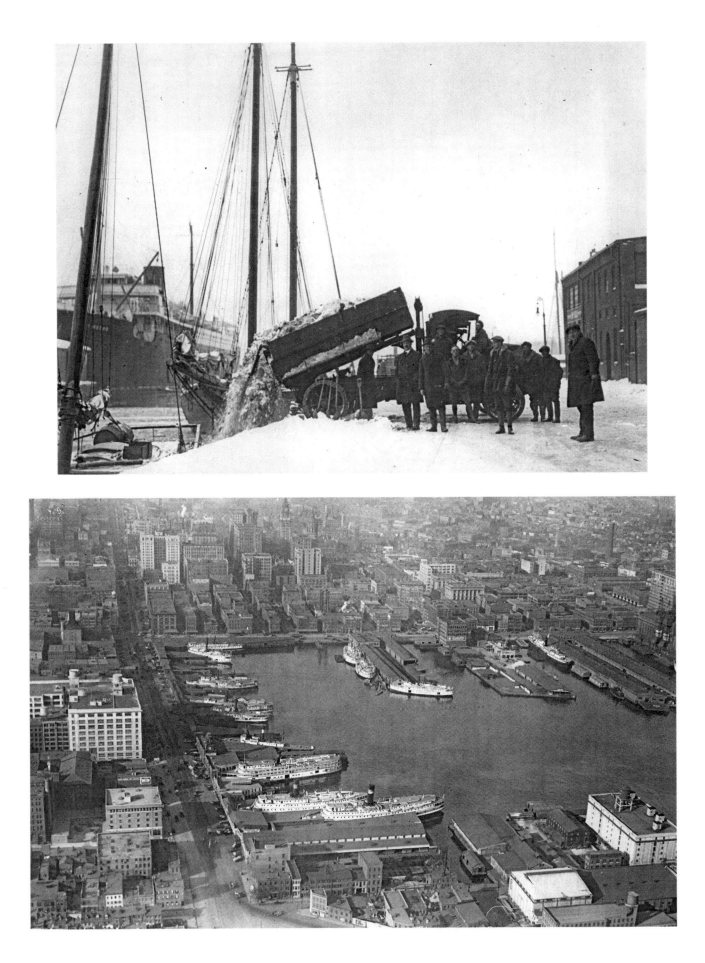

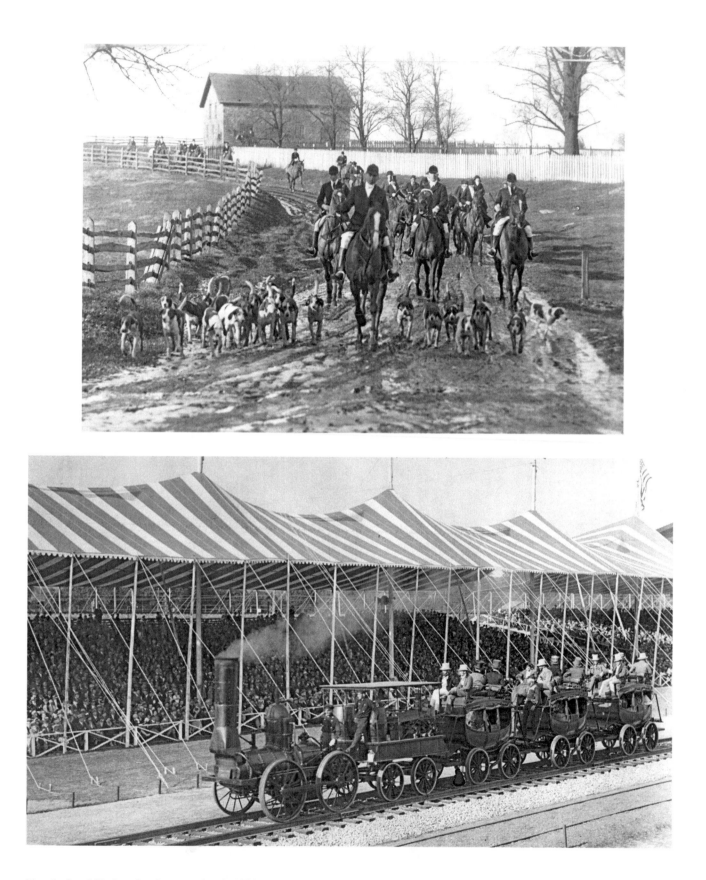

Top: In the chill of an October morning in 1926, members of the Elkridge-Harford Hunt Club dressed in their riding pinks are set to ride to the hounds, an honored Maryland ritual. *Baltimore Sun photo* BGF-083-BS

Above: The Fair of the Iron Horse, which celebrated the centennial of the founding in 1827 of the B&O, the nation's first common carrier railroad, drew thousands to Halethorpe to witness a pageant of locomotives and humanity. *Baltimore Sun photo* ABU-591-BS

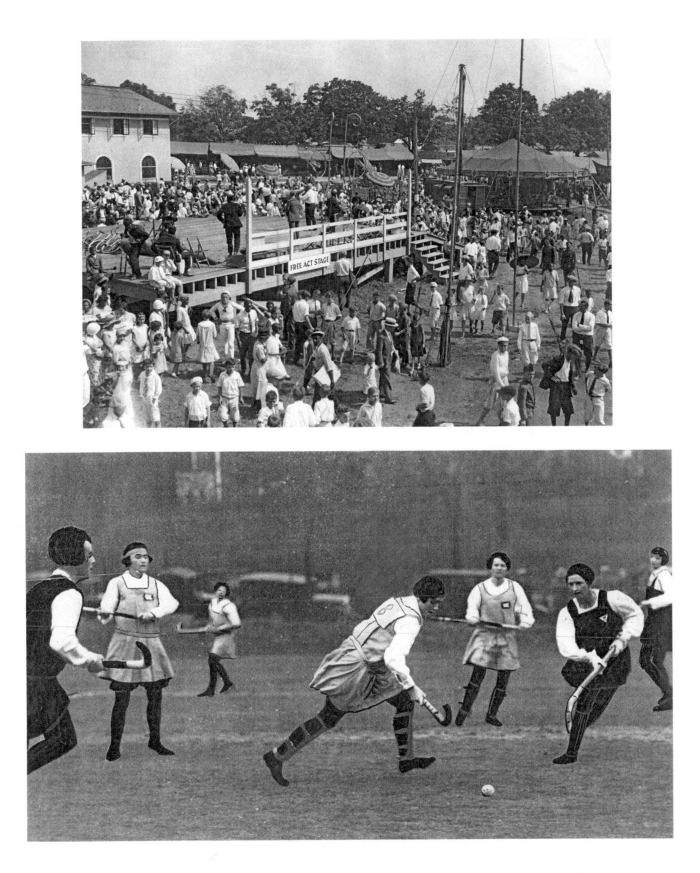

Top: Labor Day coincides with the arrival of the State Fair in Timonium, a ritual since the event's founding in 1878. Crowds jam its York Road midway and nearby racetrack in 1929. *Baltimore Sun photo* AAV-216-BS
Above: A visiting English field hockey team does battle with Southeastern on the grounds of City College in December 1926. *Baltimore Sun photo* AHB-102-BS

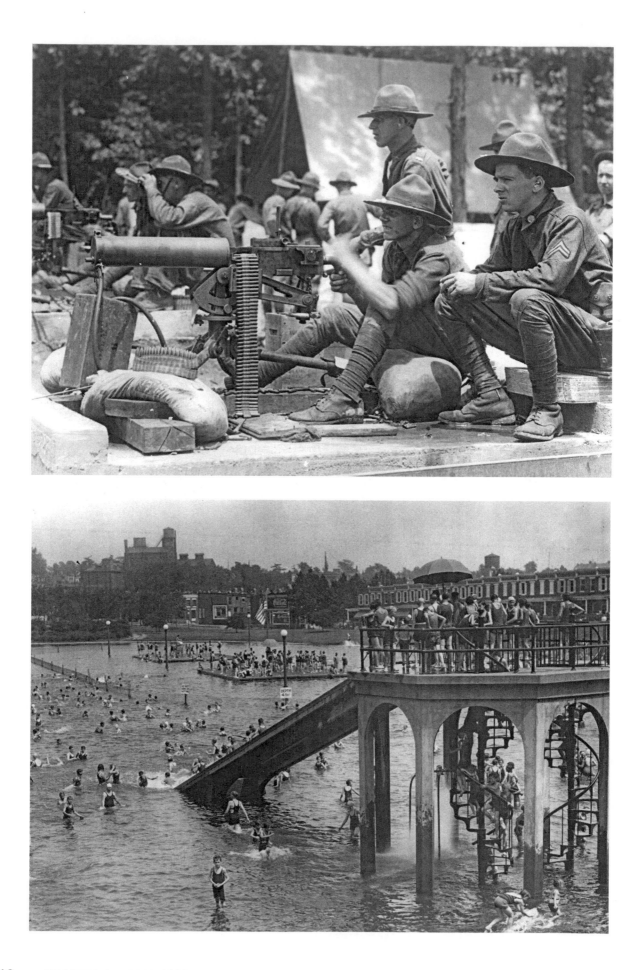

Above: While not as famous as Alvin "Shipwreck" Kelly, Baltimorean William Ruppert did his best to uphold the city's reputation in the 1920s as the "Flagpole Sitting Capital of the World." *Baltimore Sun photo* BFI-857-BS

Opposite top: Members of the Maryland National Guard practice with machine guns during a 1927 summer encampment at Camp Ritchie in Western Maryland. *Photo by A. Aubrey Bodine* AHN-123-BS

Opposite bottom: Everybody into the pool. Inner-city residents cool off in the inviting waters of the Clifton Park Pool on a warm summer's day in 1929. *Baltimore Sun photo* BDZ-277-BS

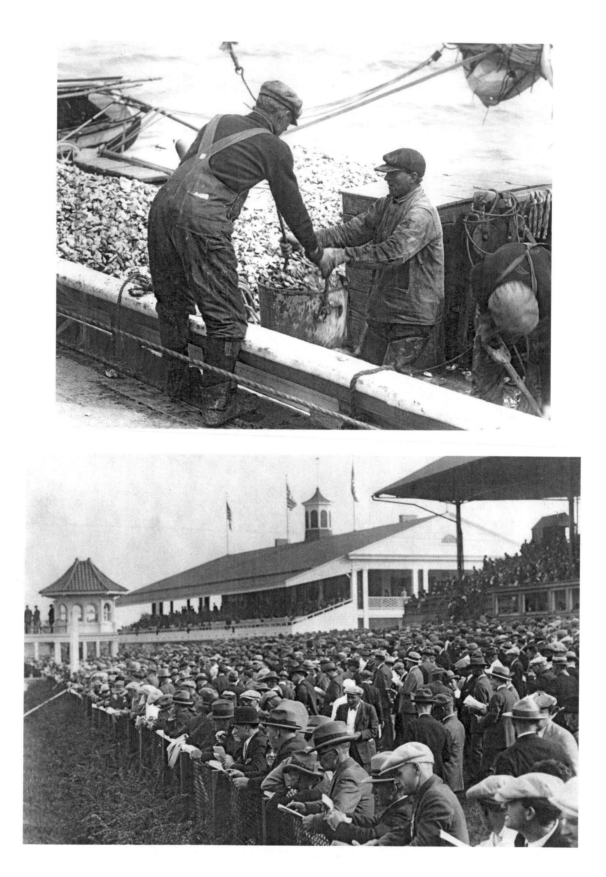

Top: Watermen unload bushels of bivalves freshly dredged from the Chesapeake Bay near the end of the 1928 oyster season.
Photo by A. Aubrey Bodine AGR-723-BS
Above: The railbirds are in evidence on opening day of the 1926 fall meet at Havre de Grace Race Track, now long gone.
Baltimore Sun photo BGQ-237-BS

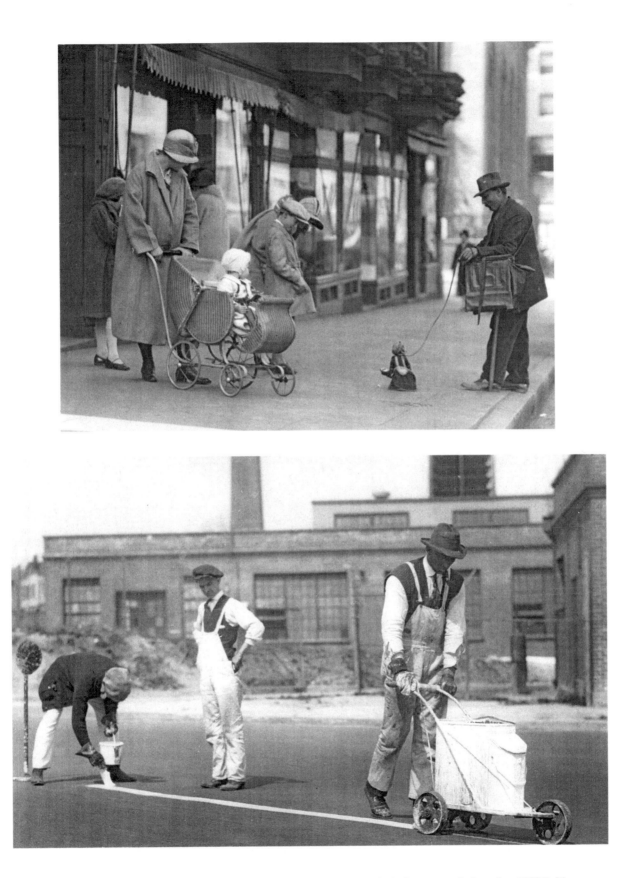

Top: The comic antics of a street organ grinder and his pet monkey entertain a baby in a perambulator in a 1925 Baltimore scene. *Baltimore Sun photo* AEX-701-BS

Above: A supervisor keeps his overalls clean as city workers paint a white line on 25th Street between Greenmount Avenue and Harford Road in the early 1920s. *Baltimore Sun photo* AEX-698-BS

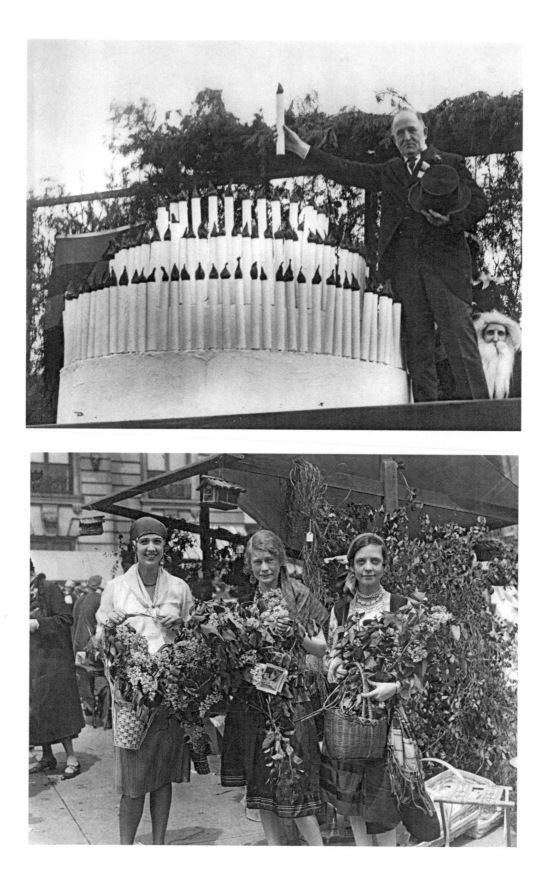

Top: On September 17, 1929, Mayor William F. Broening placed the 200th candle on the birthday cake that marked Baltimore's bicentennial. *Baltimore Sun photo* AGJ-720-BS

Above: Frances Leonard, Eleanor Goldsborough and Mary Clare Chapman display baskets of blossoms at the Flower Mart, an annual rite of spring in Baltimore since the event's founding in 1917. *Baltimore Sun photo* AAQ-446-BS

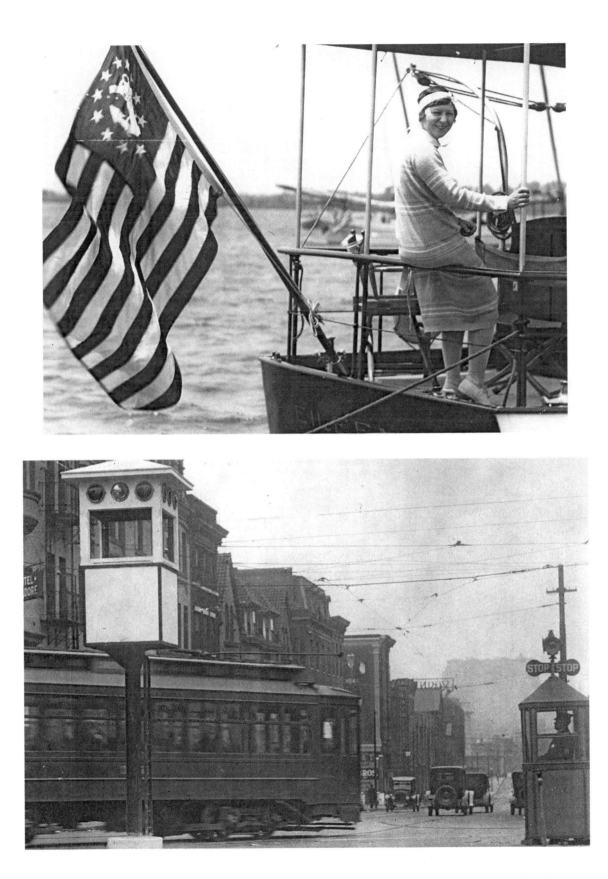

Top: Dorothy Good, dressed in her nautical finest, sailed from Philadelphia aboard the Eileen to take in the 1927 Chesapeake Bay Workboat Races. *Photo by A. Aubrey Bodine* AAV-780-BS

Above: A United Railways streetcar squeals through a switch in 1922 as it turns from North Avenue to southbound Charles Street, no doubt disturbing late sleepers in the nearby Hotel Waldorf. *Baltimore Sun photo* BGR-738-BS

The Thirties

Many hunger for jobs and bread, and a king gives up his throne for a divorcee from Baltimore

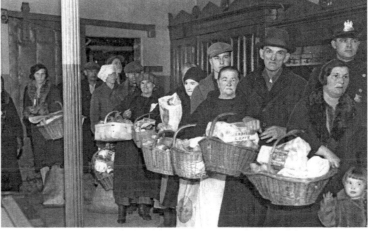

I n 1930, Pluto was discovered, Mohandas K. Gandhi embarked on a march to the Indian coast to protest the British tax on salt, and Chinese revolutionary Mao Zedong wrote that "a single spark can start a prairie fire." In 1931, The Sun's Edmund Duffy won a Pulitzer Prize for an editorial cartoon drawn the year before; by the end of the decade he would win two more.

Amid the depths of the Depression, The Sun endorsed Democrat Franklin D. Roosevelt for president in 1932, praising his stance on tariffs, debt, railroads, agriculture and other economic matters. Four years later, displeased with his New Deal programs, the paper declined to back either Roosevelt or Republican Alfred M. Landon.

In 1936, in what Mencken termed "the greatest story since the Crucifixion," Edward VIII abdicated the British throne to marry Wallis Warfield Simpson, a twice-divorced socialite originally from Baltimore.

The Sun marked its 100th birthday on May 17, 1937, with a brief front-page note to readers and the publication of a history, "The Sunpapers of Baltimore," written by staff members Gerald Johnson, Frank R. Kent, Mencken and Hamilton Owens.

In November 1938, more than 40,000 watched the little rags-to-riches horse Seabiscuit beat 1937 Triple Crown winner War Admiral in a match race at Pimlico Race Course, an event described as "the Match of the Century."

On September 3, 1939, days after German forces invaded Poland, 75,000 Sunday Sun extras were sold after England and France declared war on Germany.

Above: East Baltimore residents wait patiently in a bread line in March 1931, during the harsh days of the Depression. *Baltimore Sun photo* BEF-734-BS

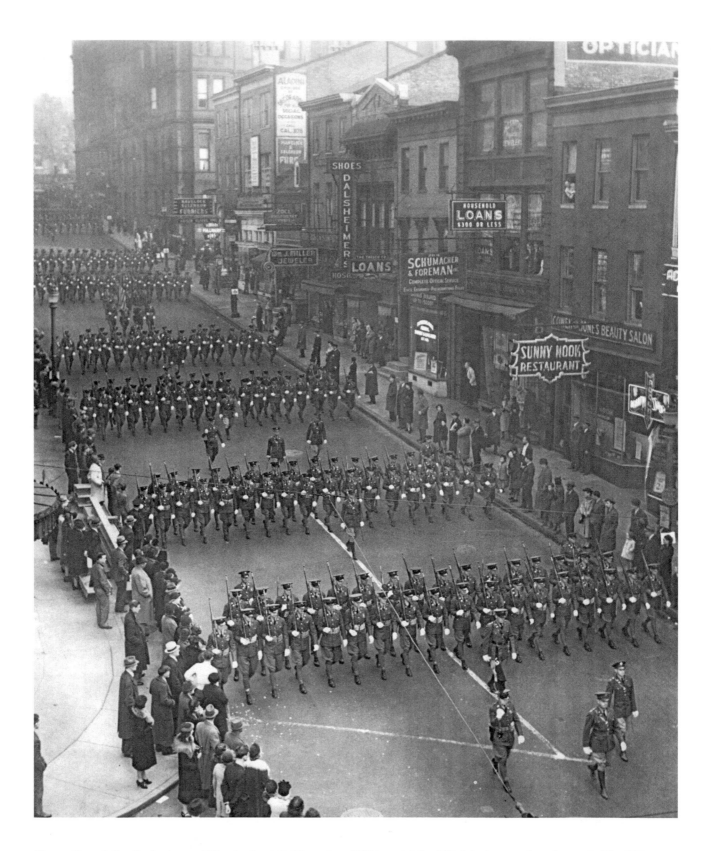

Above: Crowds line Lexington and Liberty streets in November 1938 to watch the 12th Infantry march past as part of the 20th anniversary of the armistice that ended World War I. *Baltimore Sun photo* AHO-700-BS
Opposite top: Everything from ham and beans to beef stew and hot dogs was available at the coffee house. Also advertised were "Tables for Ladies," in this photo from the early days of the Depression. *Photo by A. Aubrey Bodine* AAU-017-BS
Opposite bottom: In the 1930s, the way to fly from Baltimore's Harbor Field, now the site of the Dundalk Marine Terminal, was aboard Pan-American Airways' luxurious four-engine Clippers. *Photo by Robert F. Kniesche* BDG-962-BS

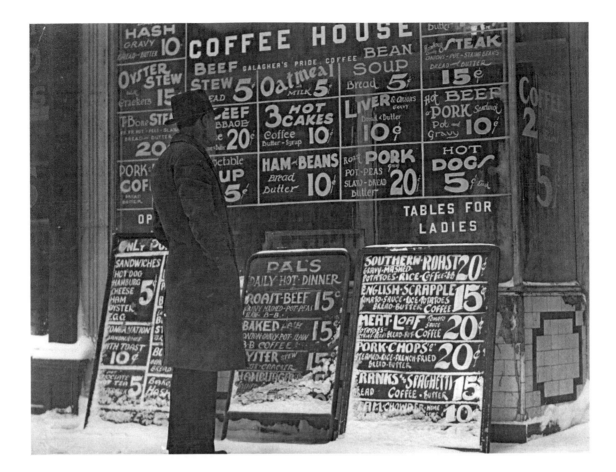

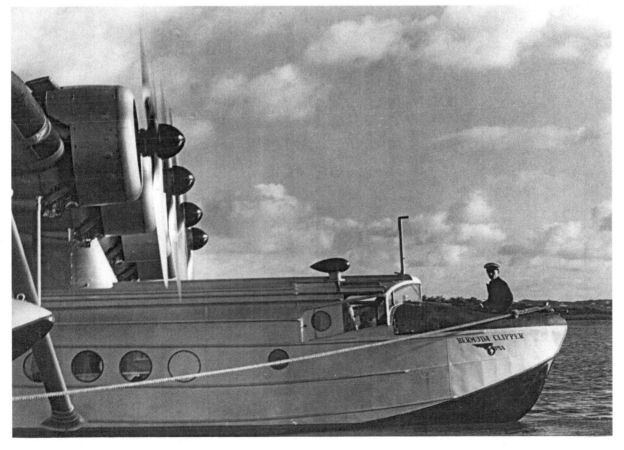

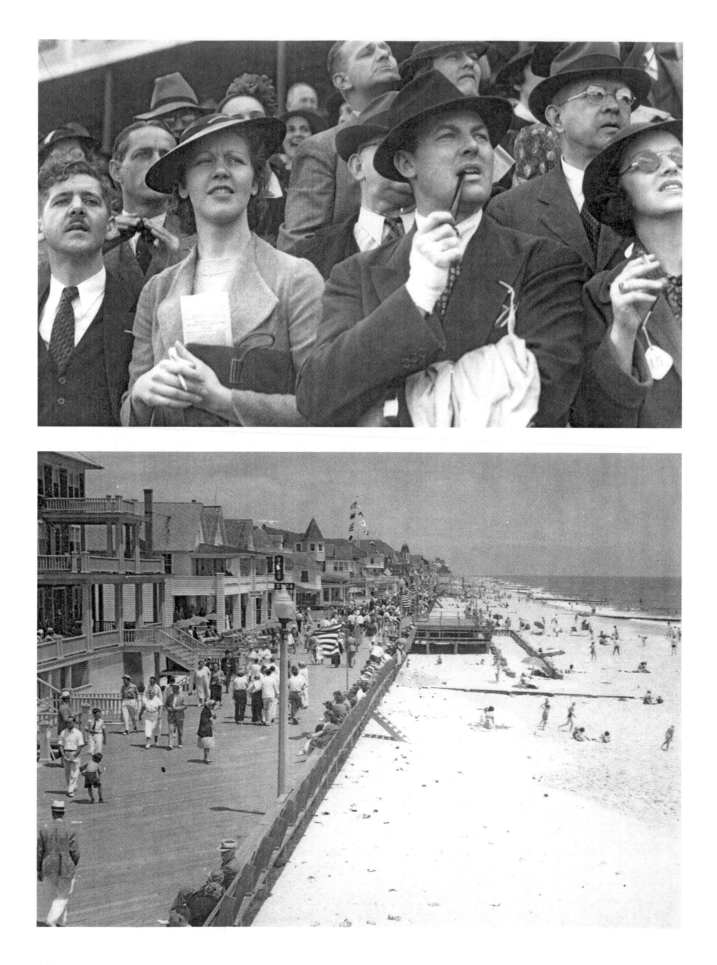

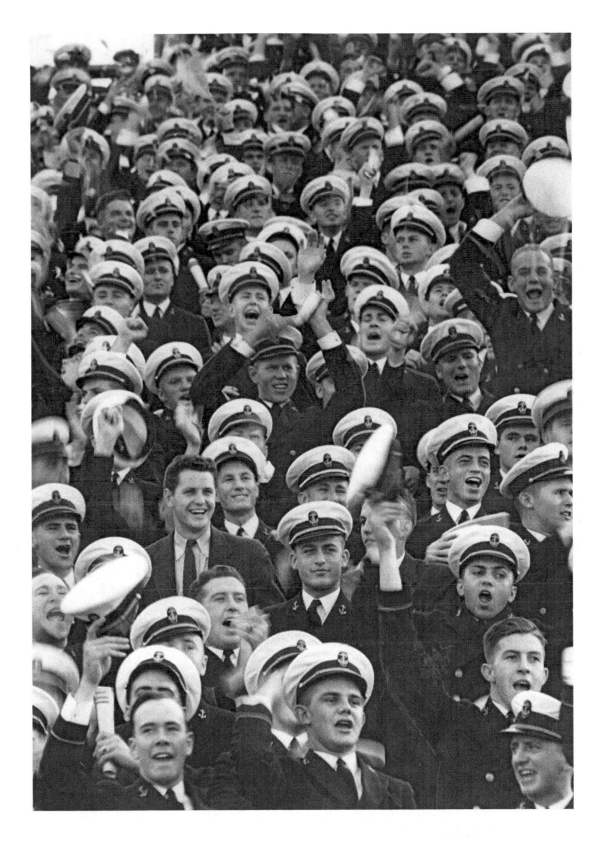

Above: Jubilant midshipmen cheer on their football team in 1936. Navy finished 6-3, with victories over Army and No. 13 Notre Dame, and was ranked 18th in the nation. *Photo by A. Aubrey Bodine* AHN-237-BS

Opposite top: A dapper crowd jammed Old Hilltop in 1937 to see War Admiral defeat rival Pompoon in the Preakness Stakes on the way to winning the Triple Crown. *Baltimore Sun photo* AGJ-672-BS

Opposite bottom: Beachgoers brave the briny Atlantic as well-dressed vacationers stroll the Boardwalk in Ocean City in 1938. *Baltimore Sun photo* ABT-840-BS

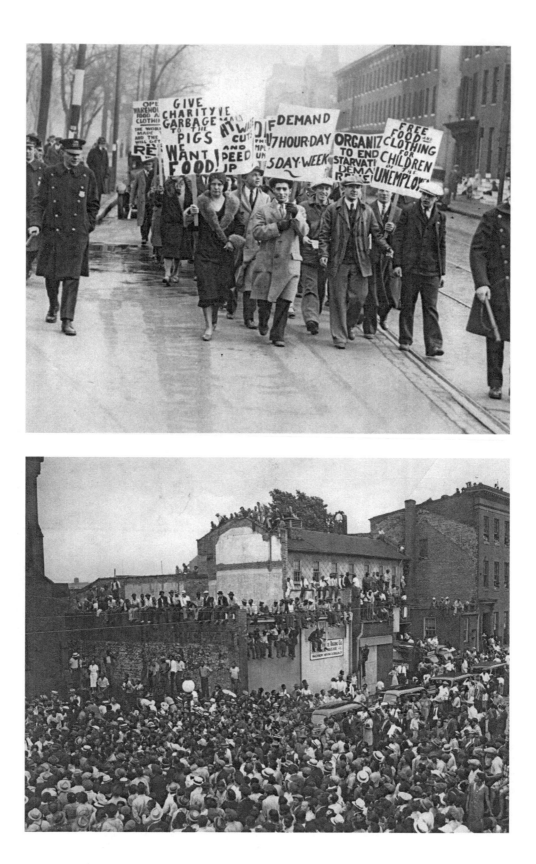

Top: Communist Party organizer Edward Bender leads a march in Baltimore in January 1931. In April, jobless whites and blacks presented demands for unemployment relief and an end to discrimination after police with clubs attacked the group at the State House. *Baltimore Sun photo* BEP-901-BS

Above: Thousands of mourners gathered at Waters African Methodist Episcopal Church in June 1939 to bid farewell to Chick Webb, a Baltimore jazz drummer and band leader who hired singer Ella Fitzgerald. *Baltimore Sun photo* ACD-962-BS

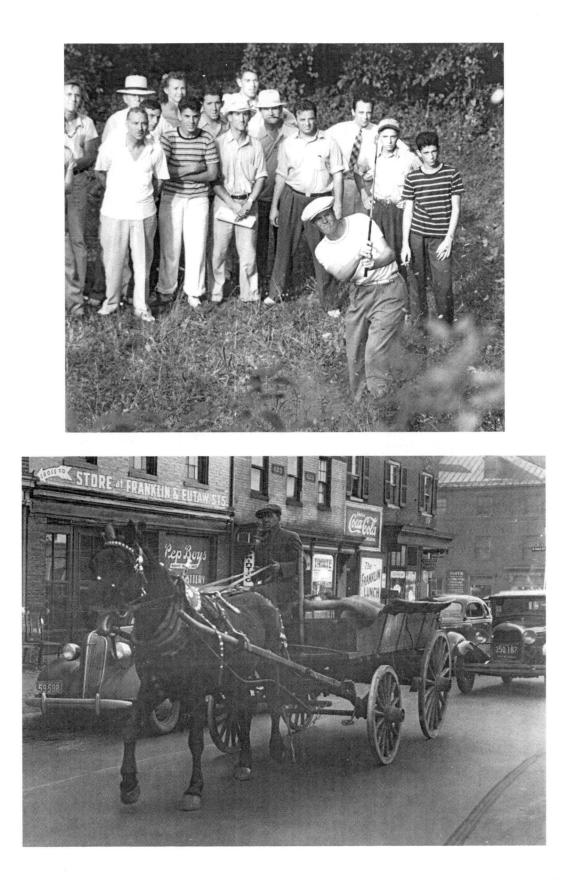

Top: Gerry Bert Jr., 18, of Seattle blasts out of the rough. His score of 2-under-par 70 was good for the first-round lead in the National Public Links Championship at Mount Pleasant Golf Course in 1939. *Baltimore Sun photo* AAW-854-BS
Above: Horse power and the internal combustion engine were still mixing it up on city streets, where Old Dobbin met Henry Ford in this view near Calvert Street in 1937. *Baltimore Sun photo* BKZ-447-BS

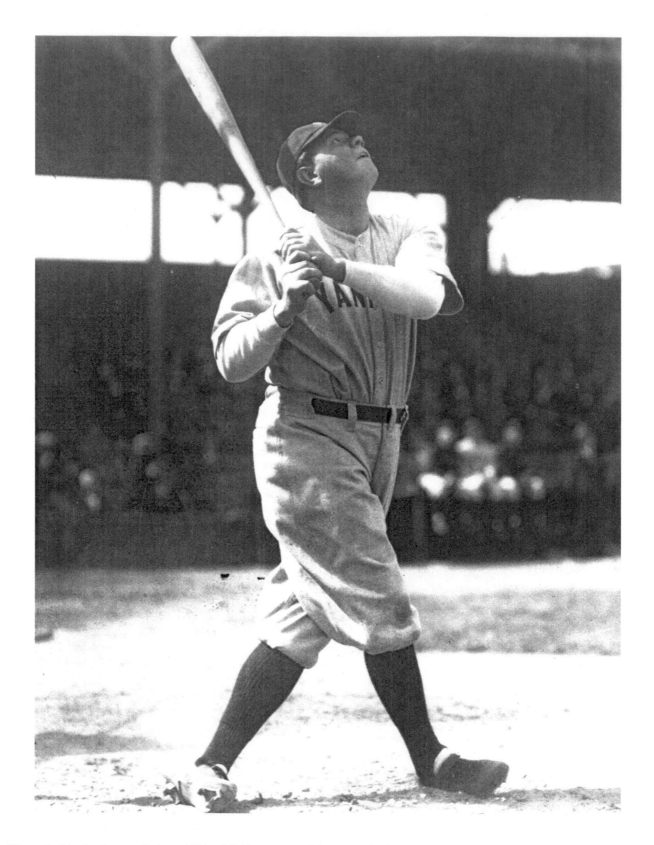

Above: In this classic pose during a 1931 exhibition game at Oriole Park, Baltimore native George Herman "Babe" Ruth Jr. demonstrates why he's called the "Sultan of Swat." *Photo by Leroy B. Merriken* BBZ-533-BS

Opposite top: More than 57,000, including aviatrix Amelia Earhart, saw Navy beat Notre Dame, 3-0, in 1936 at Baltimore's old Municipal Stadium. The rivalry dates to 1927. *Baltimore Sun photo* AGS-012-BS

Opposite bottom: On November 2, 1938, even President Franklin D. Roosevelt and the Congress gathered 'round radios to hear the rags-to-riches Seabiscuit beat Triple Crown winner War Admiral in a famous match race at Pimlico. *Baltimore Sun photo* AGX-657-BS

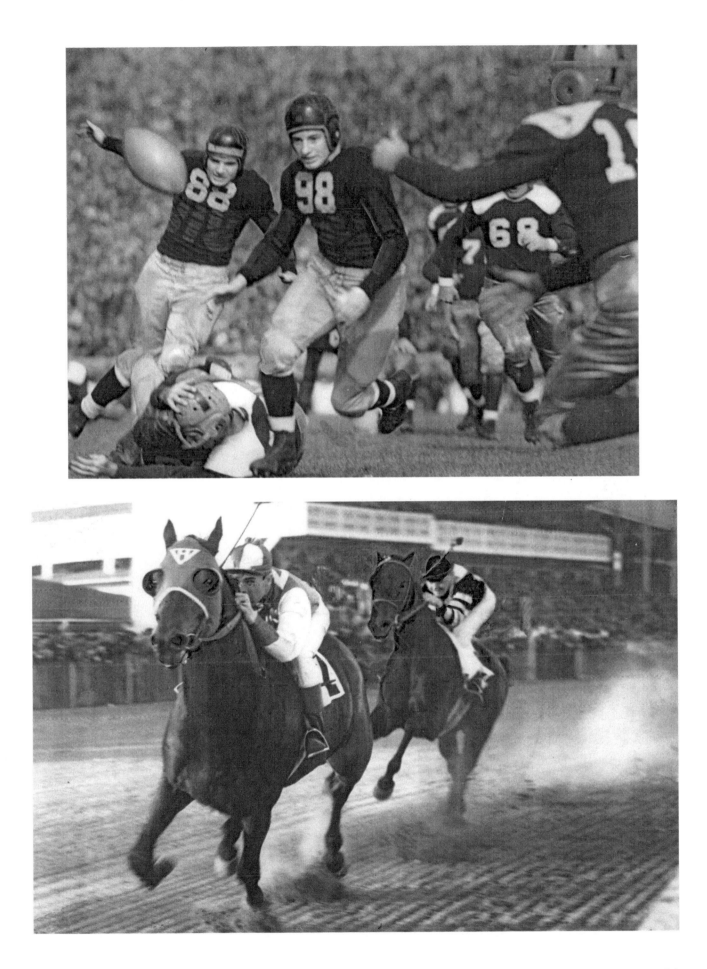

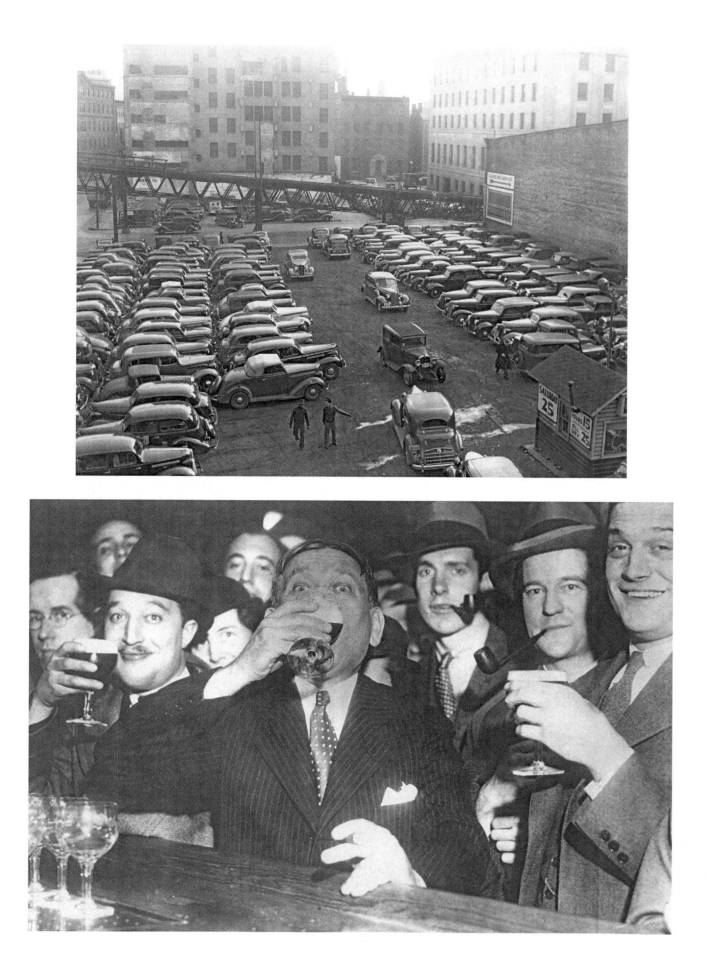

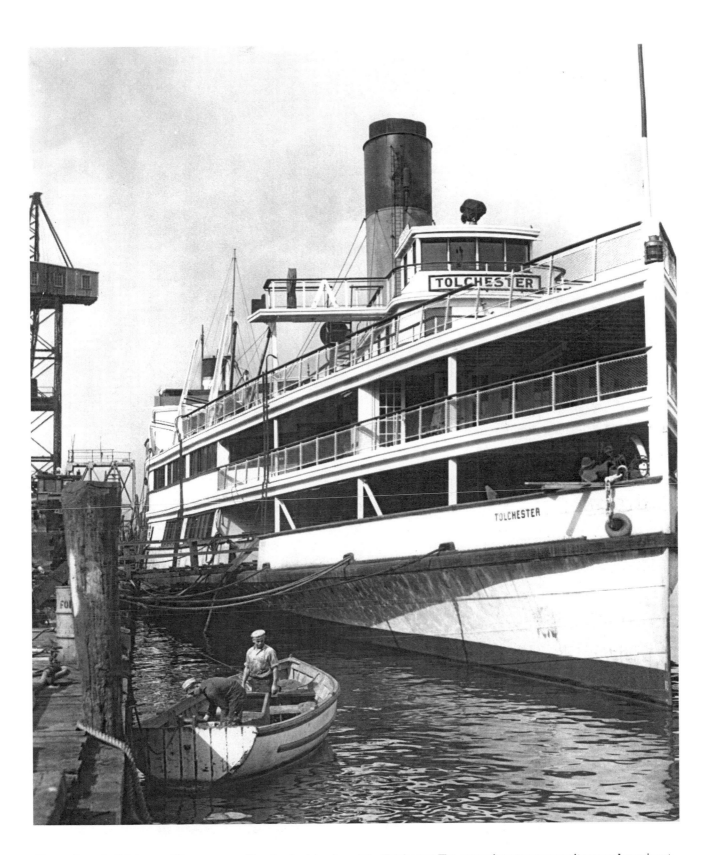

Above: Once, it didn't seem like summer without a day trip aboard the Tolchester. The excursion steamer awaits annual repairs at the Maryland Shipbuilding and Drydock Co. before the 1938 season. *Baltimore Sun photo* BFG-021-BS

Opposite top: Parking was an issue even in 1938, as this lot at Guilford Avenue and Saratoga Street attests. Perhaps they should have ridden the Guilford Avenue Elevated streetcar line in the background. *Baltimore Sun photo* BDB-310-BS

Opposite bottom: At 12:29 a.m. April 7, 1933, H.L. Mencken, "the Bard of Baltimore," marks the end of Prohibition with a glass of Arrow Beer at the Rennert Hotel. "Pretty good," he says. "Not bad at all." *Photo by Frank A. Miller* ADN-627-BS

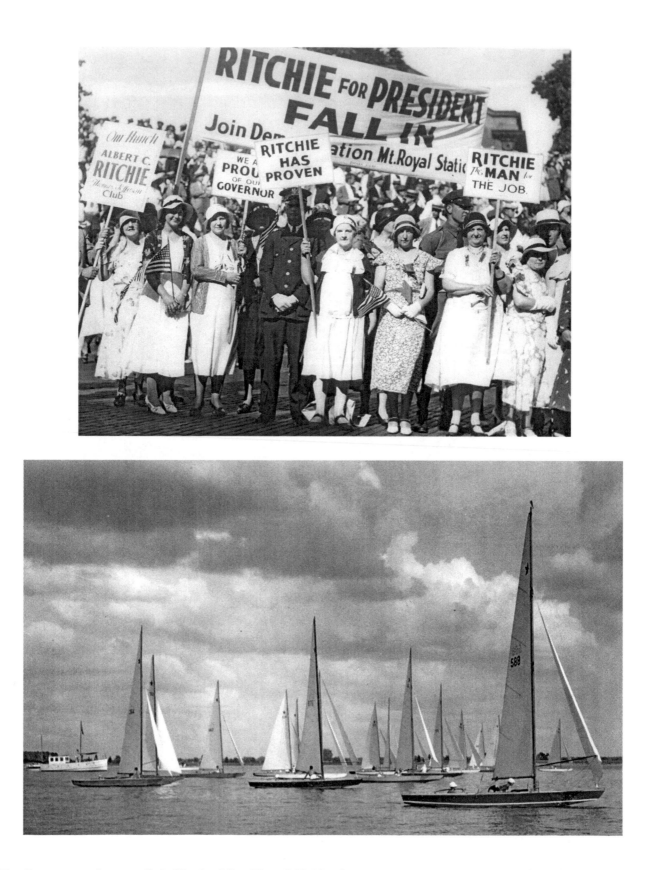

Top: Supporters gather at a rally for Maryland Gov. Albert C. Ritchie, who was touted as a possible presidential candidate in 1932. He would lose to New York Gov. Franklin D. Roosevelt at the Democratic convention in Chicago. *Baltimore Sun photo* BEV-692-BS
Above: Sailboats fill the harbor at Oxford on Memorial Day 1935. The Colonial seaport was the home of Robert Morris Jr., the "financier of the Revolution," and Col. Tench Tilghman, the aide to George Washington who carried news of the British surrender at Yorktown to Philadelphia in 1781. *Baltimore Sun photo* ACO-447-BS

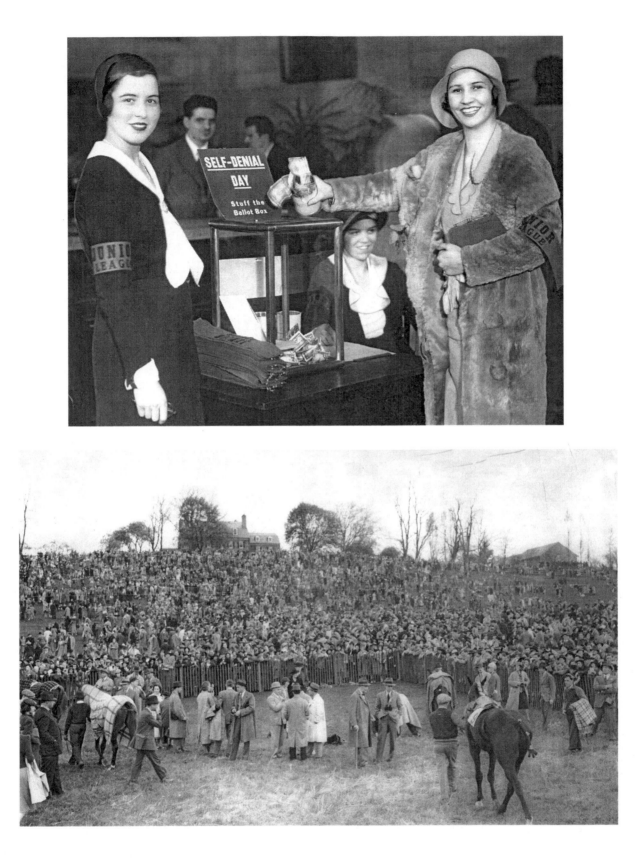

Top: On March 28, 1931, Mrs. T. Buchanan Blakiston, left, and Mrs. Esther Wight make a donation on Self-Denial Day, a citywide effort to raise relief money for the unemployed during the early days of the Depression. *Baltimore Sun photo* BEF-724-BS
Above: More than 12,000 steeplechase enthusiasts blanketed a Worthington Valley hillside in 1939 to see Blockade repeat as winner of the Maryland Hunt Cup. The race, considered the toughest timber race in the world, was founded in 1894. *Baltimore Sun photo* AAW-141-BS

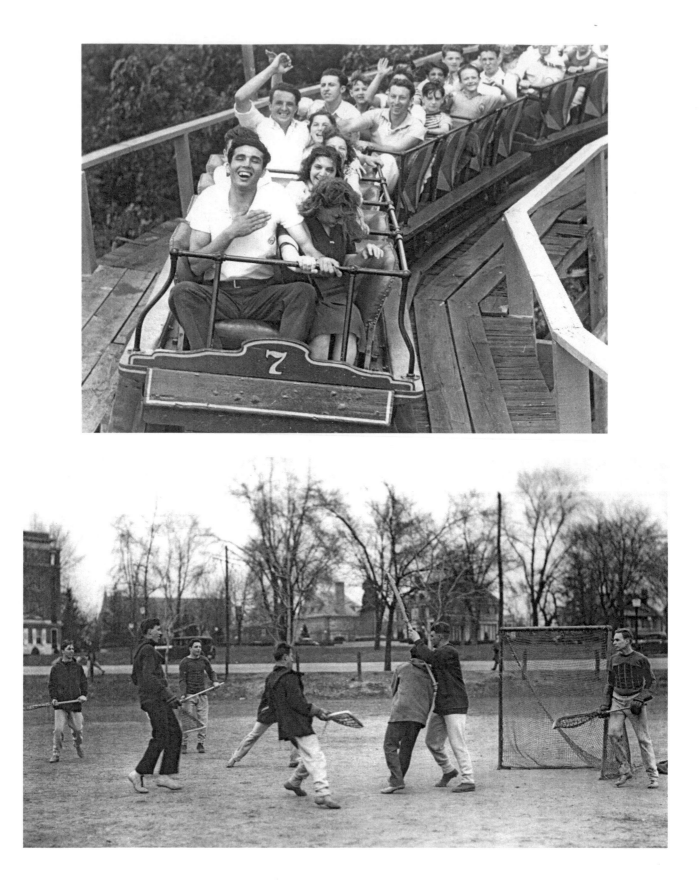

Top: Those who dared found thrills and chills on the Mountain Speedway at Carlin's Park in 1939. The Baltimore amusement park, which also featured dancing and skating, closed in the '50s. *Baltimore Sun photo* BDY-503-BS

Above: The 1931 Johns Hopkins lacrosse team practices at Homewood Field. Jack Turnbull, called by historians the "greatest attackman ever to play" the sport, was a member of that Blue Jays team. *Baltimore Sun photo* ABB-700-BS

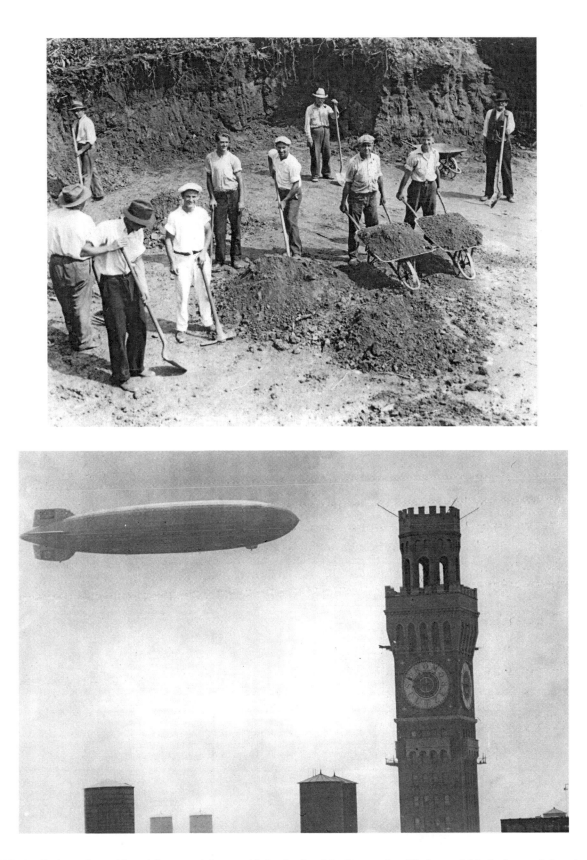

Top: Able-bodied men hoped for a job — any job — amid the depths of the Depression. Workers wielded rakes and shovels at Loch Raven Boulevard and The Alameda in September 1933. *Baltimore Sun photo* ACN-473-BS

Above: The 804-foot-long dirigible Hindenburg, the "Titanic of the Skies," soars above the Bromo-Seltzer Tower on its way to Lakehurst (N.J.) Naval Air Station on August 11, 1936. Nine months later, it would explode at Lakehurst, killing 35 passengers and crew. *Baltimore Sun photo* BKB-648-BS

The Forties

The world goes to war, and The Sun is honored for coverage at home and abroad

I n 1940, "Gone With the Wind" won eight Academy Awards, more than 859,000 people lived in Baltimore and The Sun endorsed Republican Wendell L. Willkie for president. On December 7, 1941, Japanese forces carried out a surprise attack on Pearl Harbor, leading to a declaration of war. In 1942, Time magazine ranked The Sun fifth on its list of the world's greatest newspapers.

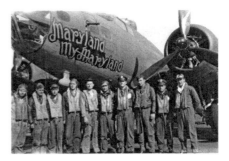

Lee McCardell was the first of many Sunpapers correspondents of World War II. They would cover the war in Europe and the Pacific, report on the invasions at Anzio and Normandy, and accompany American troops into Rome and Paris. In 1945, Howard Norton was among four American correspondents who told the world that dictator Benito Mussolini had been shot by Italian partisans. On May 7, 1945, The Sun's Price Day was among the eyewitnesses in Reims, France, to Germany's surrender. Three Sun correspondents were present for Japan's surrender aboard the battleship USS Missouri on September 2, 1945. On the home front, a fire destroyed old Oriole Park on Greenmount Avenue, home of the International League Orioles, on July 4, 1944. In 1945, thousands would gather in Sun Square to celebrate the end of World War II.

In 1946, the Sunday Sun's sepia-tone pages known as the Brown Section became a Maryland-centered Sunday Magazine. The award-winning work of Sun photographer A. Aubrey Bodine featured prominently. Over Mencken's objections, the company obtained a broadcasting license, and WMAR-TV, the first television station in the state, went on the air October 27, 1947.

The Sun won five Pulitzer Prizes from 1944 to 1949: Dewey L. Fleming in 1944 for national reporting; Mark S. Watson in 1945 for distinguished reporting in 1944 "from Washington, London and the fronts in Sicily, Italy and France"; Howard Norton "for meritorious public service" in 1947 for a series exposing problems with the unemployment compensation system in Maryland; Paul W. Ward for a series "Life in the Soviet Union" in 1948; and Price Day in 1949 for a series on India's first year of independence.

Above: Lt. Kenneth A. Reecher, right, of Hagerstown and the crew of the rugged B-17 Maryland, My Maryland. In June 1943, the plane was late in returning from a bombing raid after attacks by six enemy fighters. *Photo by Lee McCardell* ABF-421-BS

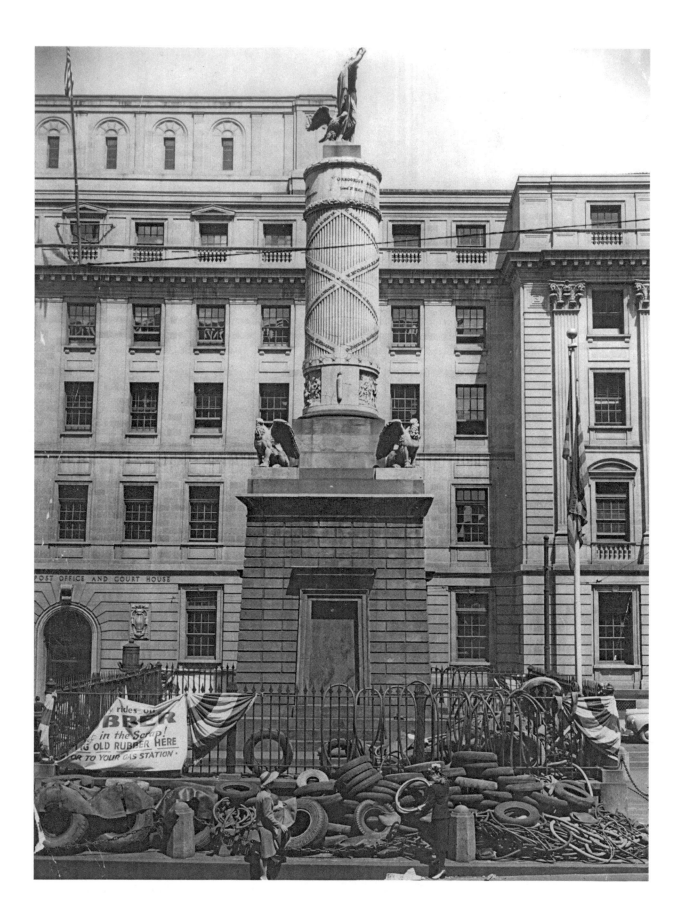

Above: Women add to the pile of tires at the Battle Monument in 1942. President Franklin D. Roosevelt ordered a scrap drive after rubber supplies were interrupted by World War II. *Baltimore Sun photo* AES-460-BS

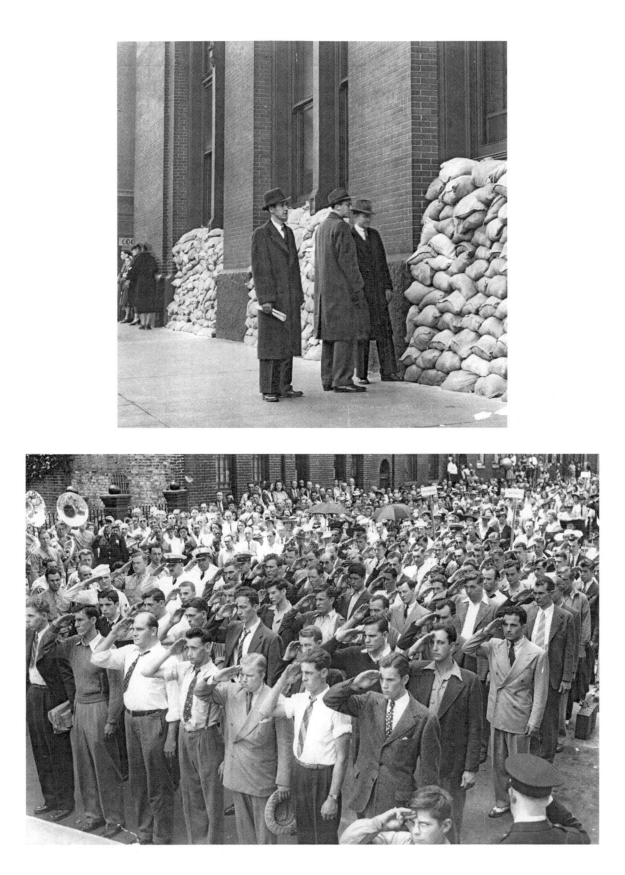

Top: Sandbags protect the B&O Annex in Baltimore during the war. Women did men's jobs amid the labor shortage, and railroad workers grew Victory Gardens. *Baltimore Sun photo* AES-441-BS

Above: Navy recruits salute after taking the oath at Flag House in Baltimore in June 1942. Thousands of brave Marylanders heeded their country's call. *Baltimore Sun photo* AES-454-BS

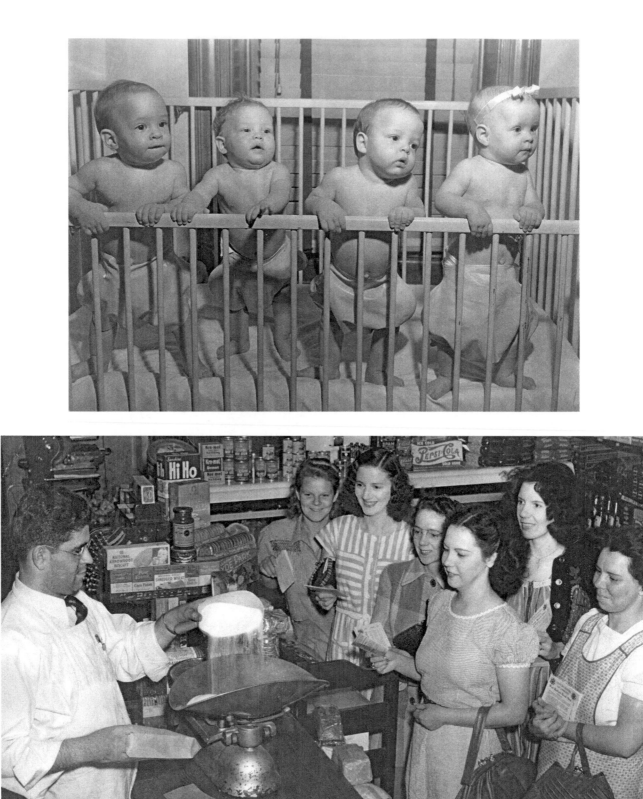

Top: The Henn quadruplets — Tommy, Donald, Bruce and Joan — on their first birthday. Their father, Charles J. Henn Jr., was a Baltimore bookbinder and Army sergeant who married Dorothy Geast of the British army in 1945. The quadruplets, born on December 22, 1946, at St. Agnes, were a sensation. *Photo by A. Aubrey Bodine* AGM-478-BS

Above: Margaret Kirby, Adeline Truckenmiller, Grace Cochran, Rozel Thompson, Kathryn Mostyn and Catherine Krach get sugar rations in George Tabak's South Baltimore grocery in 1942. *Baltimore Sun photo* ACD-017-BS

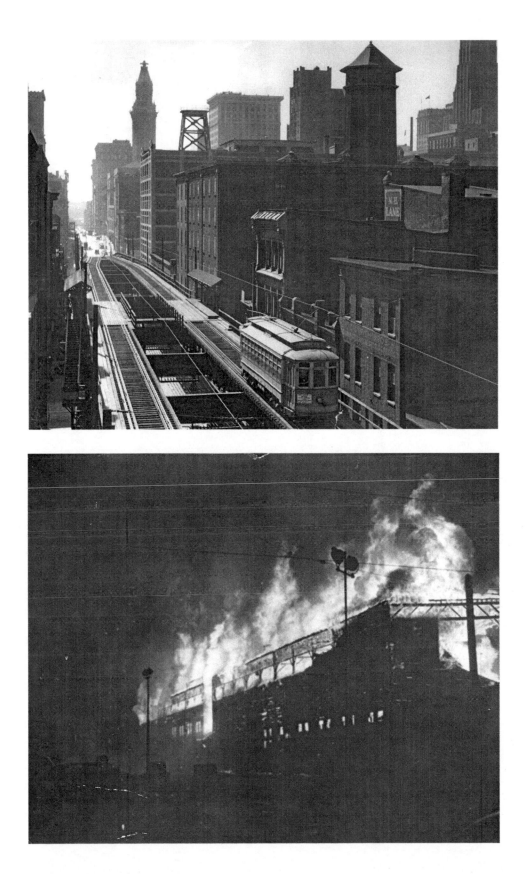

Top: A streetcar travels the Guilford Avenue Elevated line in 1940. The streetcar-only trestle extended from Saratoga to Biddle Street from 1895 to 1950. *Baltimore Sun photo* BFB-146-BS

Above: Fire engulfs Oriole Park on Greenmount Avenue, home of the International League Orioles, on July 4, 1944. Afterward, big crowds at Municipal Stadium helped lure major league baseball back to the city. *Baltimore Sun photo* ACD-176-BS

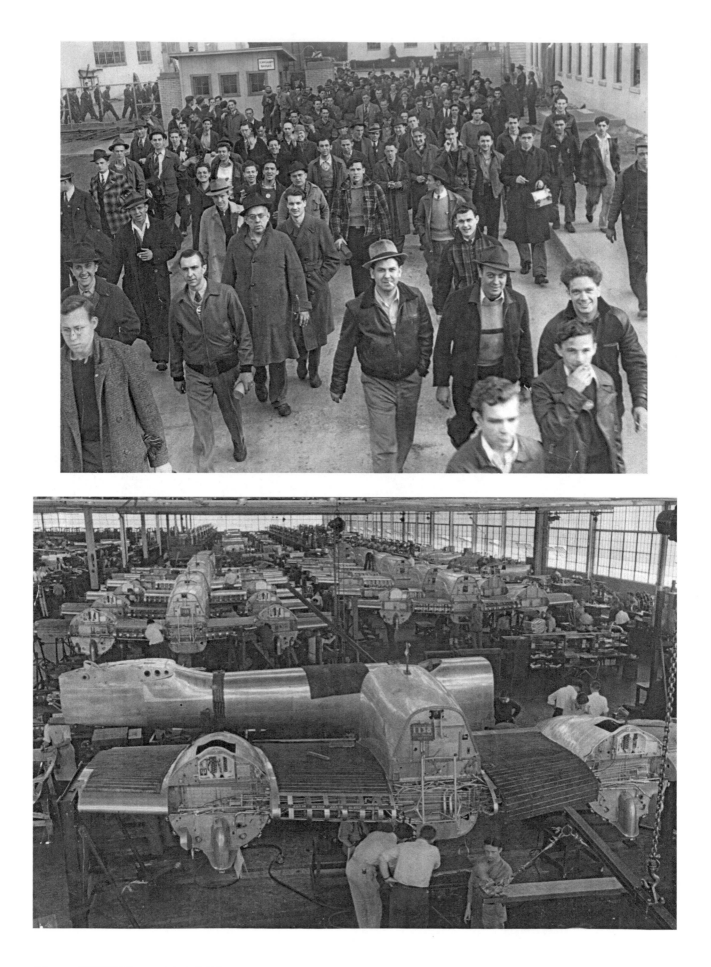

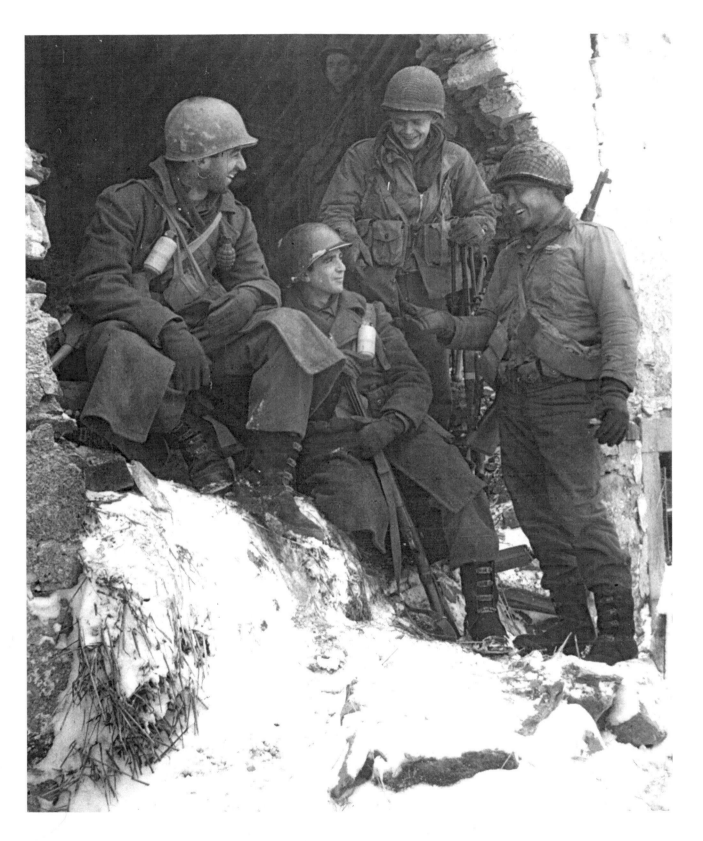

Above: Staff Sgt. Worton Cohen of Baltimore and members of the Yankee Division take a break from the war after the victory at Ardennes in February 1945. *Photo by Lee McCardell* ADX-547-BS

Opposite top: More than 53,000 men and women worked at the Glenn L. Martin plant in Middle River at the height of World War II, and thousands of B-26 Marauders were built there. *Baltimore Sun photo* ACB-528-BS

Opposite bottom: Sections of bombers intended for France march toward final assembly at the Glenn L. Martin aircraft plant in 1940. *Photo by Robert F. Kniesche* ACB-530-BS

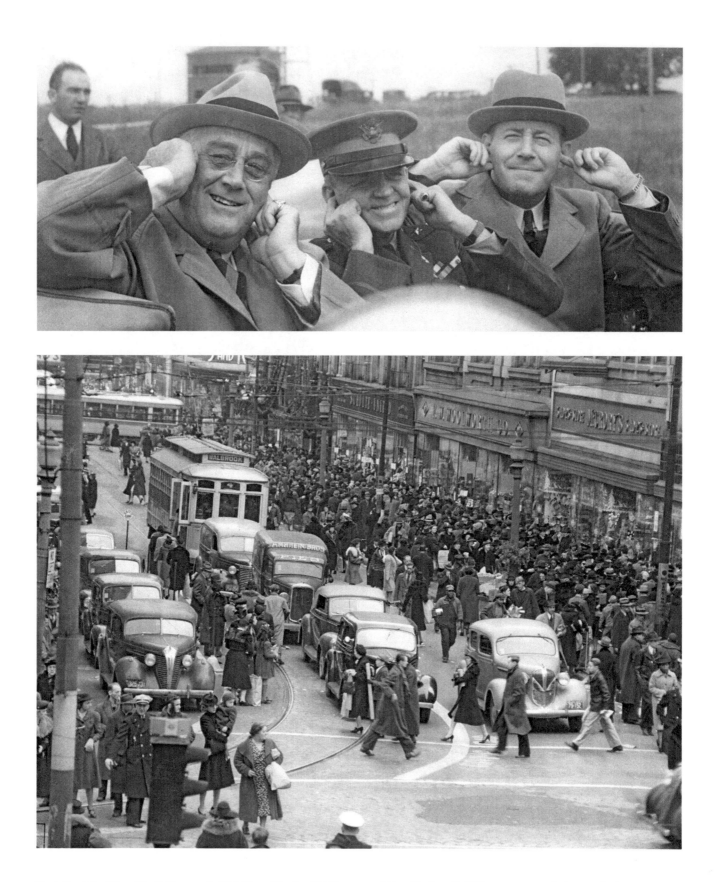

Top: President Franklin D. Roosevelt, Maj. Gen. Charles M. Wesson and Gov. Herbert R. O'Conor protect their ears during an ordnance demonstration at Aberdeen Proving Ground in 1940. *Baltimore Sun photo* AEB-793-BS

Above: Streetcars, automobiles and pedestrians vie for room in the busy Howard Street shopping district, home to Hutzler Brothers, Hochschild-Kohn, Stewart's and the May Co., later Hecht's, in 1941. *Baltimore Sun photo* ADO-807-BS

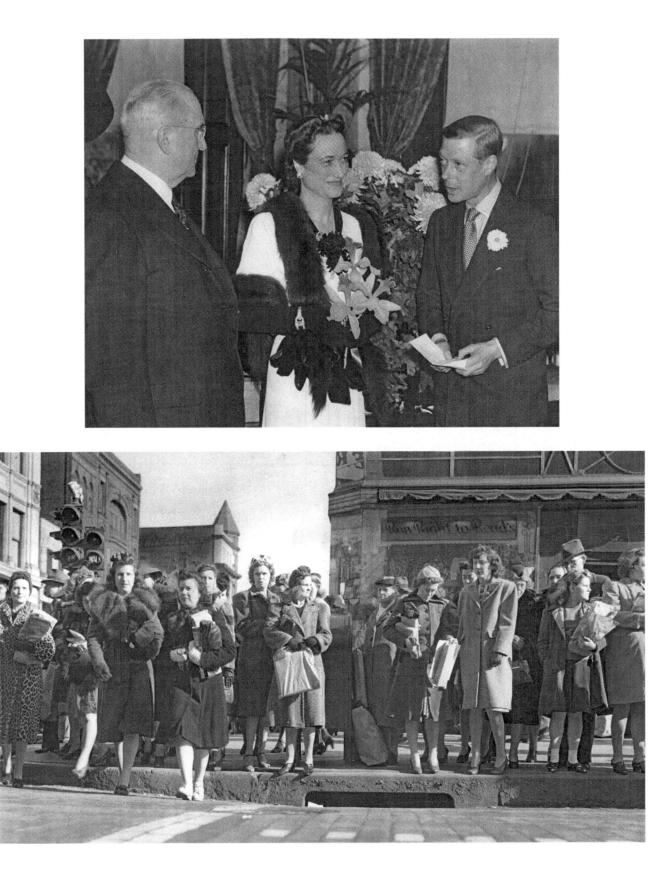

Top: Mayor Howard W. Jackson with the Duke and Duchess of Windsor during a visit to Baltimore in 1941. The duke gave up the British throne to marry Wallis Warfield Simpson, a twice-divorced socialite from Baltimore. *Photo by Robert F. Kniesche* 110277
Above: America had been at war for a year and many men were away, but Baltimore women went about their Christmas shopping on Howard Street in December 1942. *Photo by A. Aubrey Bodine* AHR-324-BS

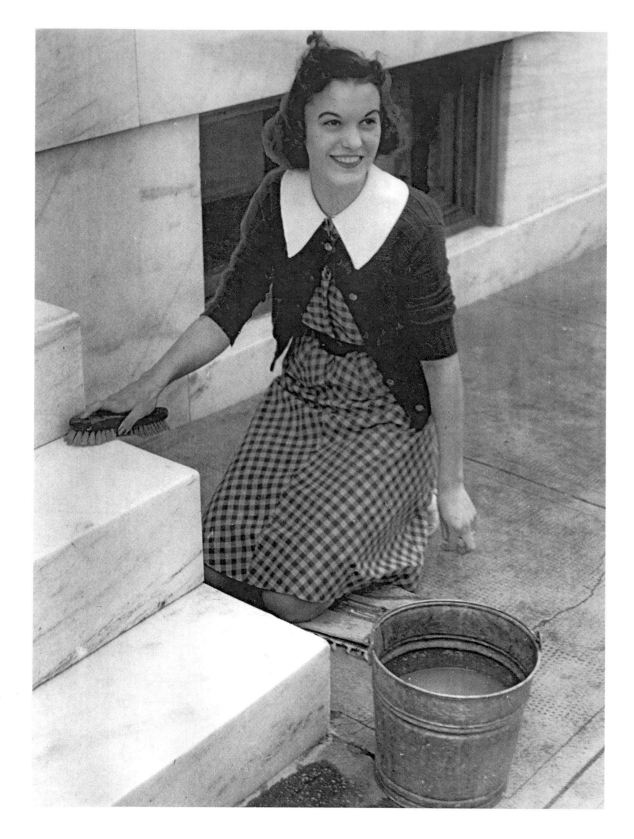

Above: Dorothy Rolley scrubs the marble steps of her home on North Linwood Avenue in June 1948, once a weekly ritual in Baltimore, typically with cleanser and pumice stone. *Baltimore Sun photo* BLN-711-BS

Opposite top: All that remained of the Eutaw Street entrance to Lexington Market after a fire in March 1949. A building would replace the Baltimore market, which dated to 1782. *Photo by Albert D. Cochran* BLN-949-BS

Opposite bottom: Cars and owners line up for gasoline rations at a Richfield station at Gilmore Street and Lafayette Avenue in Baltimore during World War II. *Baltimore Sun photo* ACD-011-BS

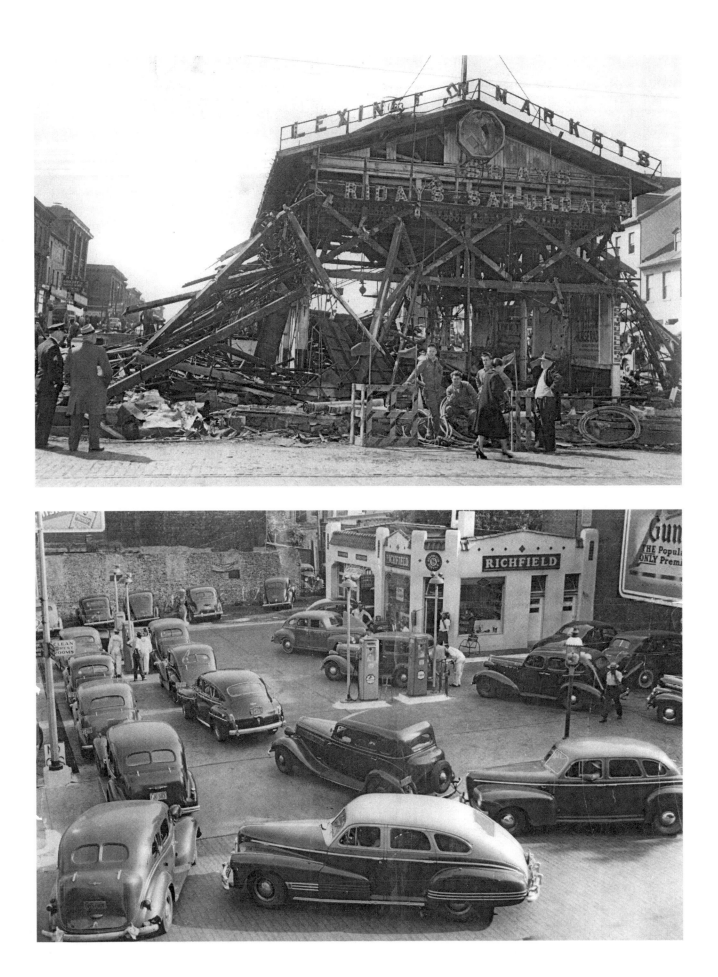

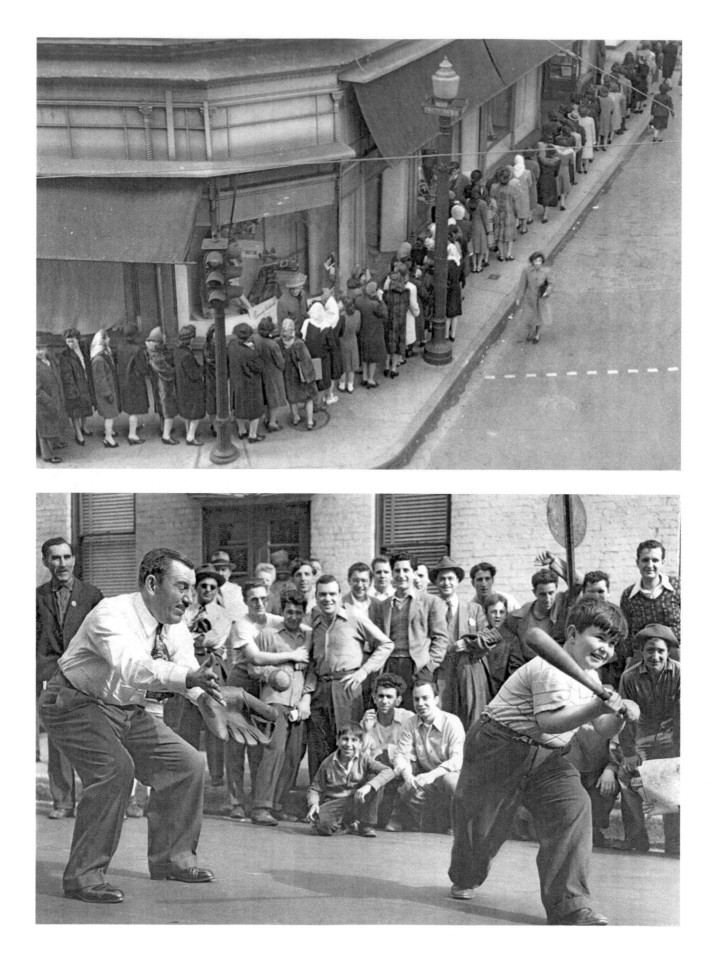

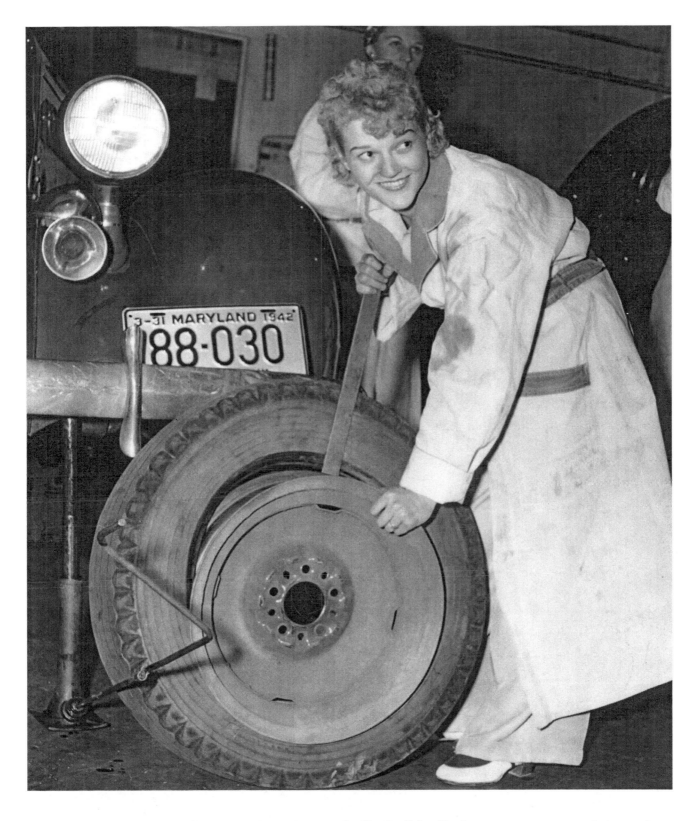

Above: Irene Grzech of the Red Cross Motor Corps changes a flat. Nearly all the aid volunteers were women, and many took mechanics courses to enable them to make needed repairs. *Baltimore Sun photo* ACD-095-BS
Opposite top: Women queue up for nylons on Lexington Street in Baltimore in February 1946. Shortages of some consumer goods persisted even after World War II. *Photo by A. Aubrey Bodine* AHP-452-BS
Opposite bottom: Mayor Thomas J. D'Alesandro Jr. joins a children's baseball game in Little Italy in 1947. The former Democratic congressman and father of Rep. Nancy Pelosi was mayor until 1959. His son Thomas J. D'Alesandro III was mayor from 1967 to 1971. *Photo by William L. Klender* ADY-946-BS

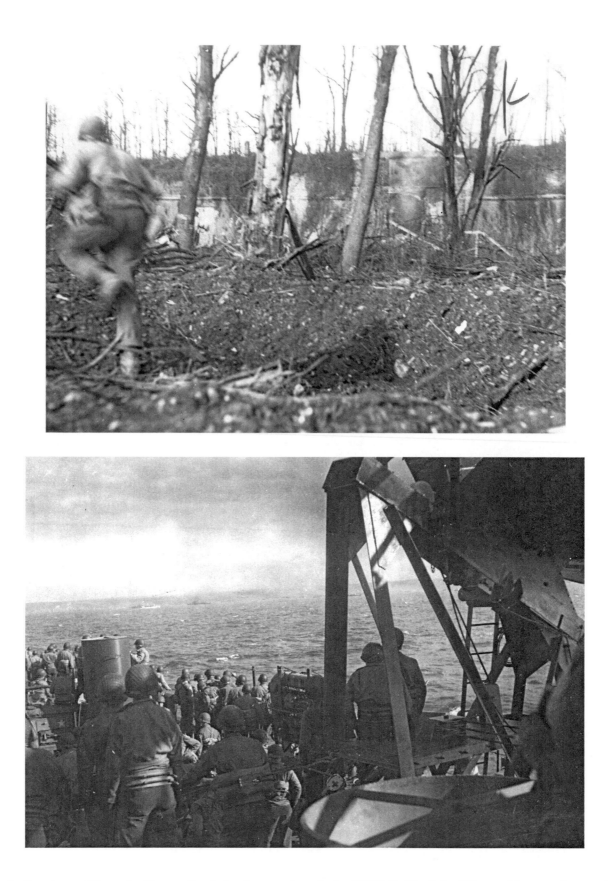

Top: An American soldier under German fire dashes for cover in early April 1945. On May 7, the Allies would accept Germany's unconditional surrender in Reims, France. *Photo by Holbrook Bradley* BKI-517-BS
Above: Troops of the "Blue and Grey" 29th Infantry near Normandy, France, on June 6, 1944. "The beach was jumping with fire and a tangled, ghastly mess it was from half a mile away," a D-Day invader said. *Photo by Holbrook Bradley* BKI-500-BS

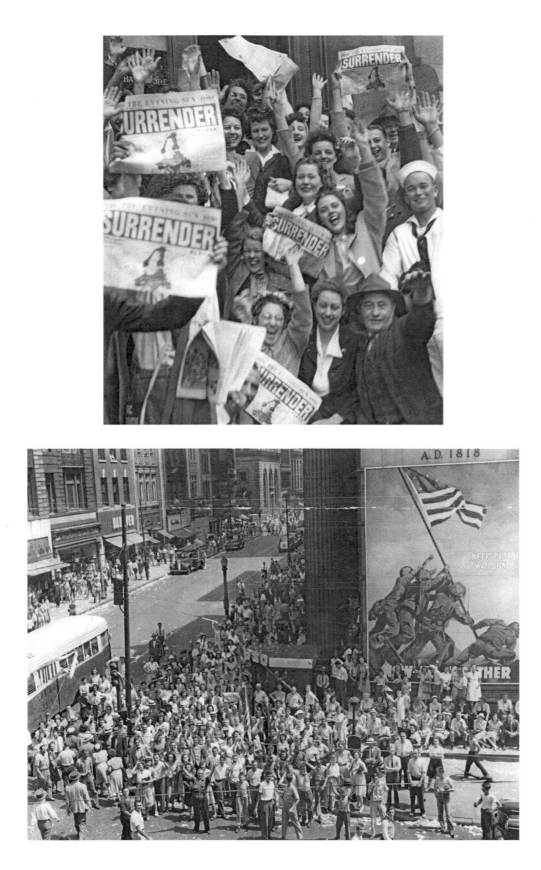

Top: Baltimoreans in Sun Square celebrate the end of the war in Europe after Germany's capitulation. The Evening Sun's exultant headline on May 7, 1945: SURRENDER. *Baltimore Sun photo* ACD-262-BS

Above: Baltimoreans gather in Sun Square to celebrate Japan's surrender on August 14, 1945. The formal ceremony aboard the battleship USS Missouri would take place September 2. *Baltimore Sun photo* ADU-036-BS

The Fifties

A great bridge links Maryland shores, and the Baltimore Colts connect a city

I n 1950, conflict broke out on the Korean Peninsula, Marylanders again were called to war and a Sun reporter landed with U.S. Marines in the decisive victory at Inchon. Baltimore's population had risen to nearly 950,000, its highest ever, and the growing Sunpapers moved into a new, larger building at Calvert and Centre streets.

In July 1952, the Bay Bridge opened, connecting the eastern and western shores of the Chesapeake. The Sun endorsed Republican Dwight D. Eisen-

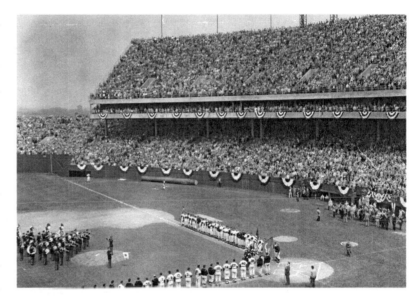

hower for president that fall (and again in 1956). Big league baseball returned to the city in 1953 as the St. Louis Browns franchise became the Baltimore Orioles, who took the field at Memorial Stadium on 33rd Street in 1954. That May, in the landmark civil rights case Brown v. Board of Education, the Supreme Court held unanimously that segregation in public schools was unconstitutional. The Sunpapers endorsed the decision.

Against the backdrop of the Cold War, the space race began on October 4, 1957, when the Soviet Union launched Sputnik, the world's first artificial satellite, raising fears that the Russians could attain technological superiority and gain the military "high ground" of space.

In December 1958, the Baltimore Colts defeated the New York Giants, 23-17, in sudden-death overtime to win the NFL championship in what became known as "the greatest game ever played." The Colts would beat the Giants again in 1959 to repeat as champions.

Above: Major league baseball returned to Baltimore when the Orioles played their home opener against the Chicago White Sox at Memorial Stadium on April 15, 1954. A sellout crowd saw the Orioles win 3-1. *Baltimore Sun photo* AAU-046-BS

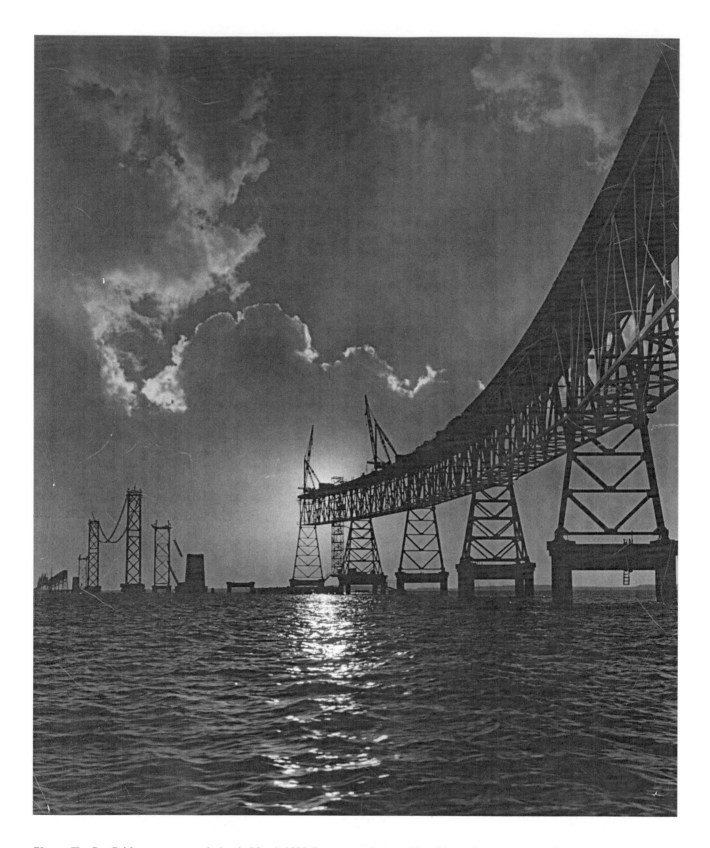

Above: The Bay Bridge nears completion in March 1952. Soon, motorists would no longer have to take the ferry across the Chesapeake Bay or make the long trek around it. *Photo by A. Aubrey Bodine* AAV-858-BS
Opposite top: Maryland Gov. Theodore R. McKeldin, Delaware Gov. Elbert N. Carvel and former Gov. William Preston Lane Jr., for whom the span is named, open the Bay Bridge on July 30, 1952. *Photo by Joseph A. DiPaola Jr.* BHG-569-BS
Opposite bottom: A worker in the blast furnace at Bethlehem Steel Co. In the 1950s, the Sparrows Point plant in Baltimore County was the world's largest steel mill. *Photo by Robert F. Kniesche* BJF-907-BS

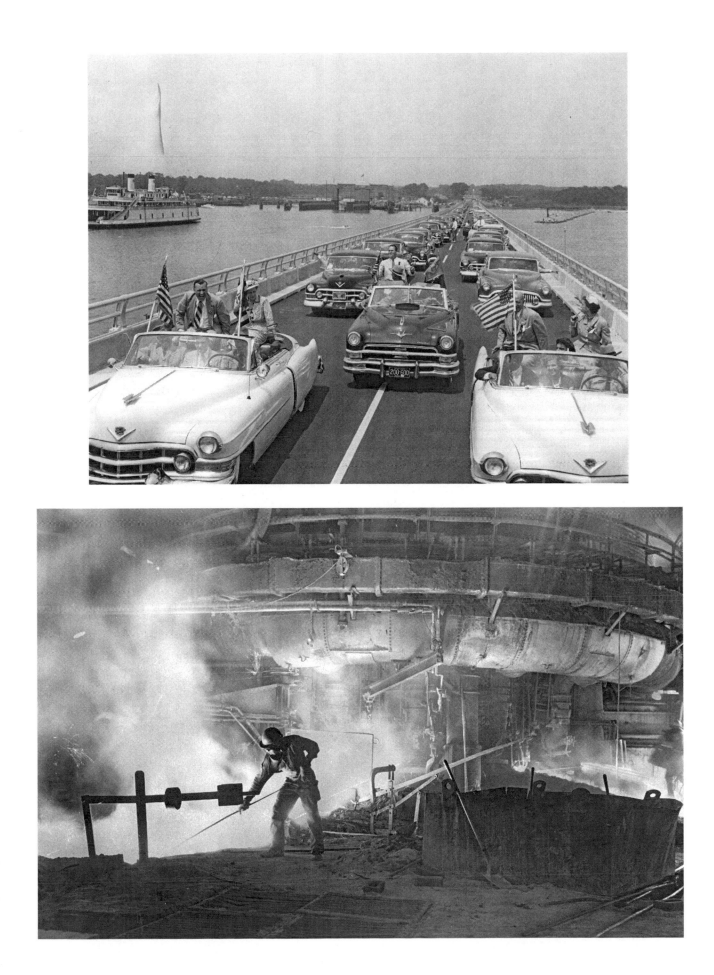

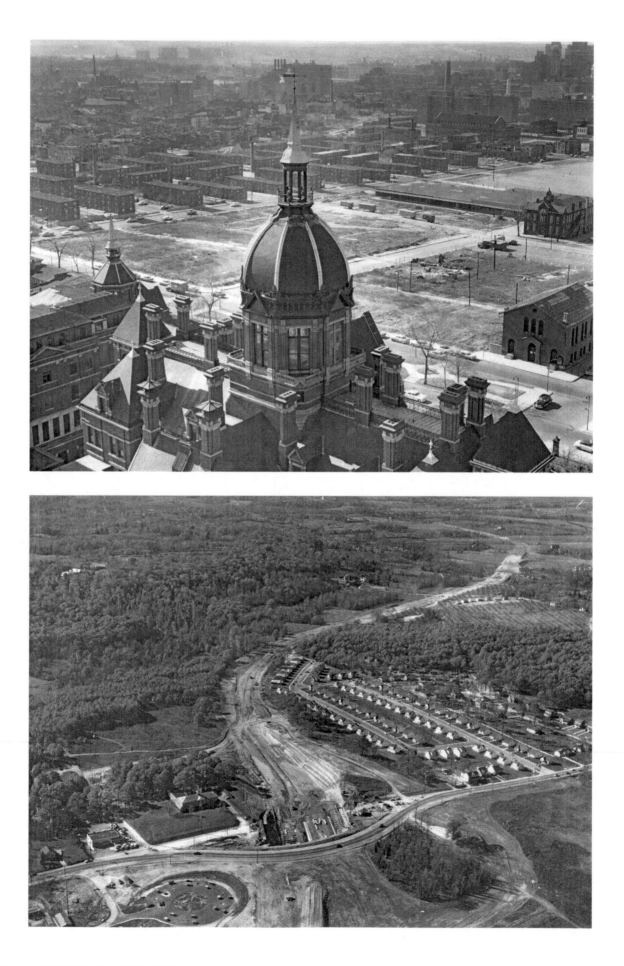

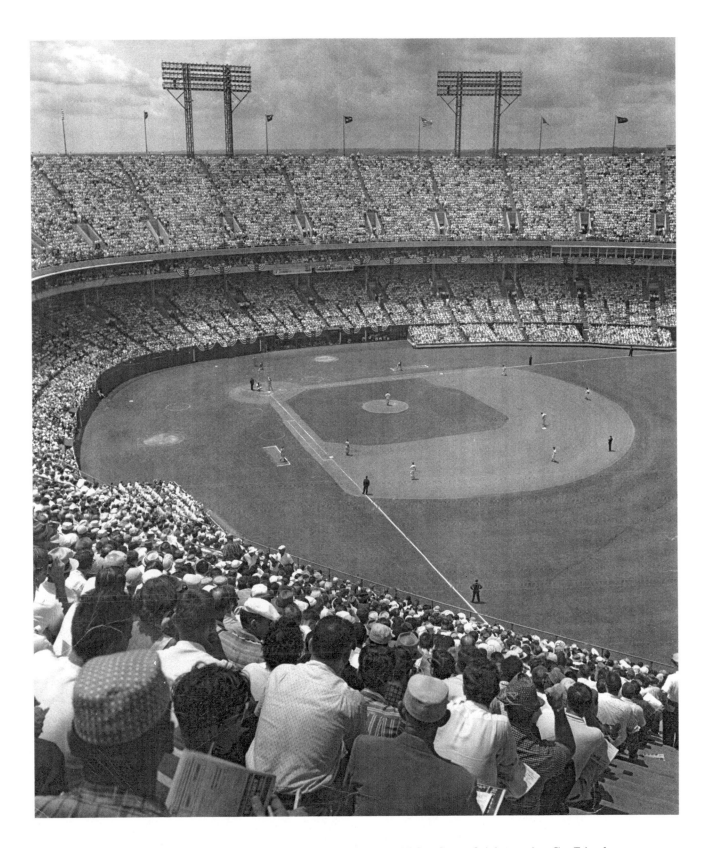

Above: Nearly 49,000 fans filled Memorial Stadium on July 8, 1958, for the All-Star Game. Orioles catcher Gus Triandos was a starter as the American League beat the National League, 4-3. *Photo by A. Aubrey Bodine* AHP-210-BS

Opposite top: The Broadway redevelopment project gets under way in January 1958 in the shadow of the dome of Johns Hopkins Hospital amid Baltimore's urban renewal movement. *Baltimore Sun photo* BJD-495-BS

Opposite bottom: Baltimore's Beltway under construction at York Road in Towson in 1954. The 36-mile bypass was finished in 1962, and the 53-mile circle completed in 1977. *Photo by Robert F. Kniesche* BKS-903-BS

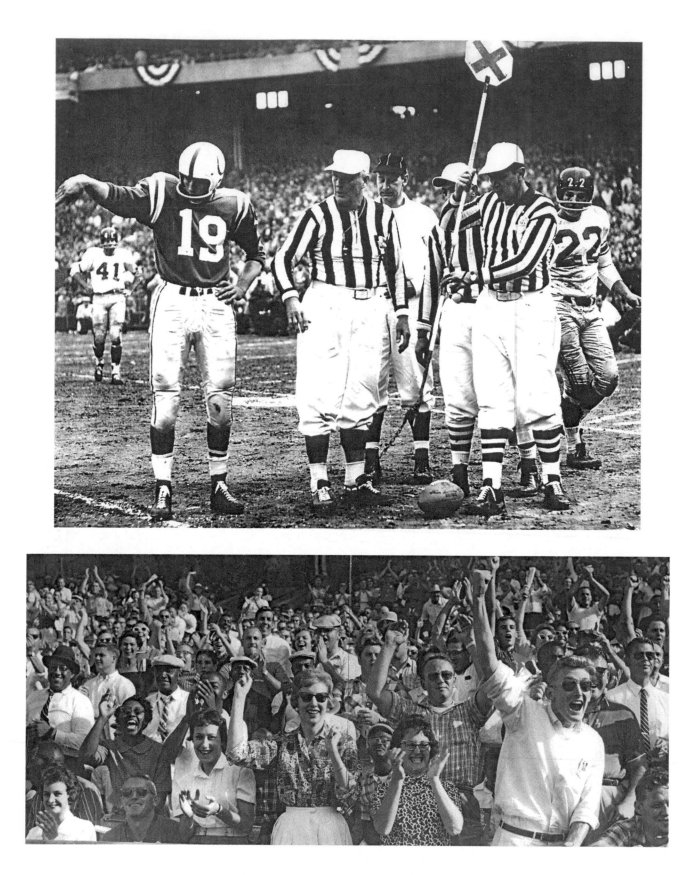

Top: Johnny Unitas checks a first-down measurement in the 1959 NFL title game at Memorial Stadium. The Colts would repeat as champions, defeating the New York Giants again, 31-16. *Photo by Joseph A. DiPaola Jr.* AAT-577-BS

Above: Baltimore fans cheer for their Colts at Memorial Stadium on September 27, 1959. Johnny Unitas threw two touchdown passes as the defending NFL champions beat the Detroit Lions, 21-9. *Photo by Robert F. Kniesche* AAB-911-BS

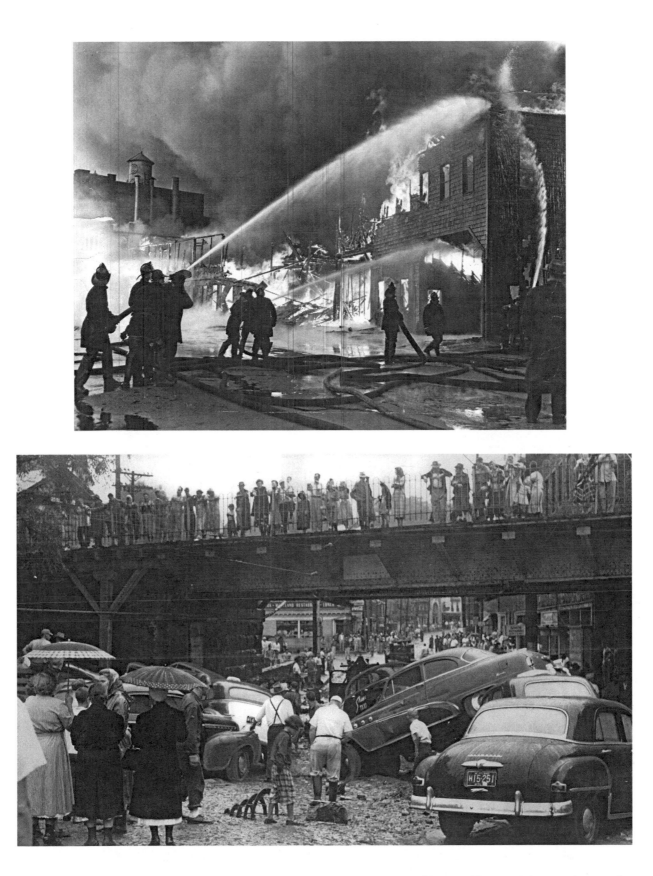

Top: An 18-alarm fire on February 17, 1953, started by a worker making repairs to an oil barge with an acetylene torch, swept the Baltimore waterfront in Canton. *Photo by Walter M. McCardell* BHI-184-BS
Above: Tropical Storm Able brought heavy rain and flash flooding on September 1, 1952, that turned Main Street in Ellicott City into a torrent and swept cars toward the Patapsco River. *Photo by Frank A. Miller* ADH-099-BS

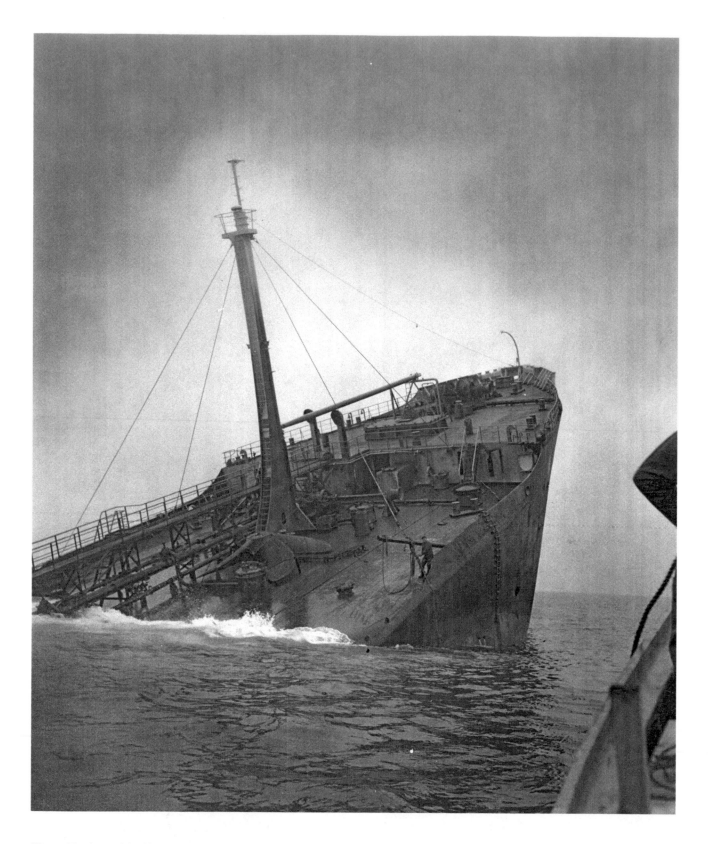

Above: The bow of the Liberian tanker African Queen juts from the Atlantic in March 1959 after striking a shoal nine miles off Ocean City on December 31, 1958. *Photo by A. Aubrey Bodine* BLA-034-BS

Opposite top: Amid Cold War fears of a nuclear attack, students at Leith Walk Elementary in Baltimore duck and cover in a school hallway during a Civil Defense drill in April 1959. *Photo by William L. Klender* AGL-896-BS

Opposite bottom: Seen from the air, a Dundalk-area housing development seems almost a work of abstract art in 1955. *Photo by A. Aubrey Bodine* AAV-480-BS

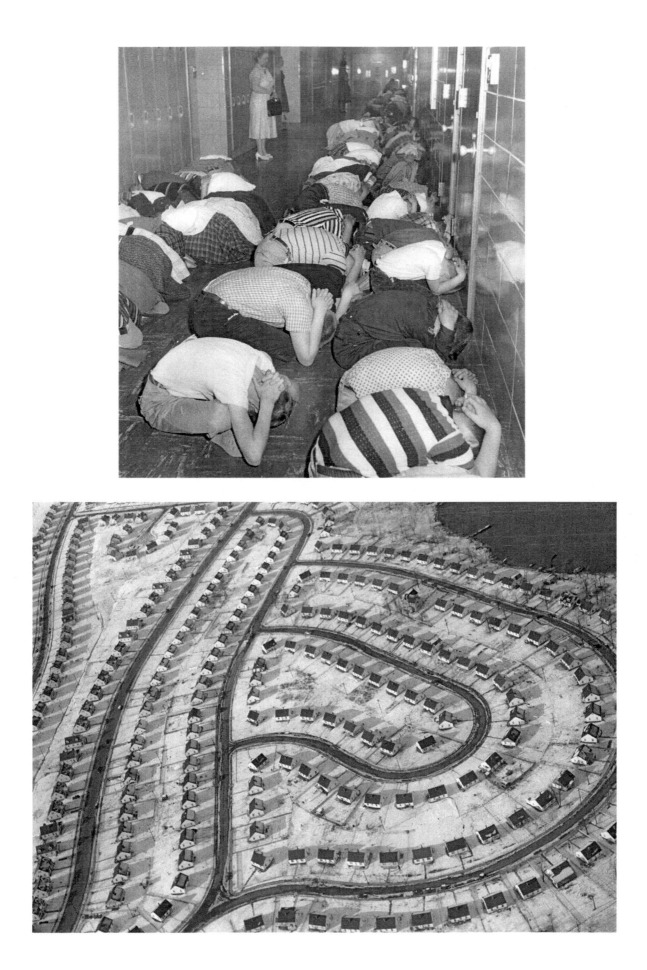

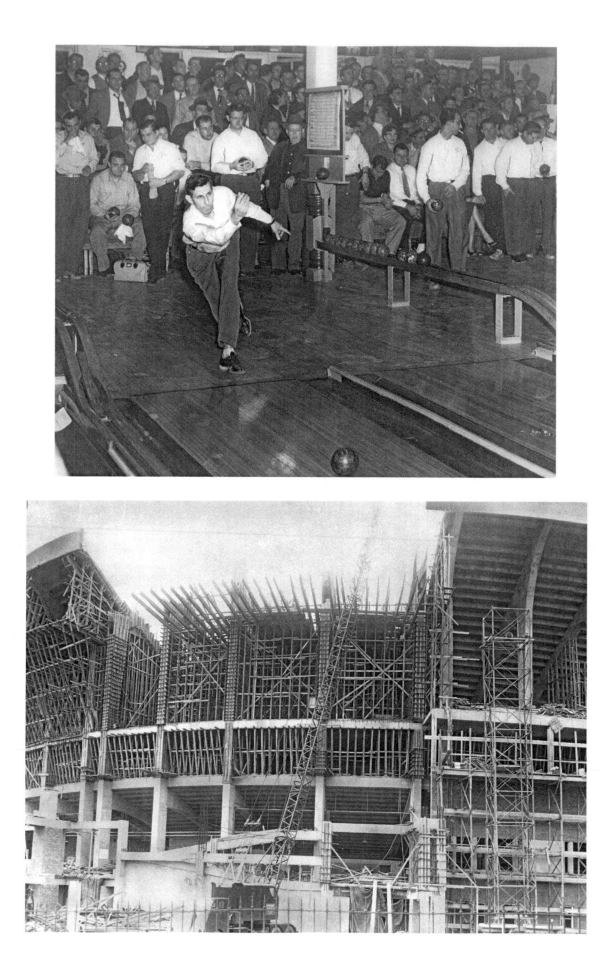

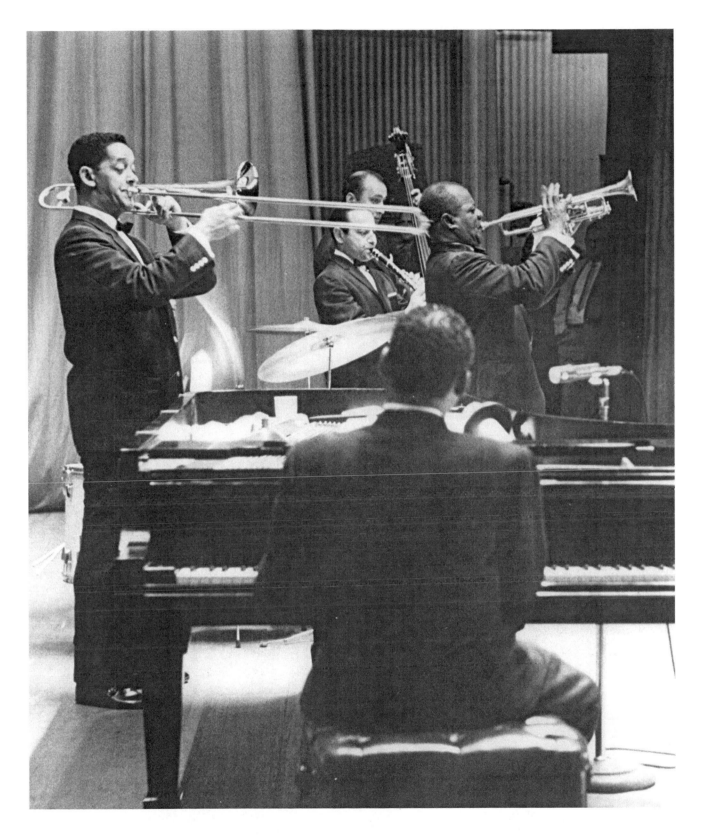

Above: The great Louis Armstrong, backed by a jazz quartet, blows his horn before a packed house at the Lyric Opera House in November 1959. *Photo by William L. Klender* AAI-188-BS

Opposite top: Competitors at Patterson Lanes vie in 1953 in a duckpin tournament sponsored by The Evening Sun, one of many contests inaugurated by the paper. *Photo by Ellis J. Malashuk* AEG-325-BS

Opposite bottom: The upper deck rises at Memorial Stadium in March 1954. The St. Louis Browns moved to Baltimore and opened the season that year as the big league Baltimore Orioles. *Photo by Frank P. Kalita* AEM-057-BS

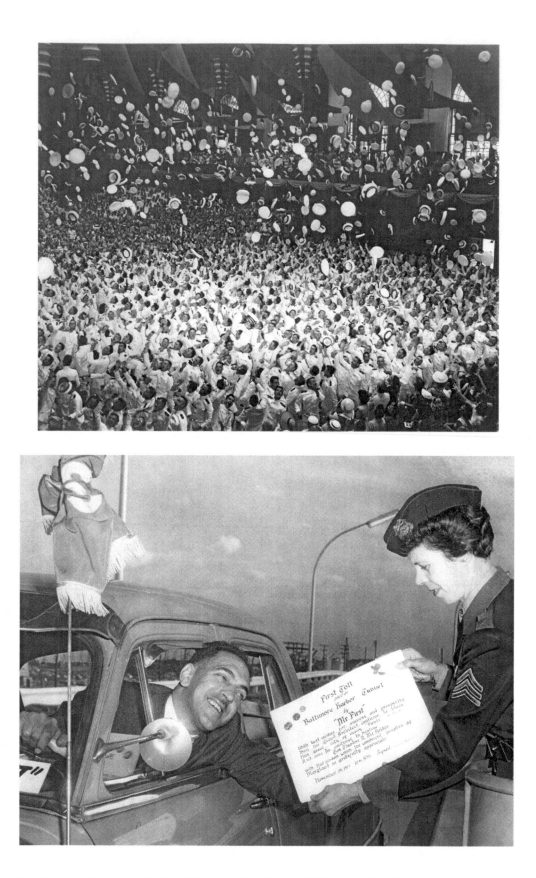

Top: U.S. Naval Academy graduates toss their midshipman's hats in June 1954, the traditional end to graduation and commissioning ceremonies since 1912. *Photo by Clarence B. Garrett* ABL-324-BS

Above: "Mr. First" Omero C. Catan, with toll officer Sgt. L.B. Gisol, was first to drive through the Harbor Tunnel in November 1957. He was also first on the New Jersey Turnpike in 1951 and the Bay Bridge in 1952. *Photo by Joseph A. DiPaola Jr.* BHG-643-BS

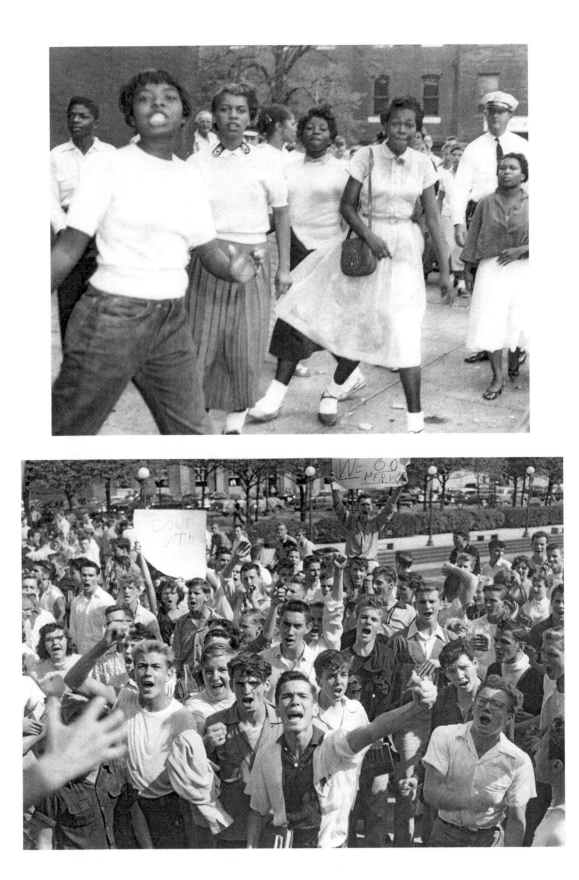

Top: A police officer escorts black students to previously all-white Southern High in Baltimore in 1954 after the Supreme Court ruled "separate but equal" schools unconstitutional. *Photo by Albert D. Cochran* BJR-144-BS
Above: Students at City Hall protest the integration of Baltimore schools in 1954 after the Supreme Court's landmark decision in Brown v. Board of Education. *Photo by Joseph A. DiPaola Jr.* BJR-139-BS

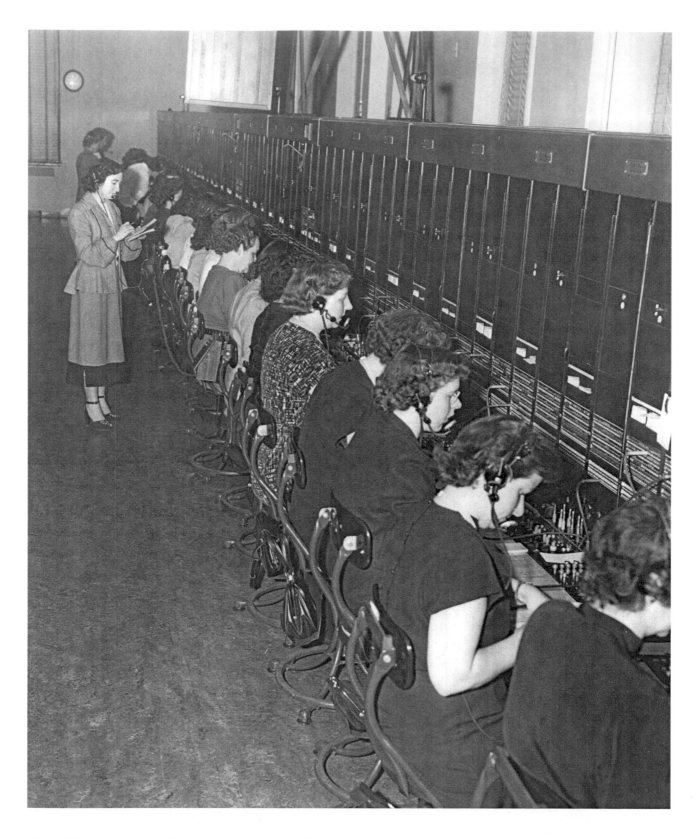

Above: With telephone installers on strike, a walkout by Chesapeake and Potomac operators seeking a 15-cent raise and scale upgrades was averted in May 1950 with a one-year deal. *Photo by William L. Klender* BJR-378-BS

Opposite top: Thousands turned out on Baltimore Street for a parade to welcome the Orioles in April 1954 as major league baseball returned to the city after 52 years. *Photo by Richard Stacks* AAU-044-BS

Opposite bottom: Sam Smith Park, honoring Baltimore's defender during the British attack in the War of 1812, would give way to Harborplace. Maj. Gen. Sam Smith's statue now stands atop Federal Hill. *Photo by Ellis J. Malashuk* BIP-809-BS

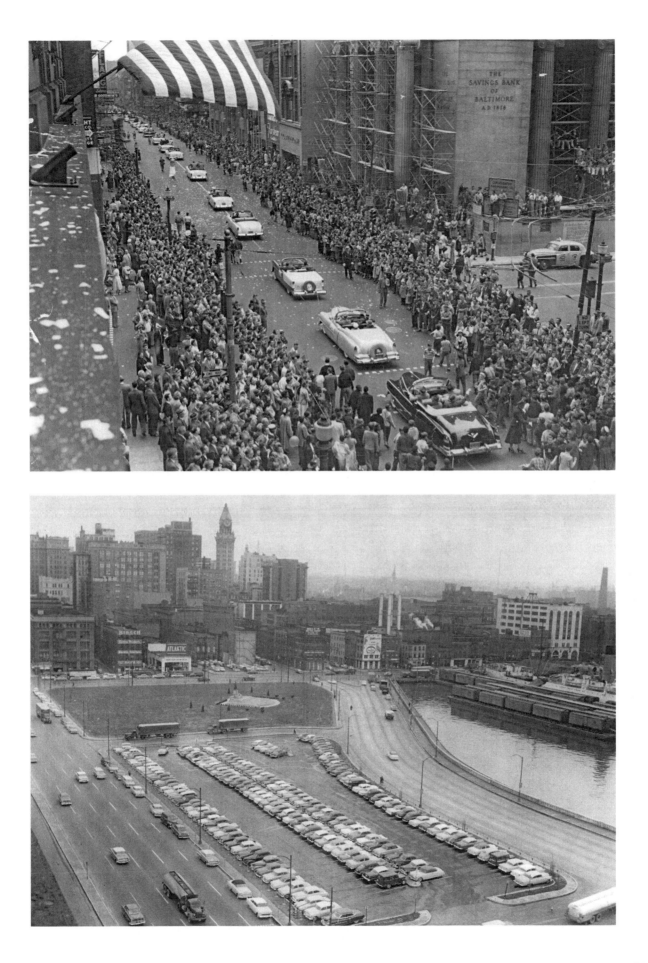

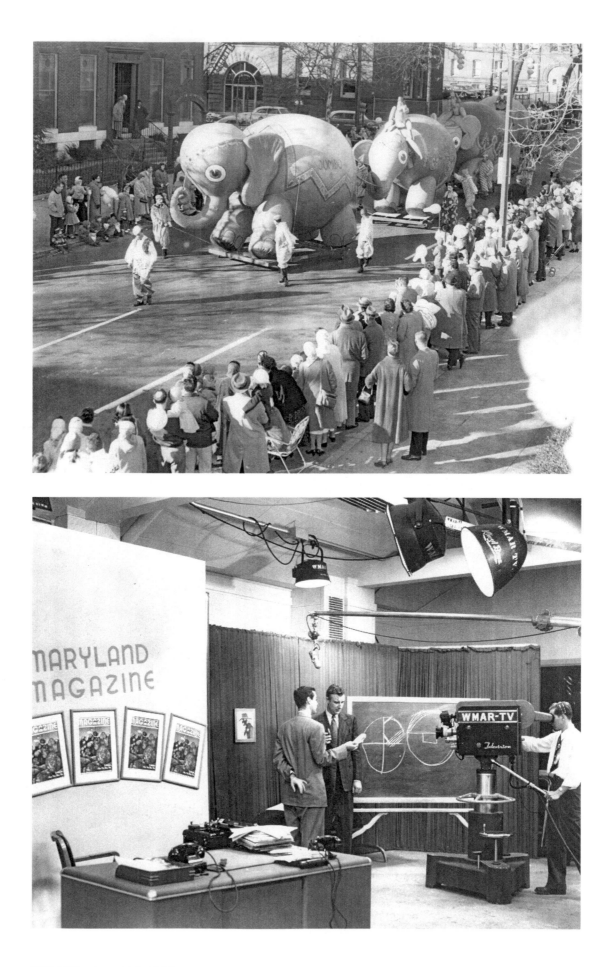

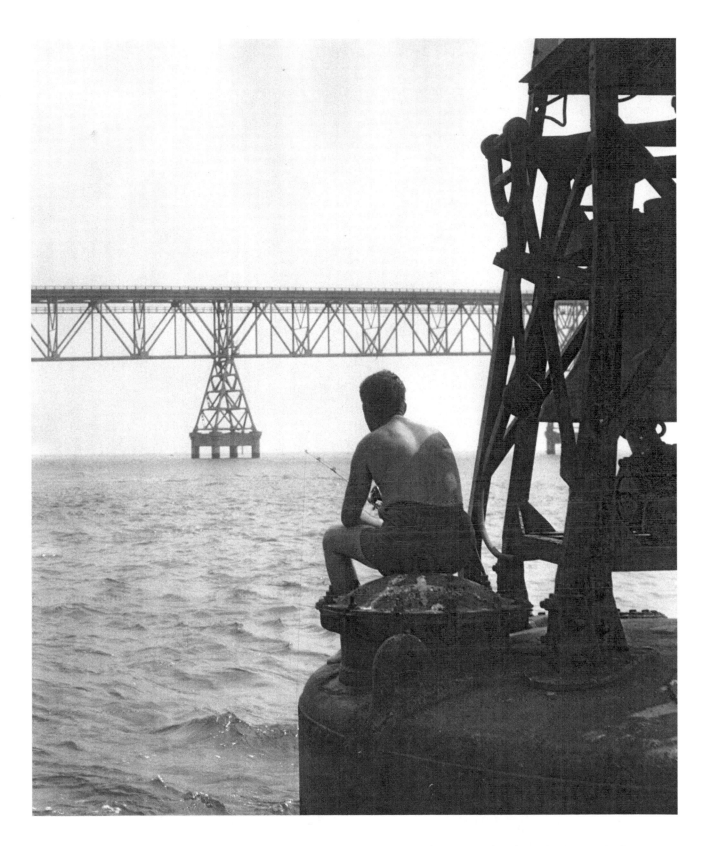

Above: An angler casts his line from a bell buoy near the Chesapeake Bay Bridge in August 1952. The 4.3-mile span had opened just weeks before. *Photo A. Aubrey Bodine* ABI-330-BS

Opposite top: The Hochschild-Kohn department store's annual Toytown Parade in 1958 marked the start of the Christmas shopping season and was long a holiday tradition in Baltimore. *Photo by Ralph L. Robinson* BFD-991-BS

Opposite bottom: Harrison Eagles, left, interviews J.E. Southern on WMAR-TV's new "Maryland Magazine" program in 1951. The Sun started Maryland's first TV station in 1947. *Photo by William L. Klender* BBF-702-BS

The Sixties

The Orioles win the Series, but the city is torn by riots after the King assassination

I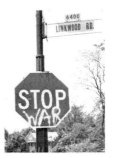n 1960, Democrat John F. Kennedy was elected president (The Sun endorsed Republican Richard M. Nixon), the Glenn L. Martin Co. went out of the airplane business after a half-century, and the city's population fell to 939,024, beginning a decline that persists. Alan B. Shepard Jr., a graduate of the Naval Academy in Annapolis and the Navy Test Pilot School in Patuxent, became the first American in space in May 1961. His 15-minute flight was shorter than many drivers' trips into Baltimore on the Jones Falls Expressway, which opened that year.

On March 6-7, 1962, "the Storm of the Century" swept the coast, killing 40. "Sea Sweeps Over Ocean City," The Evening Sun reported. The storm caused millions of dollars in damage, smashed the Boardwalk and submerged the resort in up to 5 feet of water. That October, the world stood at the brink of nuclear war as the United States imposed a blockade and demanded that the Soviet Union remove its missiles in Cuba.

In June 1963, three people were shot during racial demonstrations in Cambridge. Two months later, more than 200,000 would hear the Rev. Martin Luther King Jr.'s "I Have a Dream" speech in Washington. That November, Kennedy was assassinated in Dallas and Lyndon B. Johnson was sworn in as president.

By the mid-1960s, the Charles Center project was under way as Baltimore undertook urban renewal. On October 10, 1966, a Sun headline rejoiced "Would You Believe It? Four Straight" after the Orioles swept the Los Angeles Dodgers in the World Series. In October 1967, Baltimore native Thurgood Marshall, the former NAACP lawyer who had argued Brown v. Board of Education, was sworn in as the first African-American on the Supreme Court.

By 1968, the fighting in the Vietnam War had escalated and American public opinion turned against the war. In April, King was murdered in Memphis, and rioting erupted in Boston, Chicago, Washington and a hundred other cities. In Baltimore, six people were killed, hundreds hurt and more than 5,700 arrested as parts of the city burned. About 11,000 National Guardsmen and U.S. troops were deployed. The turbulent decade came to a close as Neil A. Armstrong and Edwin E. "Buzz" Aldrin Jr. walked on the moon in July 1969.

Above: A three-letter addition to a road sign in Guilford was a sign of the times in 1969, expressing the writer's hope for a speedy end to the Vietnam War. *Photo by Ralph L. Robinson* BGR-805-BS

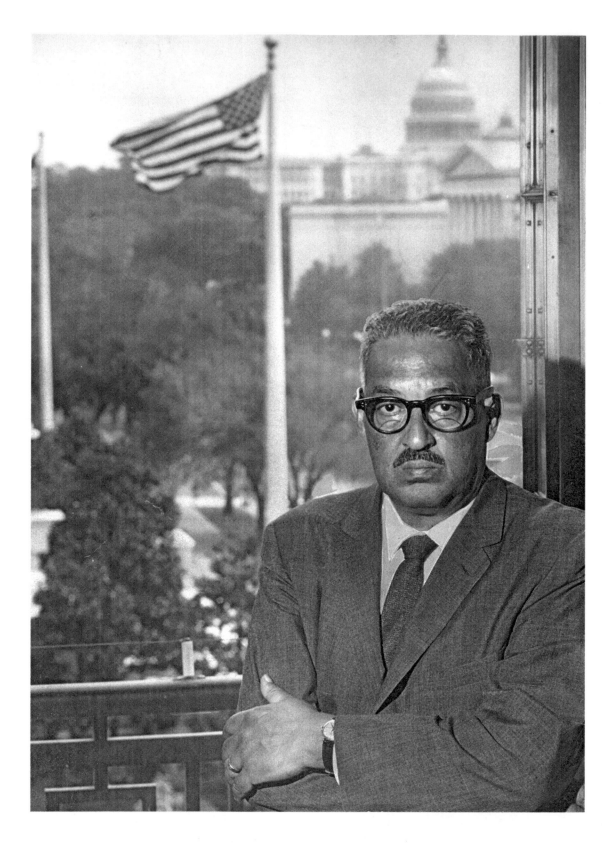

Above: U.S. Solicitor General Thurgood Marshall, a Baltimore native who argued Brown v. Board of Education as an NAACP lawyer in 1952, was sworn in as the first black justice of the Supreme Court in 1967. *Photo by Richard Stacks* AFW-734-BS
Opposite top: Thousands turned out on Gay Street to see the Rev. Martin Luther King Jr. during a get-out-the-vote campaign in October 1964, when he was announced as Nobel Peace Prize laureate. *Photo by Paul M. Hutchins* AHQ-788-BS
Opposite bottom: Democrat John F. Kennedy greets supporters at Towson Plaza in September 1960. He would narrowly defeat Republican Richard M. Nixon in the presidential campaign. *Photo by Frank R. Gardina* AEM-894-BS

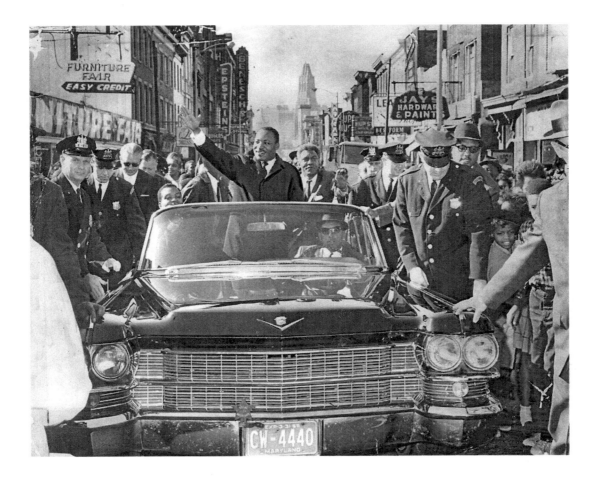

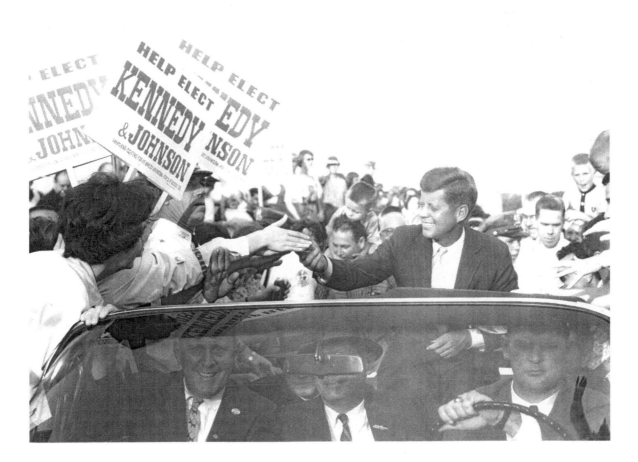

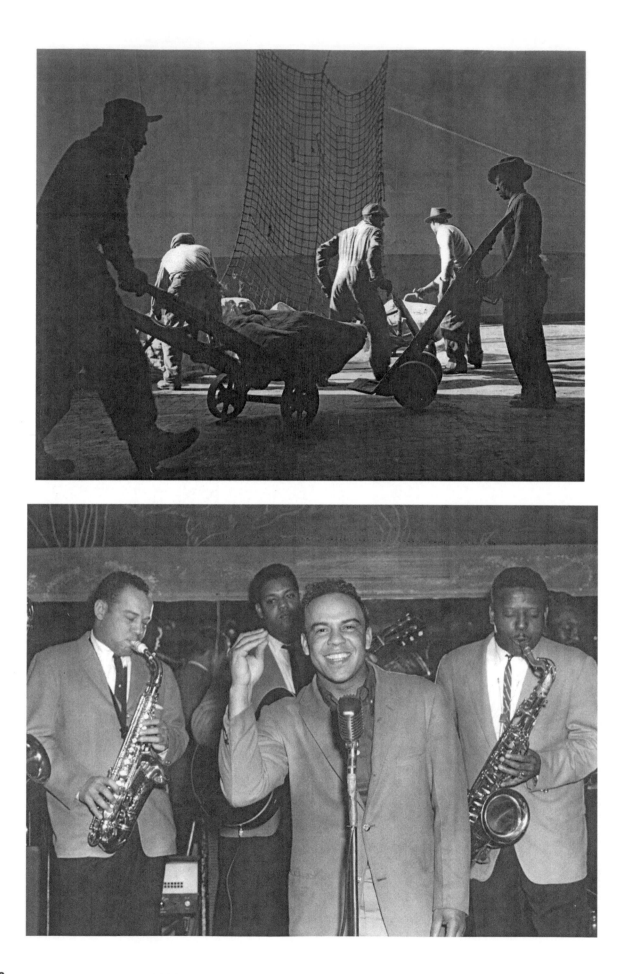

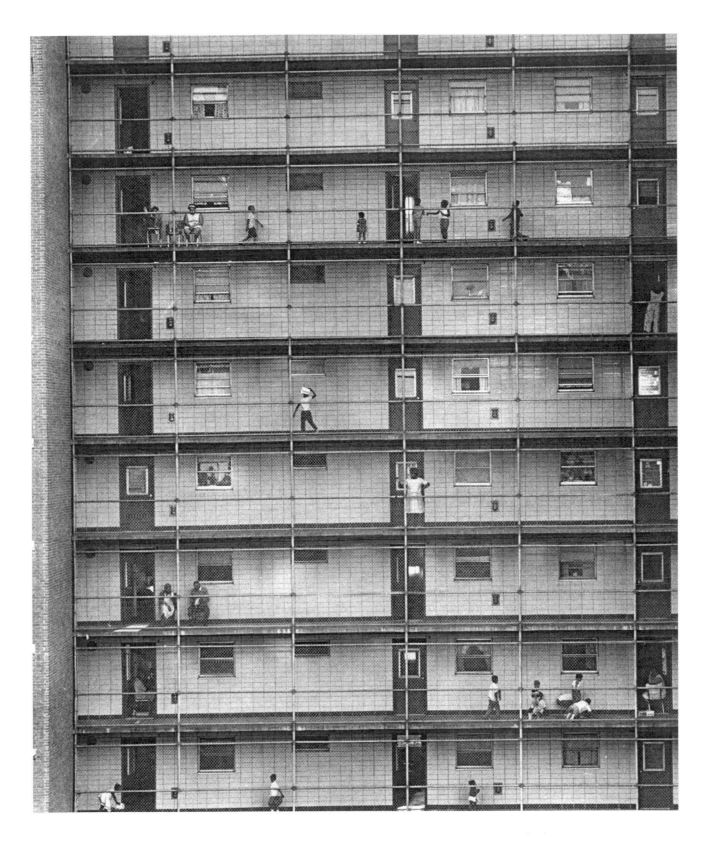

Above: The Lafayette Courts high-rises on Aisquith Street opened to high hopes in 1955. But the public housing was plagued by drugs and crime and eventually demolished in 1995. *Photo by Richard Stacks* BHZ-054-BS
Opposite top: Longshoremen unload rubber at the B&O Railroad's pier at Locust Point in 1960. It was once a familiar sight to see workers carrying hundred-pound stems of bananas off boats in the harbor. *Photo by A. Aubrey Bodine* AGM-814-BS
Opposite bottom: Al Brown and his Tunetoppers were regulars at the Club Tijuana, a rhythm and blues club on Pennsylvania Avenue. In 1960, his hit "The Madison" spawned a dance craze. *Photo by Frank R. Gardina* BLP-516-BS

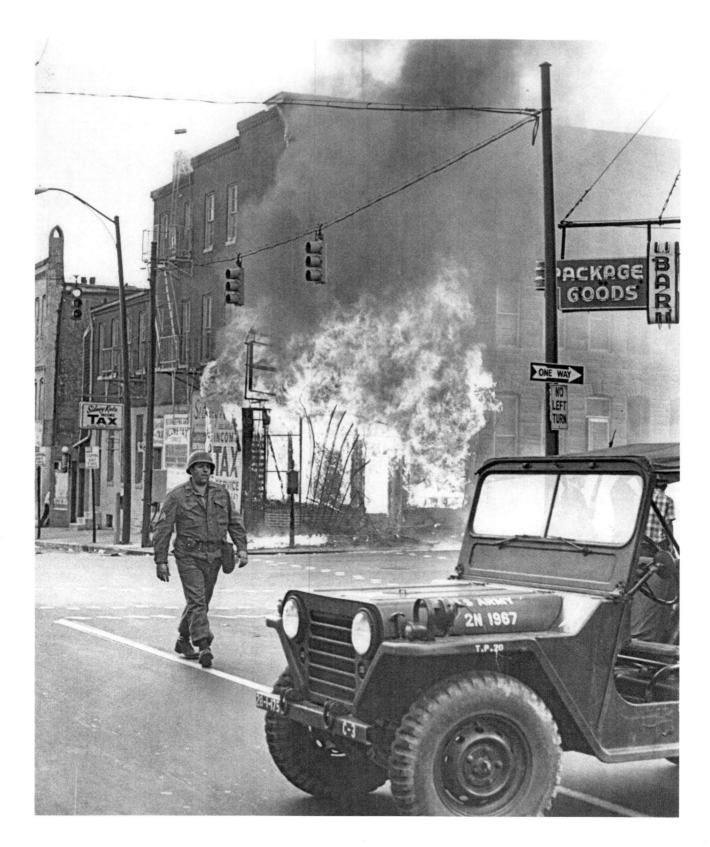

Above: A National Guardsman can do little as a shop burns out of control amid the 1968 riots. Insurers estimated damage in Baltimore at $8 million to $10 million during the unrest. *Photo by William H. Mortimer* BFA-899-BS

Opposite top: A National Guardsman watches over prisoners at the City Jail. Troops and police made more than 5,700 arrests during the Baltimore riots of April 6-13, 1968. *Photo by Weyman Swagger* BEC-258-BS

Opposite bottom: Guardsmen patrol North Avenue in April 1968. Gov. Spiro T. Agnew called out the troops when rioting erupted after the assassination of the Rev. Martin Luther King Jr. on April 4. *Photo by William L. LaForce Jr.* BFA-898-BS

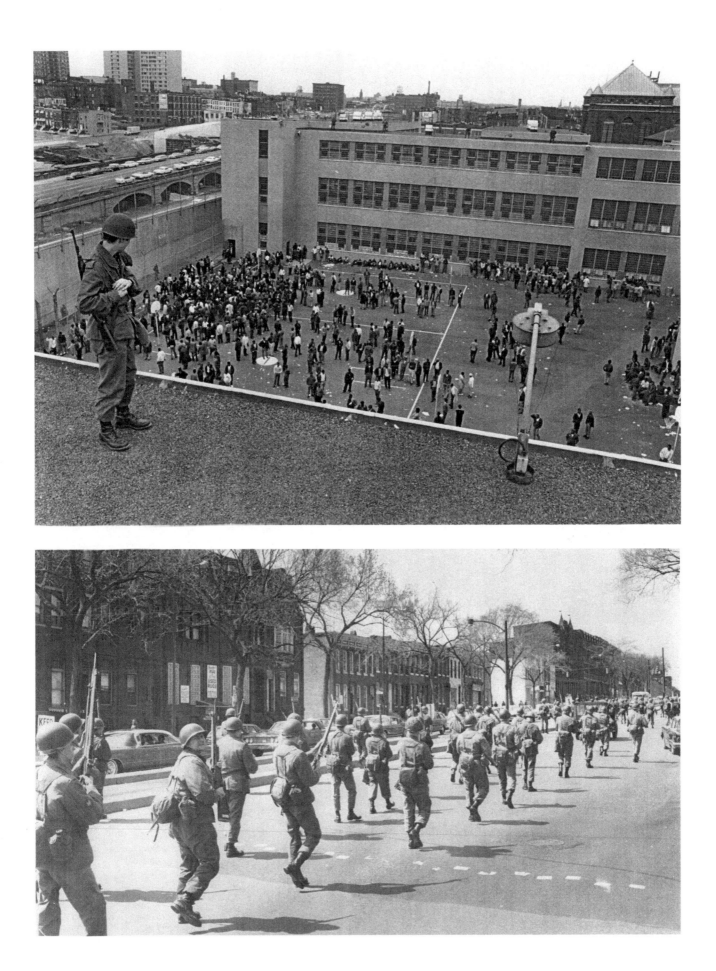

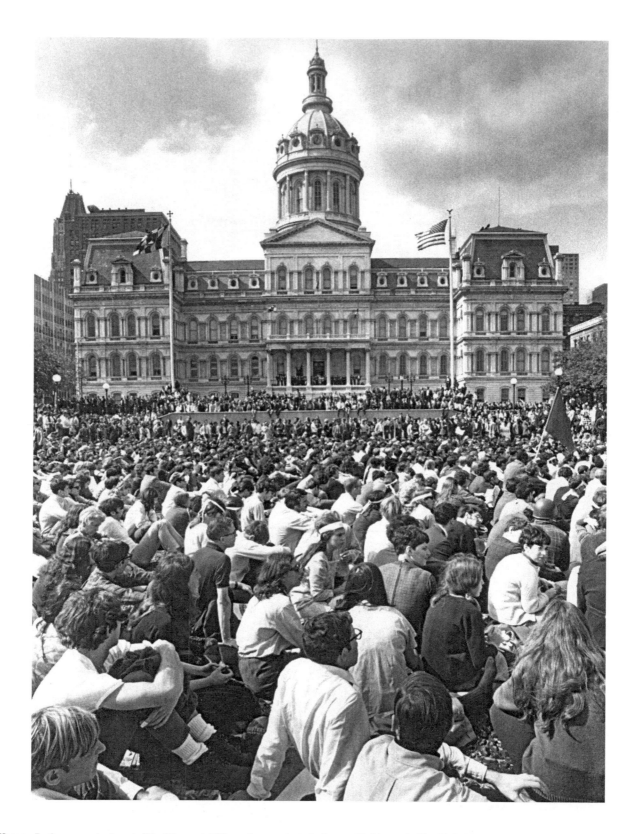

Above: Anti-war protesters in War Memorial Plaza demonstrate in front of Baltimore's City Hall during a tense midday rally in October 1968. *Photo by William L. LaForce Jr.* BGL-213-BS

Opposite top: The 17.6-mile Chesapeake Bay Bridge-Tunnel, shown under construction, was hailed as "one of the seven engineering wonders of the modern world" upon its opening in 1964. A parallel crossing of the mouth of the bay opened in 1999. *Photo by A. Aubrey Bodine* AAV-763-BS

Opposite bottom: School crossing guard Naomi Fitzhugh holds back students at 27th Street and Maryland Avenue headed to SS. Philip and James Elementary in September 1963. *Photo by Walter M. McCardell* BAQ-547-BS

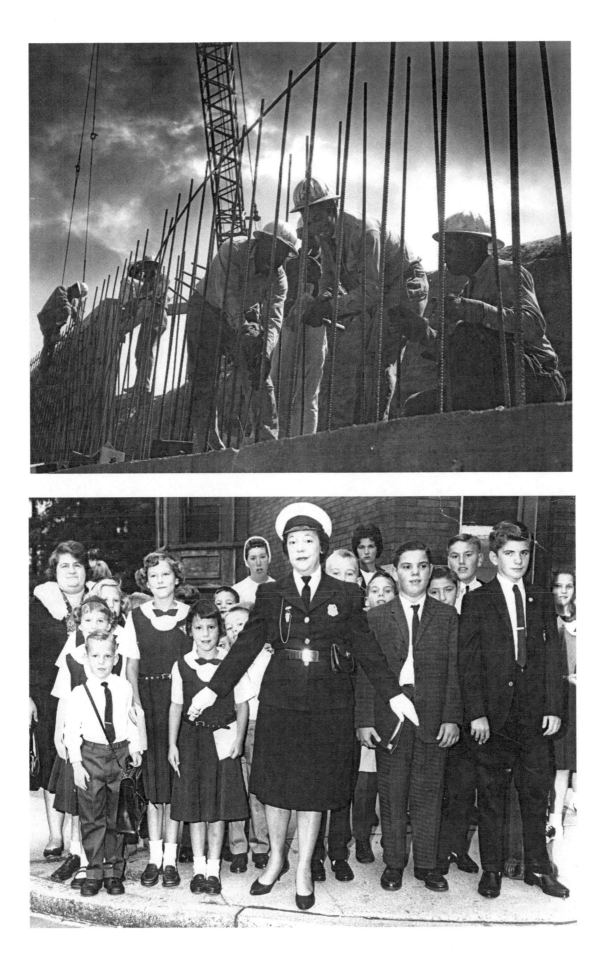

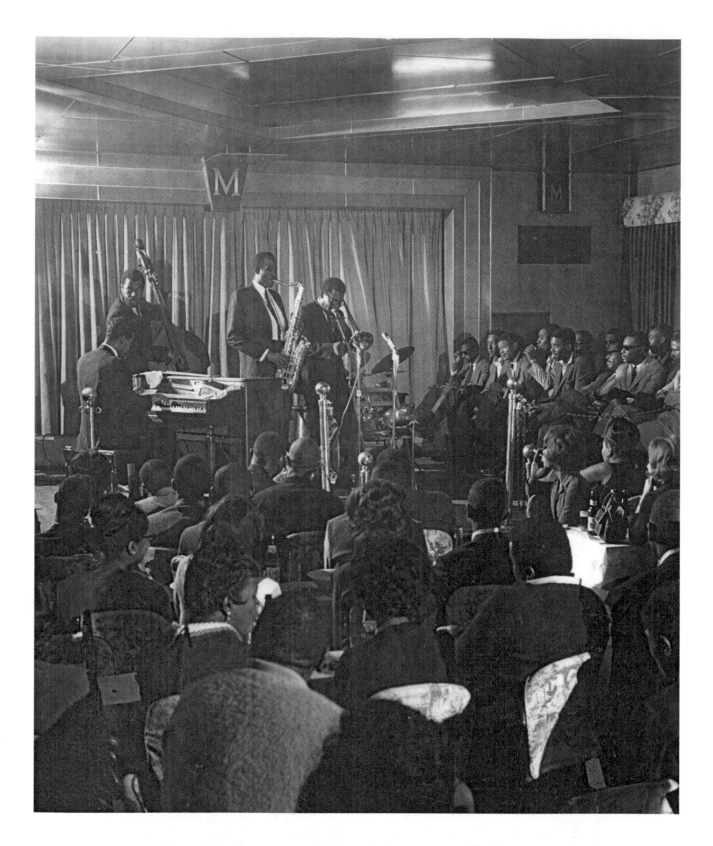

Top: The Jazz Crusaders perform in 1965 at the Madison Club, home of the Left Bank Jazz Society in East Baltimore. After a fire in 1966, the scene moved to the Famous Ballroom, now the Charles Theatre. *Photo by Richard Stacks* AAI-201-BS

Opposite top: Third baseman Brooks Robinson and catcher Andy Etchebarren converge on pitcher Dave McNally after the Orioles swept the Los Angeles Dodgers in 1966 to win their first World Series. *Photo by Paul M. Hutchins* BFU-493-BS

Opposite bottom: Johnny Unitas, an all-time great, led the Colts to NFL titles in 1958 and 1959. He threw touchdown passes in a record 47 straight games and entered the Hall of Fame in 1979. *Photo by George H. Cook* AAT-514-BS

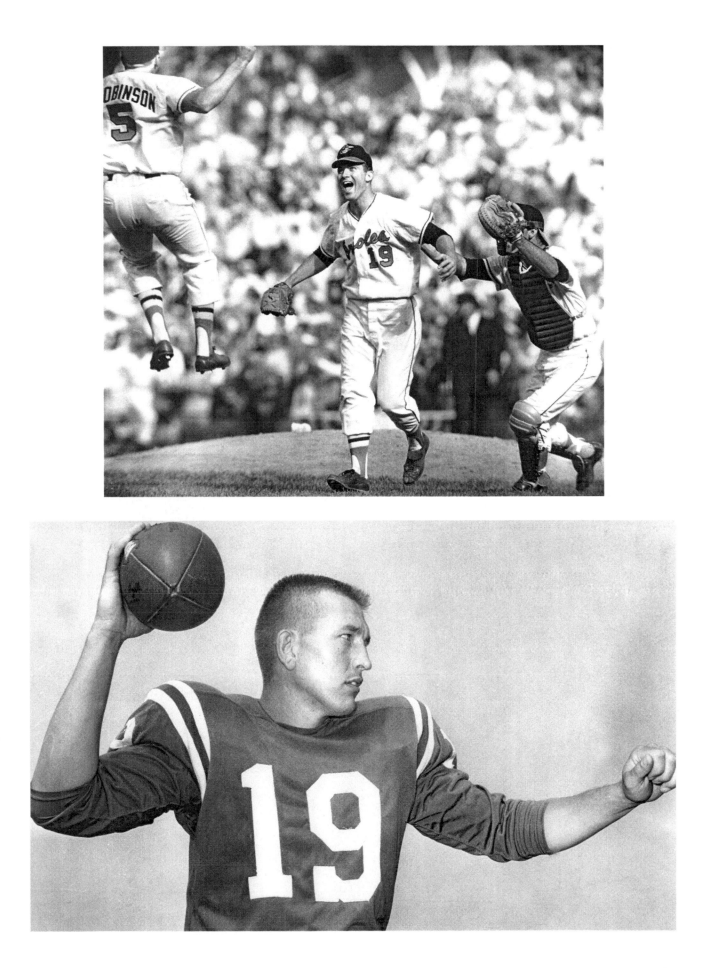

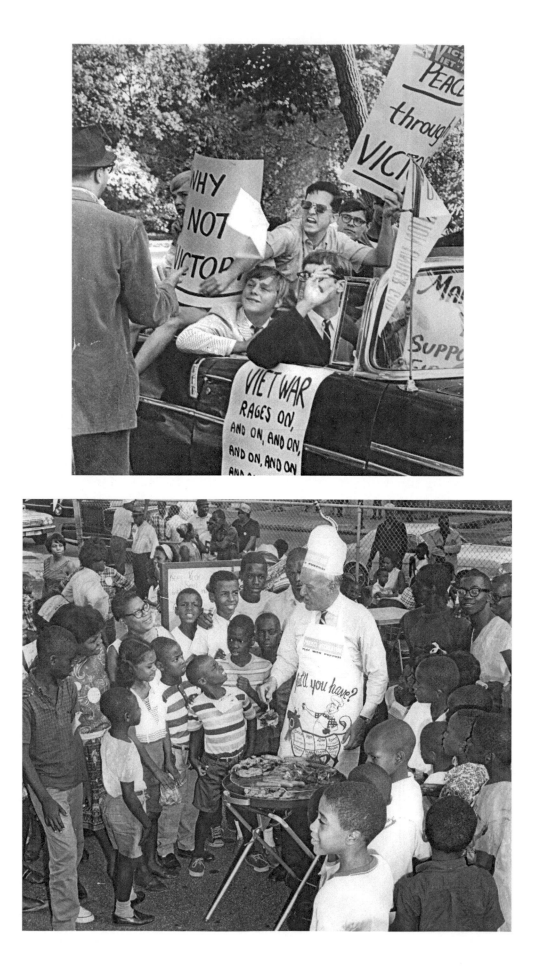

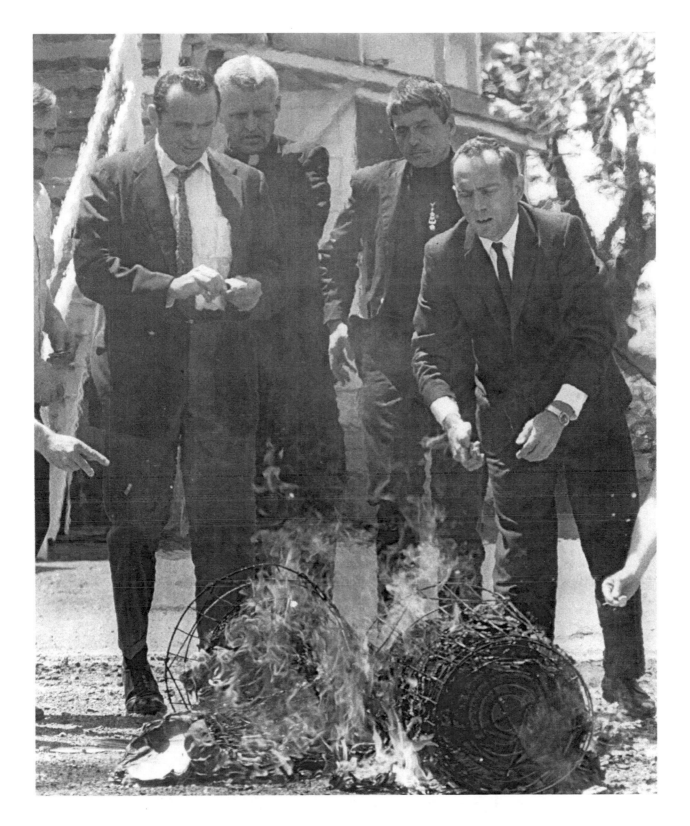

Above: The Revs. Philip and Daniel Berrigan, center rear, and other Catholic activists burn draft records taken from the Selective Service office in Catonsville in May 1968. The trial of the Catonsville Nine galvanized the anti-war movement. *Photo by William L. LaForce Jr.* AGD-173-BS

Opposite top: In 1965, protesters at the Johns Hopkins University urge peace through victory in the Vietnam War. The last U.S. troops would leave in 1973; more than 58,000 Americans were killed in the war. *Photo by William L. LaForce Jr.* BGR-666-BS

Opposite bottom: Mayor Theodore R. McKeldin presides over a grill at a Project Recreation cookout in 1967. He began a program of urban renewal in Baltimore during his second term. *Photo by William G. Hotz* BBN-958-BS

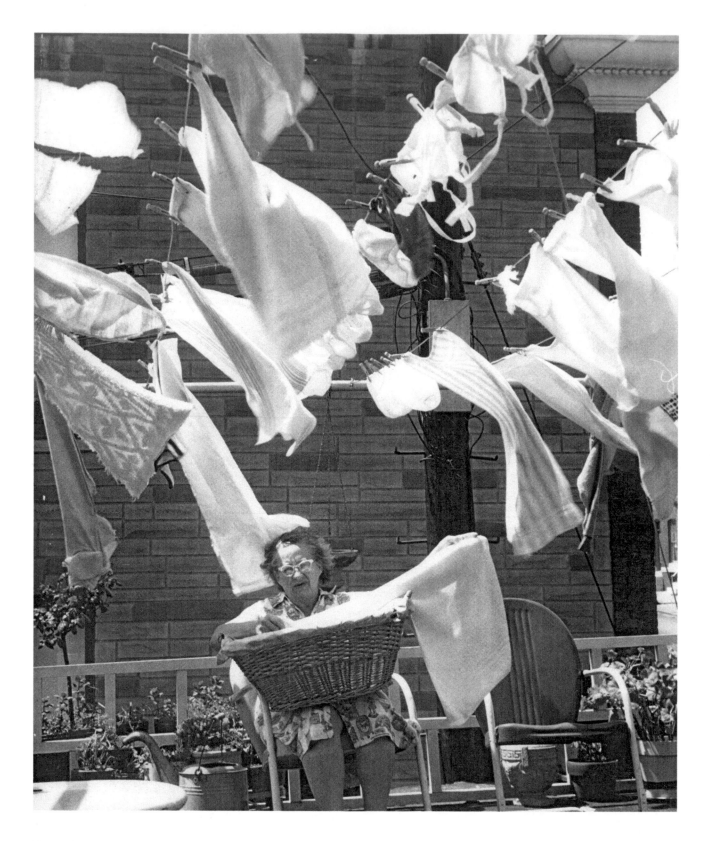

Above: In what once was a typical scene in the city, Mrs. Charles J. Kafka hangs her wash out to dry in East Baltimore on a sunny afternoon in May 1969. *Photo by Joseph A. DiPaola Jr.* ABM-559-BS

Opposite top: Flanked by Mayor Philip H. Goodman, left, and Charles McCormick, Nathan S. Jacobson of the Civic Center's franchise committee announces the Chicago Zephyrs' move to Baltimore as the Bullets in 1963. *Photo by Ellis J. Malachuk* BFC-178-BS

Opposite bottom: A northeaster hit Ocean City on March 6-7, 1962, smashing the Boardwalk and doing millions of dollars in damage in what was labeled "the Storm of the Century." *Photo by Clarence B. Garrett* ABL-790-BS

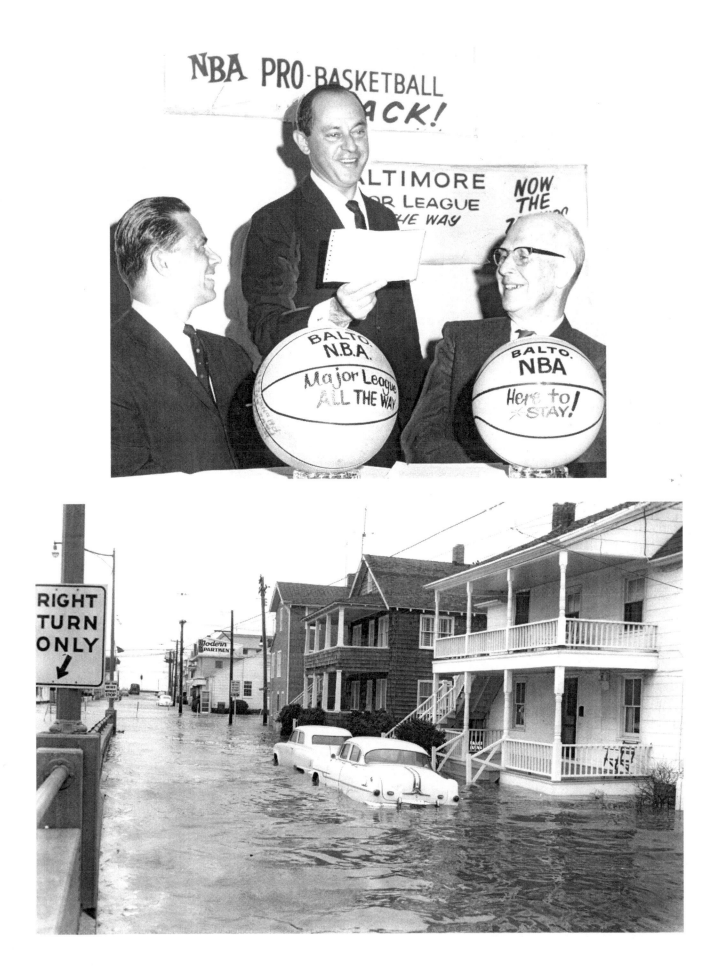

The Seventies

Agnes inundates Maryland, and a presidency founders over Watergate

In 1970, the Beatles disbanded, Ohio National Guardsmen shot and killed four students at Kent State during campus protests against the U.S. invasion of Cambodia, and a devastating cyclone struck East Pakistan, killing up to 500,000 and prompting ex-Beatle George Harrison's Concert for Bangladesh. That fall, the Baltimore Orioles, led by the "human vacuum cleaner" Brooks Robinson, beat the Cincinnati Reds in the World Series.

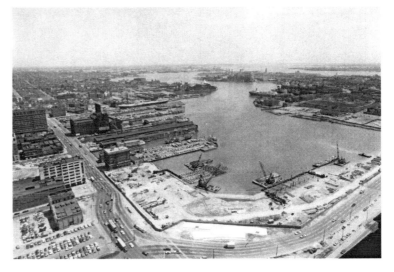

On May 15, 1972, Alabama Governor George C. Wallace was shot during a presidential campaign stop in Laurel. On June 22, Tropical Storm Agnes raked Central Maryland, causing heavy flooding, killing 21 and doing an estimated $62 million damage. Richard Q. Yardley, whose cartoons and whimsical, "old-style" maps of the state had been featured in The Sun since the early 1930s, retired because of ill health.

In October 1973, Vice President Spiro T. Agnew, a former Maryland governor, resigned in the face of tax-evasion charges. On August 9, 1974, Nixon would resign the presidency amid the Watergate scandal. In 1975, Saigon fell and the Vietnam War ended. That year, the Sunpapers became a model for the industry as computers were installed and the switch was made from hot type to cold.

An early Sun endorsement of Democrat Harry R. Hughes was widely credited for his being elected governor in 1978. In 1979, Evening Sun science writer Jon D. Franklin won a Pulitzer Prize in feature writing for "Tales from the Gray Frontier," which described a remarkable brain operation, and the Sunpapers began construction of a $16 million annex to house new, state-of-the-art Goss Metroliner presses.

Above: A view from the USF&G Building shows Inner Harbor construction in July 1972, amid urban renewal that would change the face of Baltimore. Harborplace would open to great fanfare in 1980. *Photo by Carl D. Harris* AGQ-786-BS

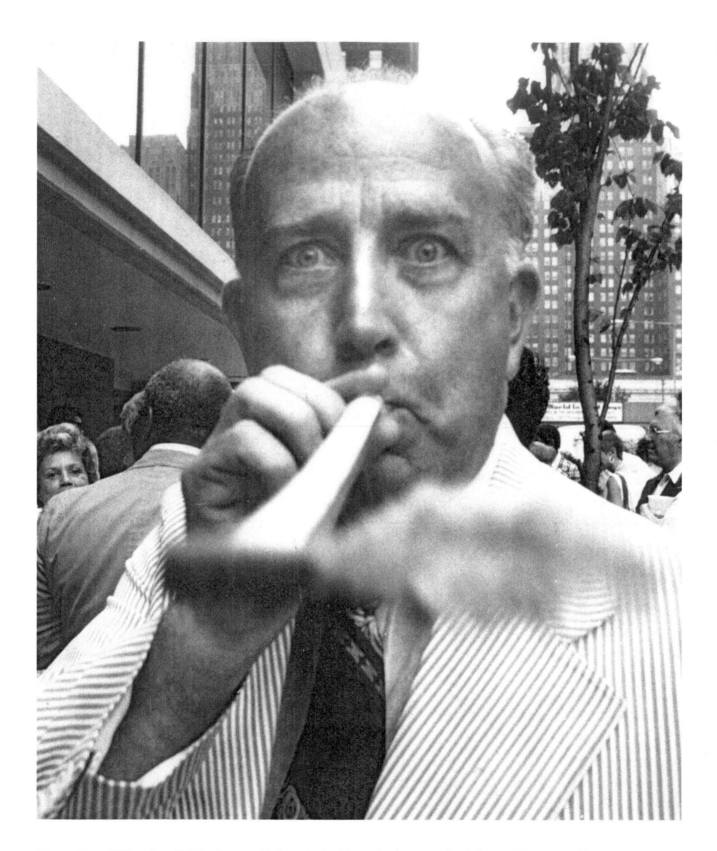

Above: Mayor William Donald Schaefer toots his horn during his re-election campaign in June 1975. He served four terms as mayor and two as governor, championing projects that changed Baltimore. *Photo by Carl D. Harris* AAU-887-BS

Opposite top: Barbara A. Mikulski helped stop a highway through Fells Point, then ran for City Council and won as an outsider in 1971. She would later be elected to the U.S. House and Senate. *Photo by Irving H. Phillips Jr.* AAW-968-BS

Opposite bottom: The Pride of Baltimore sails under the Key Bridge on the way home in June 1977. The captain and three crew members died when the goodwill vessel sank in 1986. *Photo by Lloyd Pearson* BDJ-705-BS

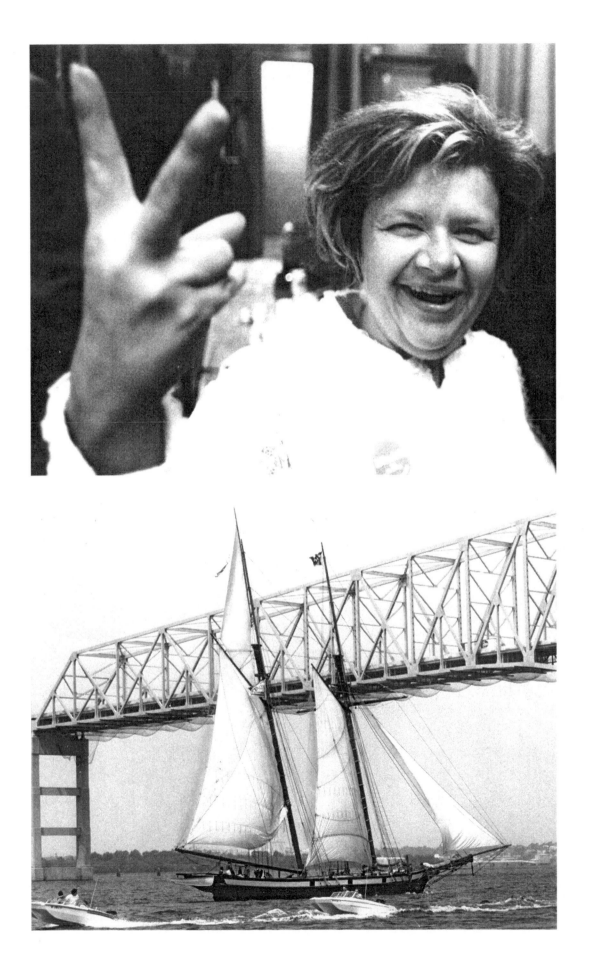

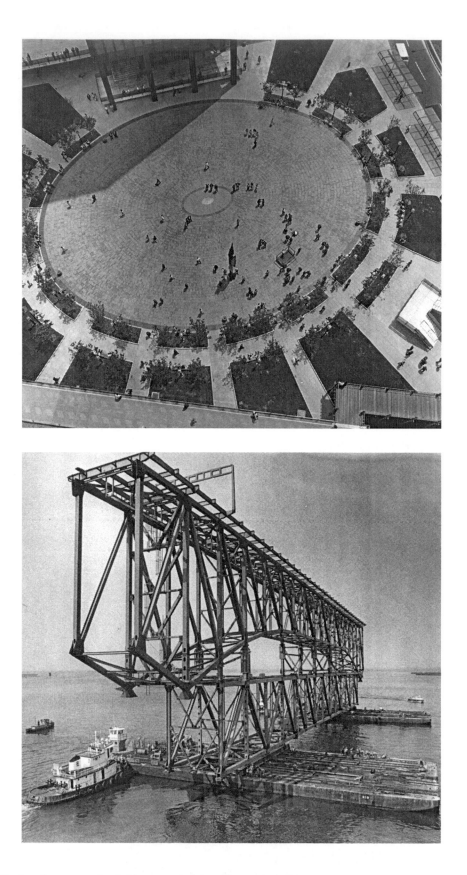

Top: The plaza in Charles Center, a major Baltimore redevelopment project. The adjacent One Charles Center office tower was designed by Ludwig Mies van der Rohe. *Photo by A. Aubrey Bodine* AHN-042-BS
Above: Tugs push barges carrying a truss section for the eastern side of the second Chesapeake Bay Bridge, necessitated by heavy traffic and completed in June 1973. *Photo by Lloyd Pearson* AGK-896-BS

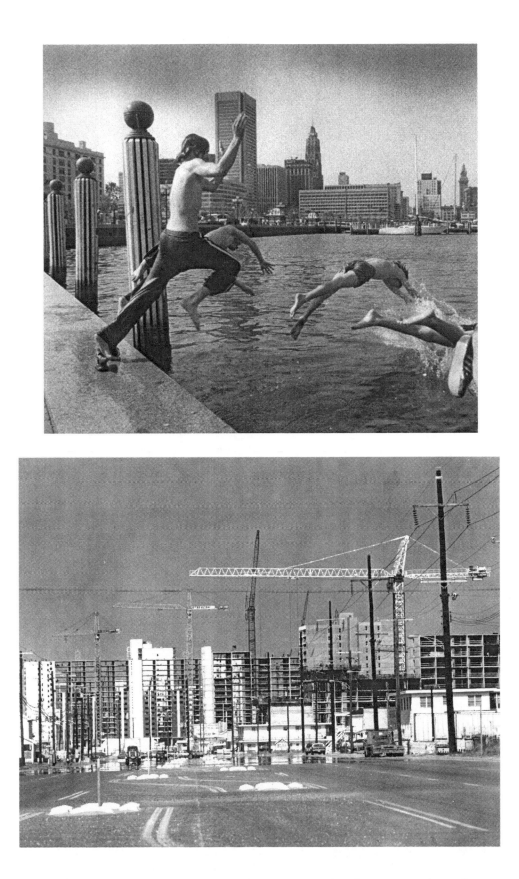

Top: With the exuberance of youth — and perhaps less than full regard for their health — a group takes an impromptu dive into the Inner Harbor in May 1979. *Photo by George H. Cook* AGQ-481-BS

Above: High-rises go up at 94th Street in Ocean City in 1973. Once a fishing village, the resort is now Maryland's second-largest city in summer, with a weekend population of more than 320,000. *Photo by William L. LaForce Jr.* BDO-699-BS

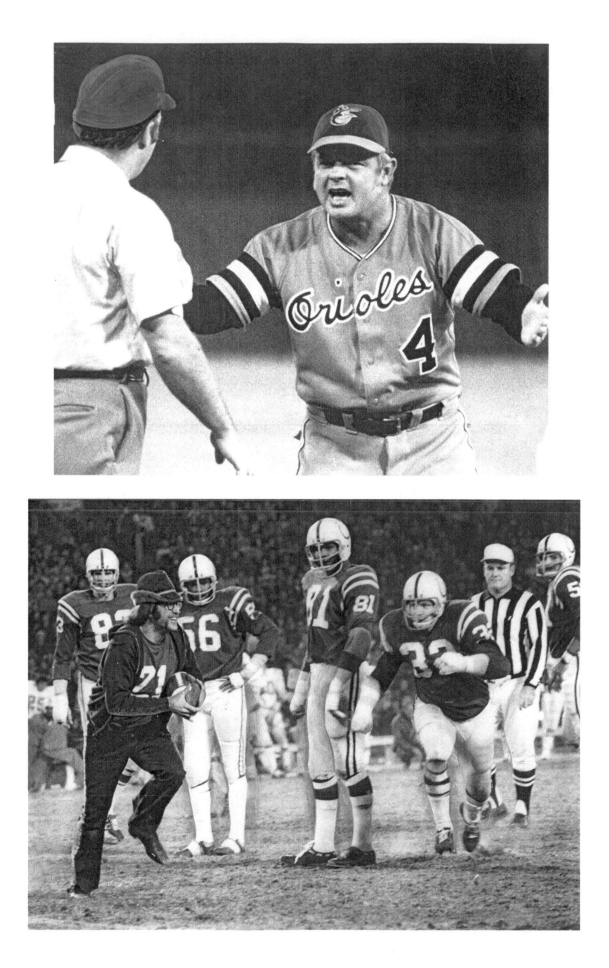

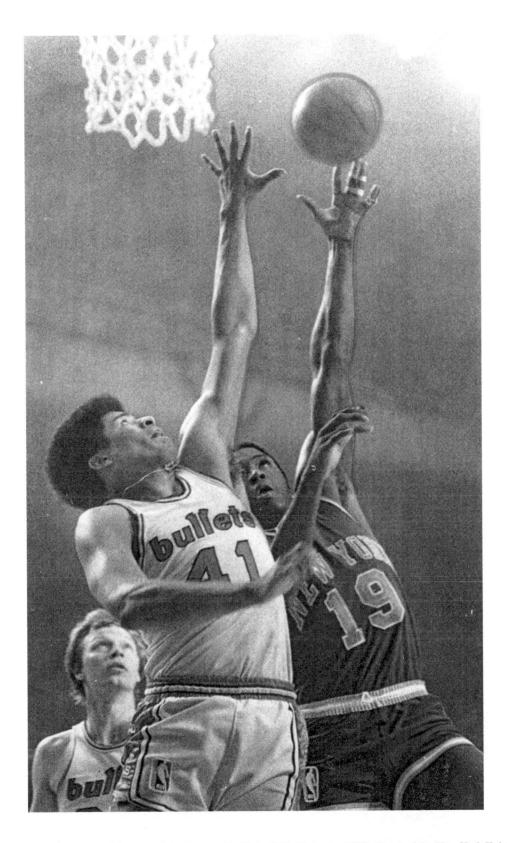

Above: Baltimore's Wes Unseld, NBA Rookie of the Year and MVP in 1968-69, battles Willis Reed of the New York Knicks in 1971. The Bullets moved to Washington; Unseld went to the Hall of Fame. *Photo by Walter M. McCardell* ABO-200-BS

Opposite top: Orioles manager Earl Weaver argues with umpire Marty Springstead in 1971. The "Earl of Baltimore" had a .583 winning percentage and entered the Hall of Fame in 1996. *Photo by Lloyd Pearson* AAU-445-BS

Opposite bottom: Colts linebacker Mike Curtis, right, goes after Donald W. Ennis, left, of Rochester, N.Y., who grabbed the ball during a game in December 1971. Curtis decked the fan, but Ennis got up smiling. *Photo by Carl D. Harris* AHJ-362-BS

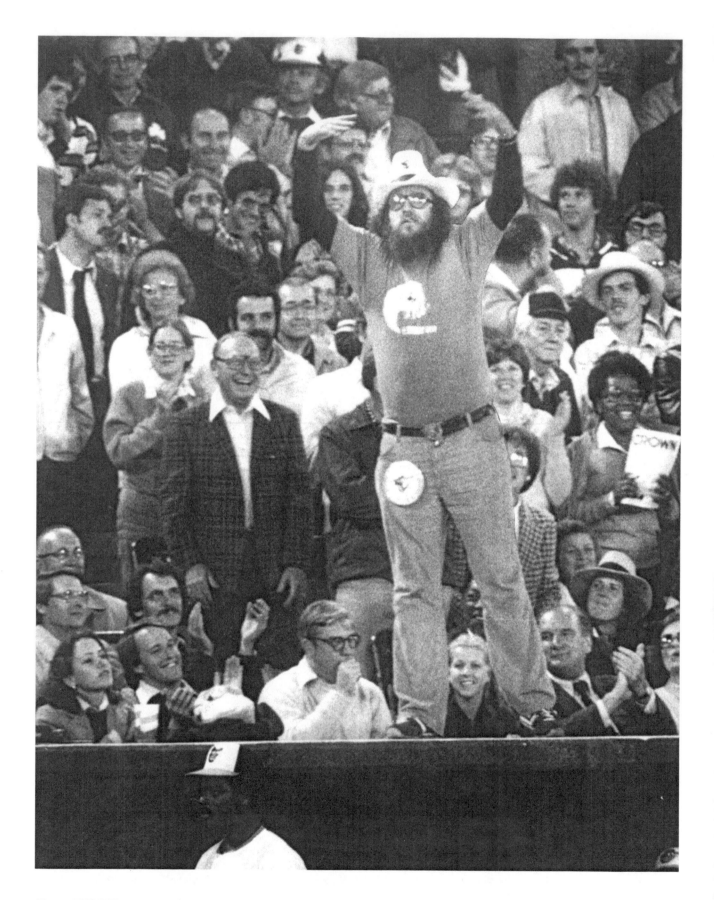

Above: "Wild Bill" Hagy leads his signature cheer, spelling out O-R-I-O-L-E-S with his body, on October 4, 1979. The Orioles beat the Angels, 9-8, and went on to win the American League pennant. *Photo by J. Pat Carter* BJA-853-BS

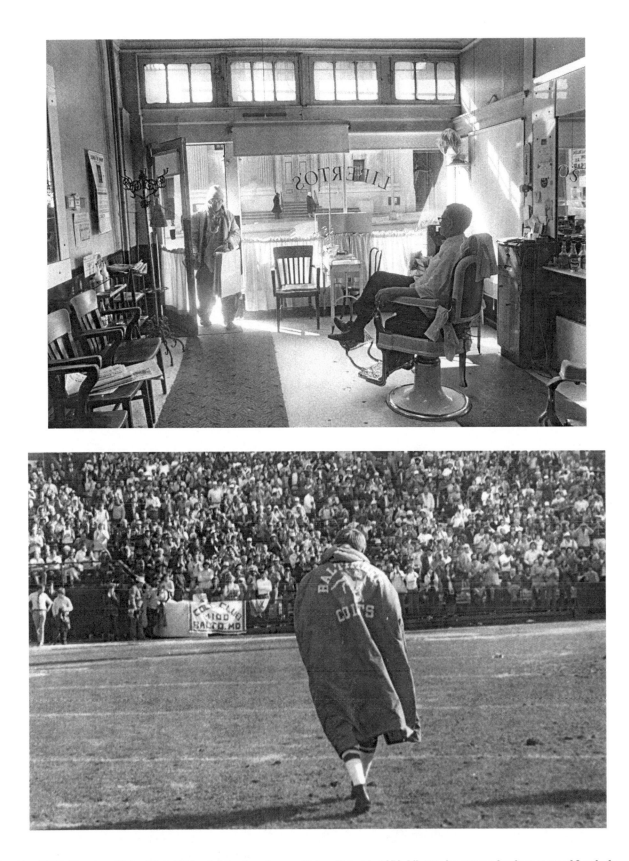

Top: Freddi Gold enters Pietro "Pete" Liberto's barbershop on Eutaw Street in 1973. Liberto became a barber at age 12 to help support his family and retired at age 85. *Photo by Richard Childress* BFV-719-BS
Bottom: Colts legend Johnny Unitas walks off the field at Memorial Stadium for the last time. His last pass there in a Colts uniform was a short completion that Eddie Hinton turned into a 63-yard touchdown against the Buffalo Bills in December 1972. *Photo by Irving H. Phillips Jr.* AAT-505-BS

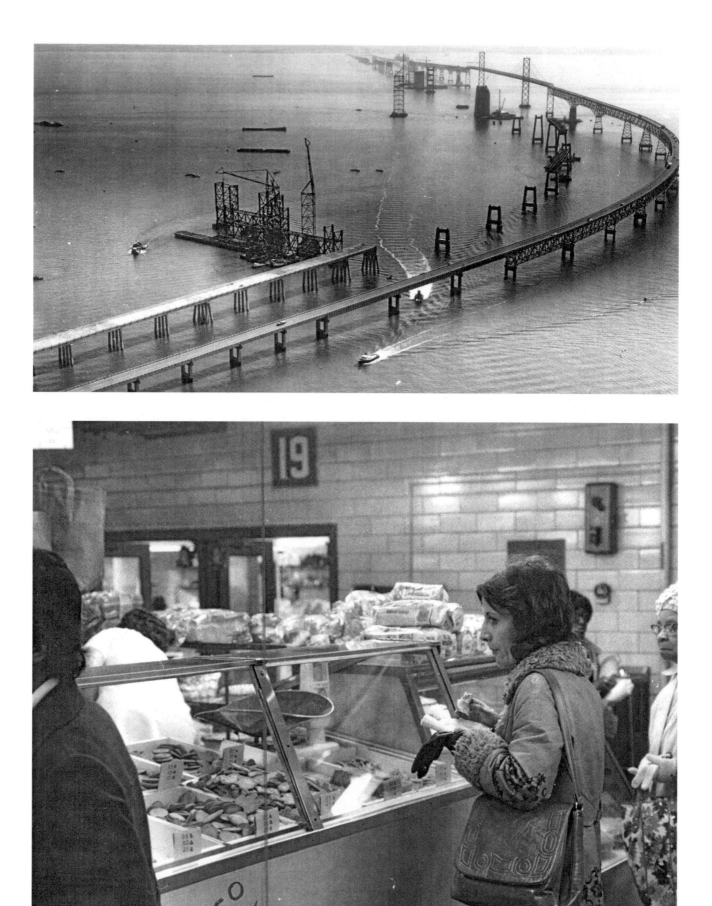

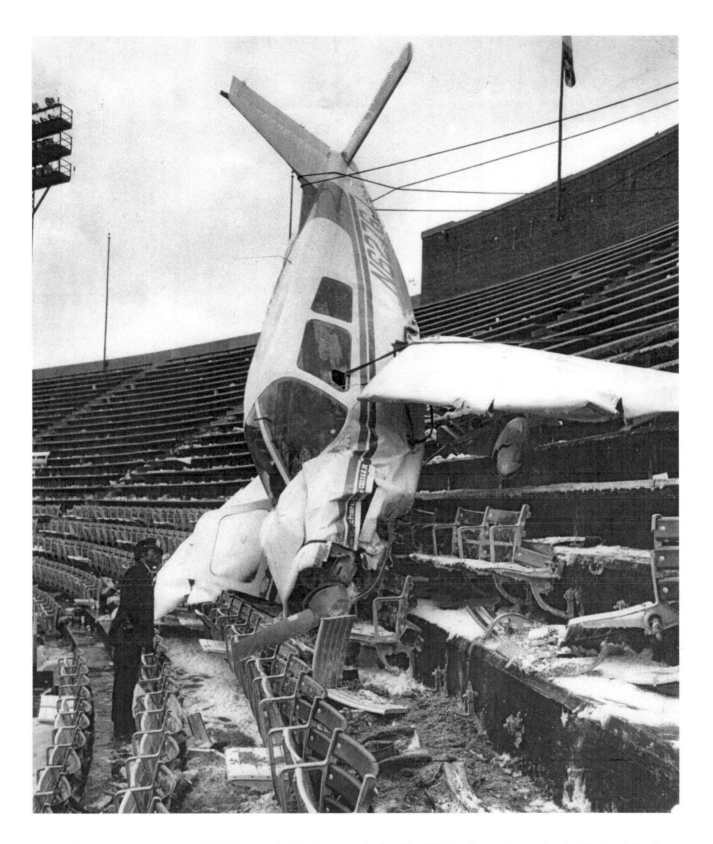

Above: Donald Kroner buzzed the field, then crashed in the upper deck at Memorial Stadium minutes after the Pittsburgh Steelers demolished the Colts, 40-14, in a playoff game December 19, 1976. *Photo by Lloyd Pearson* BBX-566-BS

Opposite top: The second span of the Bay Bridge takes shape next to the first in a view looking eastward in October 1971. The newer bridge has three lanes, the older one two. *Photo by William L. LaForce Jr.* AGK-873-BS

Opposite bottom: At Lexington Market, in existence since 1782, vendors sell fruit, vegetables, meats, pastries and Maryland delicacies that include crab cakes, oysters and muskrat. *Photo by George H. Cook* ABW-441-BS

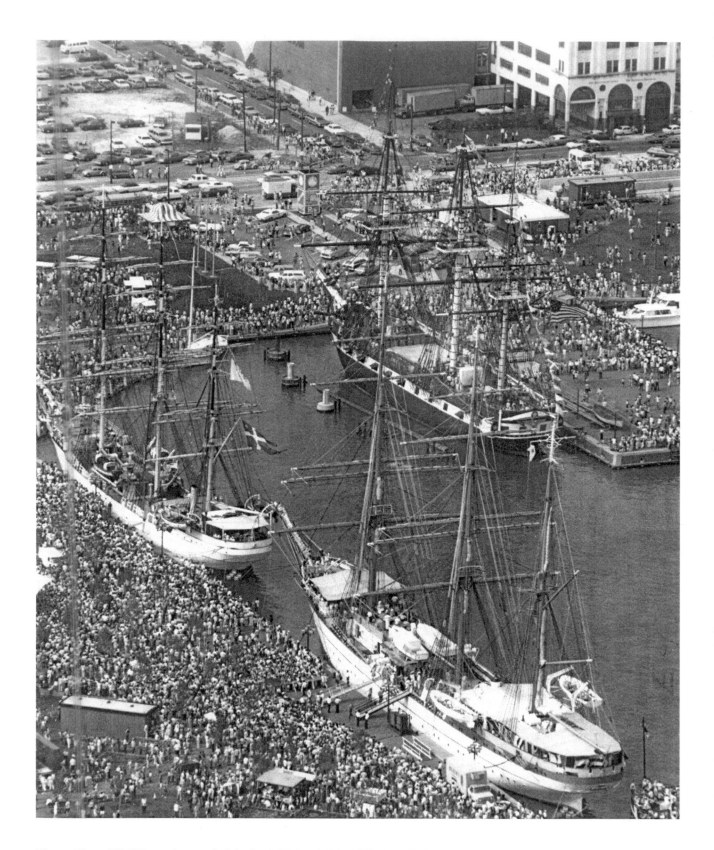

Above: About 100,000 people crowded the Inner Harbor in July 1976 when the Danmark, left, the Gorch Fock and other tall ships joined the Constellation, top, for America's Bicentennial fete. *Photo by Weyman Swagger* BCN-611-BS
Opposite top: Secretariat drives to the wire in the Preakness in 1973. "Big Red" also won the Kentucky Derby and the Belmont Stakes, to capture the first Triple Crown since Citation in 1948. *Photo by William H. Mortimer* AHK-205-BS
Opposite bottom: In keeping with Baltimore tradition, many in the throng gathered in the infield on Preakness Day at Pimlico in 1973 were more interested in partying than watching the race. *Photo by George H. Cook* AHK-183-BS

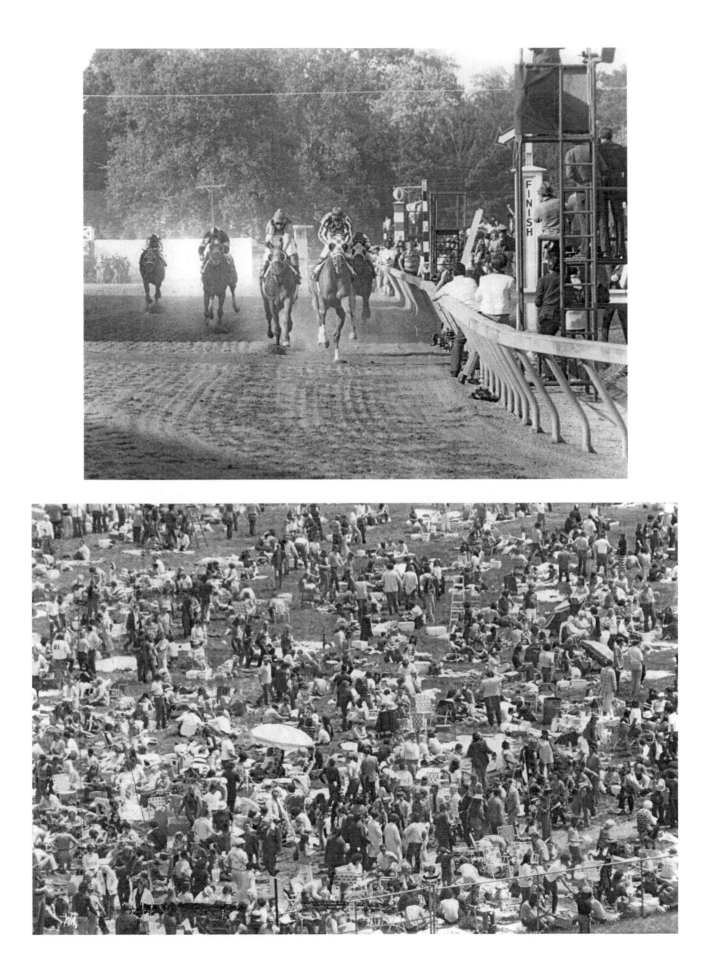

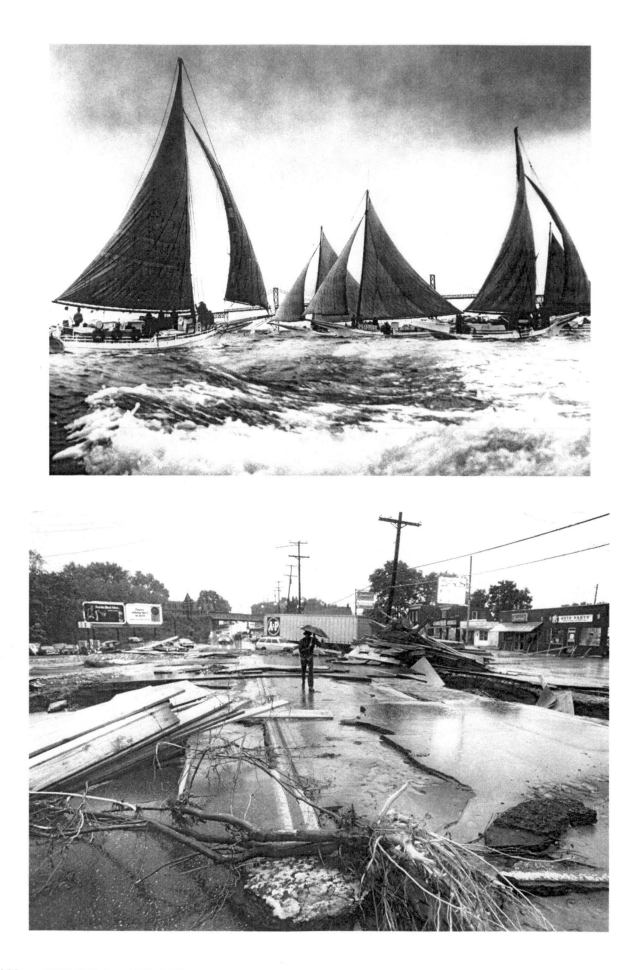

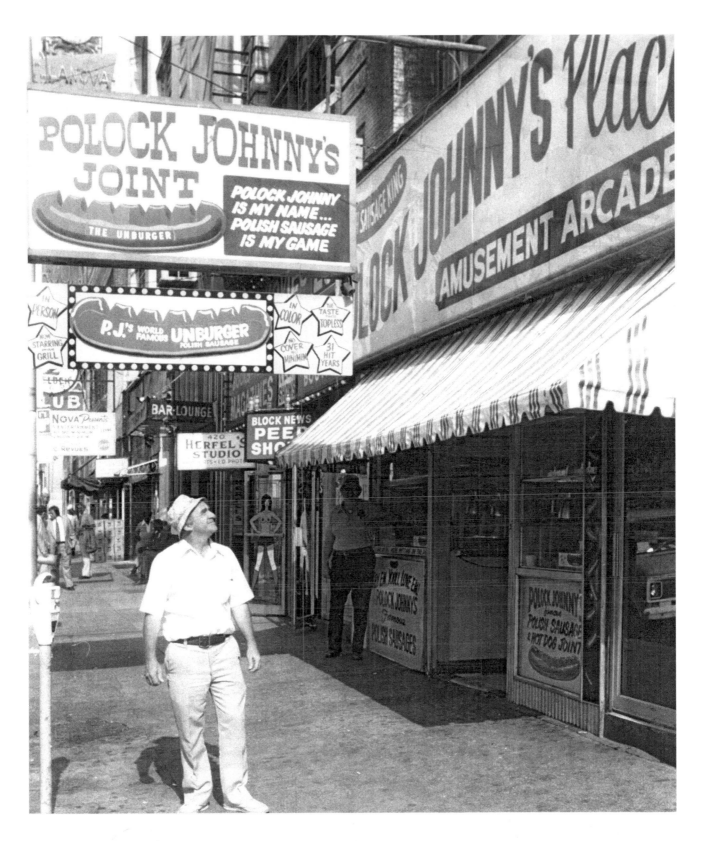

Above: John F. Kafka surveys his Polock Johnny's hot dog stand and amusement arcade on The Block in 1976. His sausages with "The Works," and his eating contest, were famous. *Photo by Joseph A. DiPaola Jr.* BDQ-532-BS

Opposite top: With sails filled and the bay waters foaming about them, Maryland's skipjack fleet races off Sandy Point State Park before the start of the oyster season in 1970. *Photo by Clarence B. Garrett* BJF-606-BS

Opposite bottom: Tropical Storm Agnes raked Central Maryland on June 22, 1972, causing heavy flooding, killing 21 and doing an estimated $62 million damage. *Photo by Lloyd Pearson* ADH-191-BS

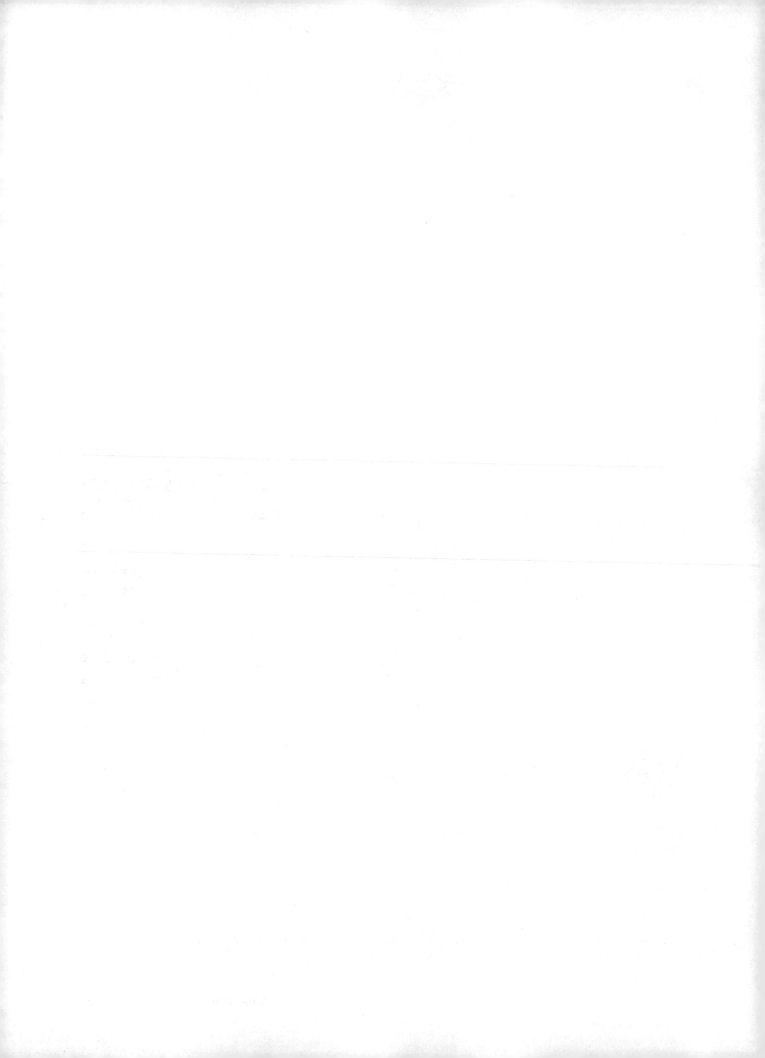

The Eighties

Harborplace transforms a city, the Colts bolt Baltimore and The Sun changes hands

In 1980, Harborplace opened with great fanfare; the population was 786,775, making Baltimore the 10th-largest city in America, its lowest ranking since 1800; and The Sun endorsed Democrat Jimmy Carter for president.

In 1981, the paper was redesigned and expanded under Reg Murphy, the new president, chief executive and publisher, who was hired to refresh it. Color photos and graphics began to appear on the front page. Fulfilling a promise, Mayor William Donald Schaefer took his rubber ducky for a dip in the National Aquarium's seal pool after the facility failed to open on schedule.

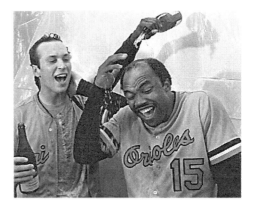

In 1983, in Cal Ripken Jr.'s second full season, the Orioles beat the Philadelphia Phillies in the World Series, the last time Baltimore would appear in the fall classic. Months later, the city mourned when the Colts were moved to Indianapolis under cover of darkness on March 29, 1984.

On May 27, 1986, the News American, a blue-collar afternoon paper that traced its roots to 1773, ceased publication. A day later, Murphy announced that Times Mirror Co. of Los Angeles had bought the A.S. Abell Co., which included the three newspapers, WMAR and a television station in Richmond, Va., for $600 million cash, saying, "It is the end of one dream, the beginning of another." The Sun declared, "What we were yesterday, we are today and will be tomorrow." After the sale, the A.S. Abell Foundation, the largest shareholder, became the richest foundation in Maryland, providing major grants to educational, cultural and medical institutions. That September, The Sun's reported circulation was 222,000, The Evening Sun's 175,000 and The Sunday Sun's 465,000.

In May 1987, The Sun celebrated its 150th birthday. Its anniversary issue had 24 sections, 1,090 pages, weighed more than 6 pounds and cost $1.25. It was the biggest issue with the largest circulation, 596,694, ever published by The Sun. In 1988, the company purchased 60 acres at Port Covington in South Baltimore, where it intended to build a state-of-the-art printing plant.

Above: Shortstop Cal Ripken Jr., left, and outfielder Dan Ford celebrate the Orioles' victory over the Philadelphia Phillies in the 1983 World Series with champagne. No doubt, Chuck Thompson said, "Ain't the beer cold?" *Baltimore Sun photo* 120307

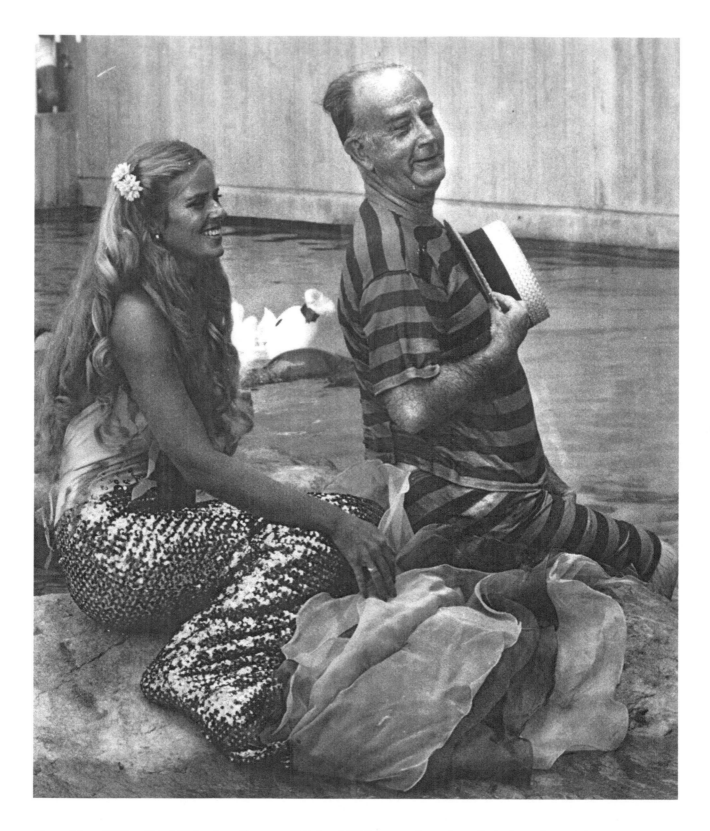

Above: Mayor William Donald Schaefer, with mermaid Deborah Walker, vowed to go for a dip in the seal pool if the National Aquarium didn't open on schedule. It didn't, he did in July 1981. *Photo by Lloyd Pearson* BBB-023-BS

Opposite top: In late January 1984, Colts owner Robert Irsay angrily denied that he intended to move the team. On March 29, the team skipped town, with Irsay breaking his promise to give Baltimore Mayor William Donald Schaefer, right, fair notice. *Photo by Gene Sweeney Jr.* AFY-940-BS

Opposite bottom: The newest attraction to anchor the Inner Harbor was the National Aquarium, which replaced abandoned Pratt Street piers and opened to visitors August 8, 1981. *Photo by Paul M. Hutchins* AGQ-552-BS

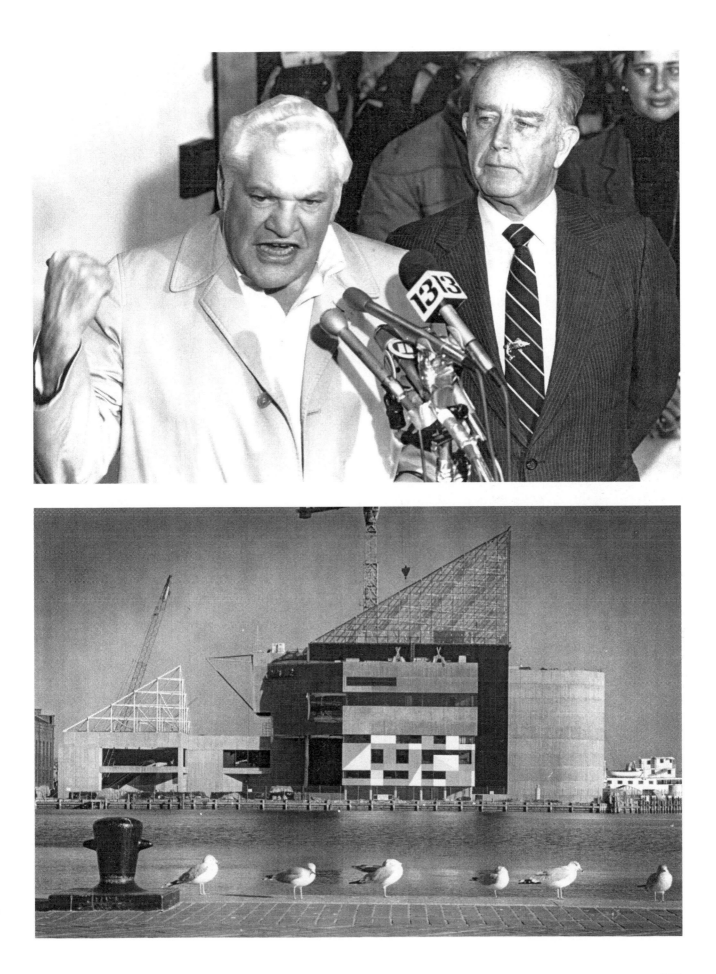

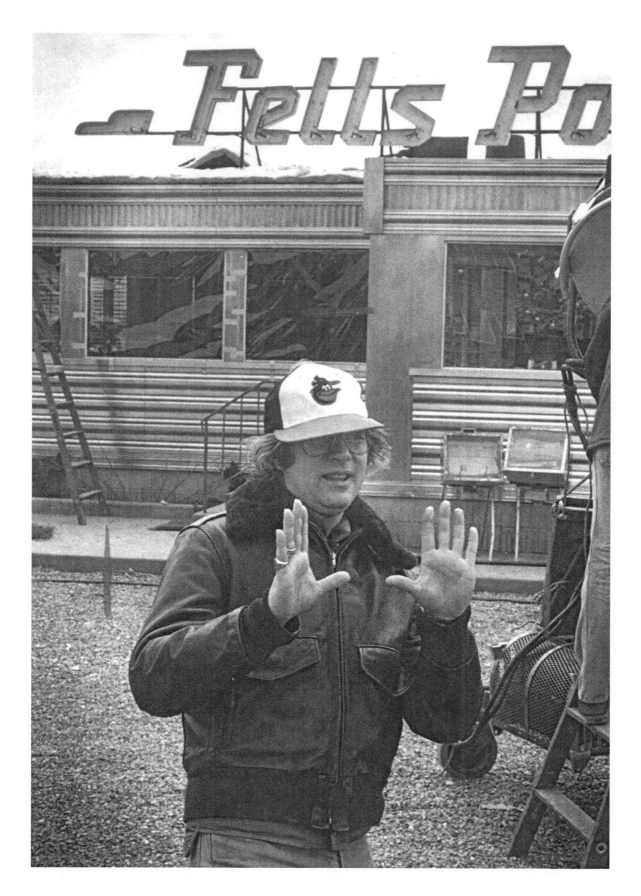

Above: Baltimore native Barry Levinson sets up a shot in 1980 during the filming of "Diner," the first of four films that make up his "Baltimore trilogy." *Baltimore Sun photo* BFL-540-BS

Above: In 1981, ecdysiast Fannie Belle Fleming was better known as Blaze Starr at her Two O'Clock Club on The Block, where she also told jokes and sang songs, including one she wrote about her ample bosom, "38 Double-D." *Photo by Paul M. Hutchins* BNQ-337-BS

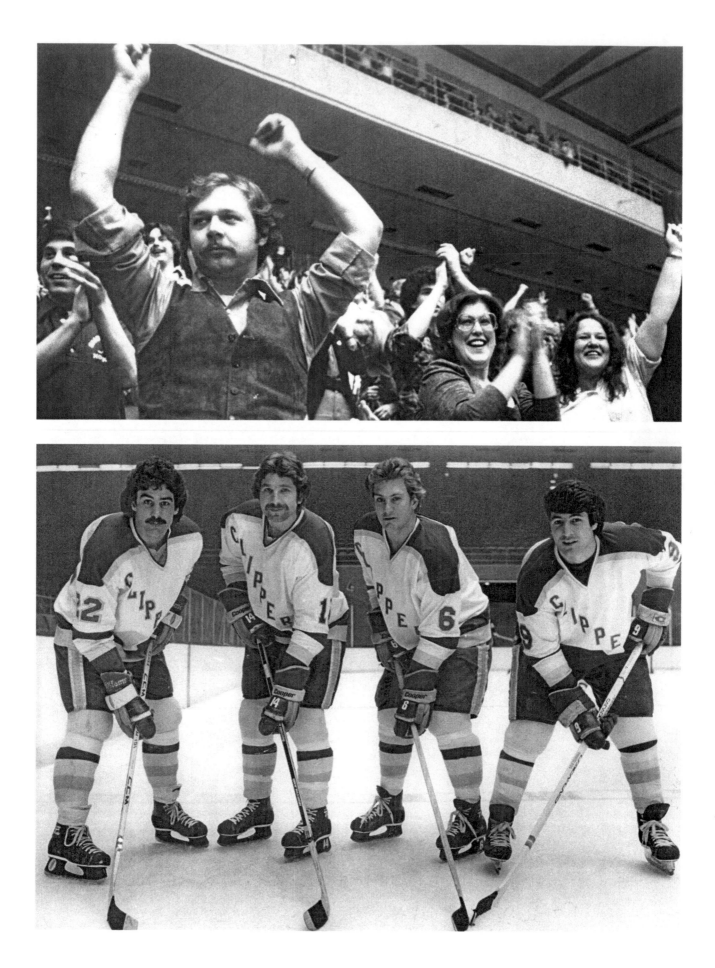

Above: "A Gift From Hutzler's Means More" was the slogan of one of Baltimore's premier department stores, which began serving shoppers in 1858. Hutzler's sold its flagship Howard Street store in 1984 and six years later would be a retail memory. *Baltimore Sun photo* ABG-857-BS

Opposite top: Euphoric fans show their approval as Baltimore's Clippers eliminated the Richmond Rifles in the Eastern Hockey League playoff semifinals at the Civic Center in 1980. *Photo by George H. Cook* BLC-805-BS

Opposite bottom: Clippers players, from left, Fred Ahern, Paul Pacific, Gerry Ciarcia and Jon Fontas line up at the Civic Center. The team was replaced by the Skipjacks for the 1981-82 season. *Photo by Weyman Swagger* AAY-066-BS

Above: All-American Len Bias was the second pick overall by the defending NBA champion Boston Celtics in the 1986 draft. Two days later he died of a cocaine overdose. Amid the fallout, longtime coach Lefty Driesell and Maryland's athletic director were forced to resign. *Photo by Ellis J. Malashuk* 1982127624

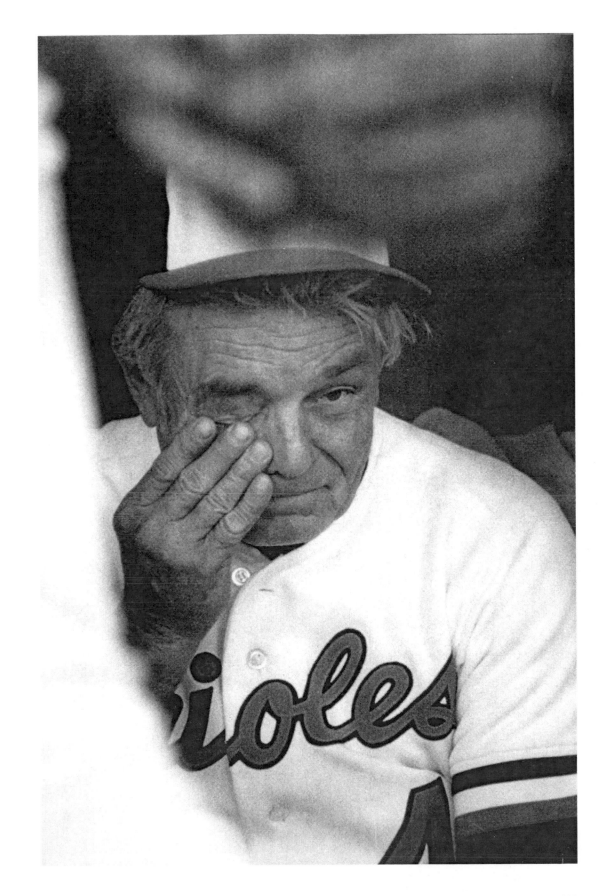

Above: A tearful Earl Weaver, headed into retirement, ponders the last regular-season game against the Brewers in 1982. He would return as Orioles manager for the 1985 and 1986 seasons and enter the Hall of Fame in 1996. *Baltimore Sun photo* 120296

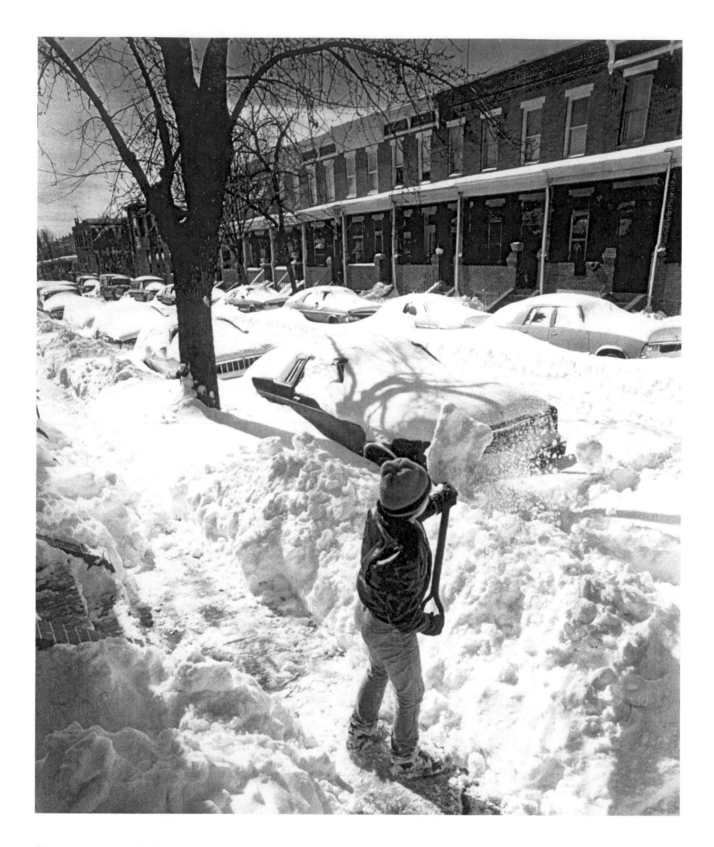

Above: "The Blizzard of 1983," which dumped a record 22.8 inches of snow in 24 hours, was a big story. The February 11 snowstorm was the second-largest to hit the Baltimore area since weather records began in 1892. *Photo by Jed Kirschbaum* ADL-429-BS
Opposite top: Brooklandville's Pam Shriver, right, congratulates tennis great and world No. 1 Chris Evert-Lloyd after a 1981 match at the Capital Centre in Landover. *Photo by Paul M. Hutchins* ACL-219-BS
Opposite bottom: Die-hard Colts fans, from left, Dennis King, Lewis Goodman, Ken Meltzer and Alan Rifkin wear their feelings on their chests during a 1981 game: "Impeach Irsay." *Photo by Walter M. McCardell* AAB-887-BS

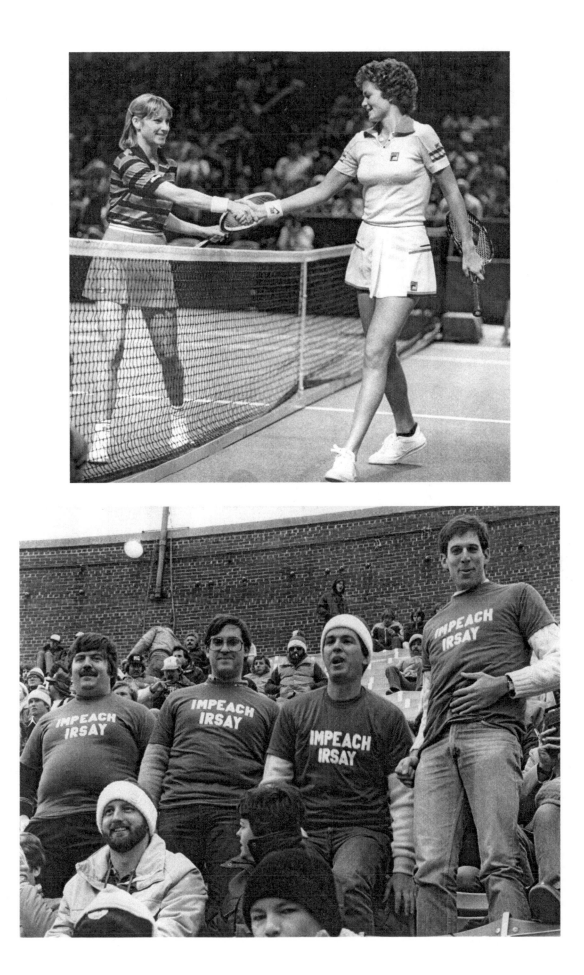

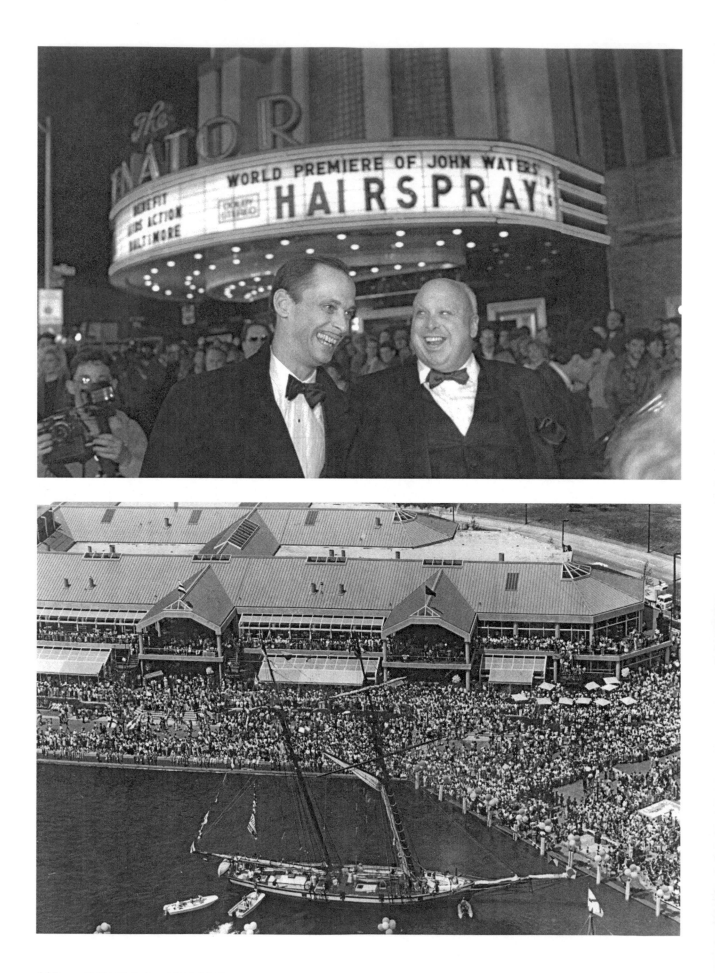

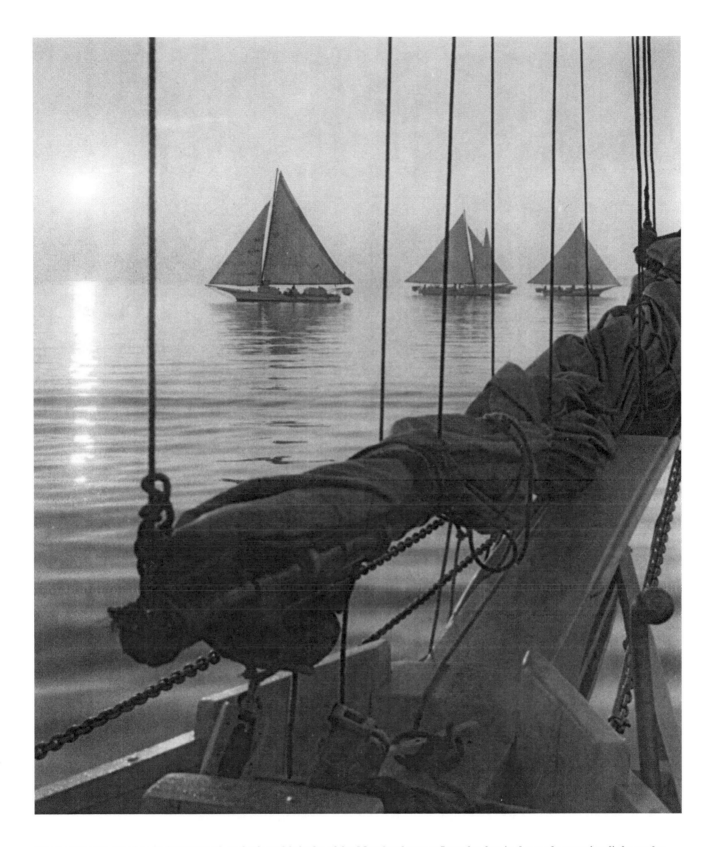

Above: The Martha Lewis, foreground, and other skipjacks of the Maryland oyster fleet dredge in the early morning light on the Choptank River in November 1987. *Photo by George H. Cook* BJF-606BCW-639-BS

Opposite top: Baltimore director John Waters and drag queen extraordinaire Divine, aka Harris Glenn Milstead, share a light moment outside the Senator Theatre at the world premiere of "Hairspray" in 1988. *Photo by Amy Davis* 127625

Opposite bottom: The goodwill vessel Pride of Baltimore sailed into the Inner Harbor to take part in ceremonies to mark the opening of Harborplace on July 2, 1980. *Photo by J. Pat Carter* AHF-070-BS

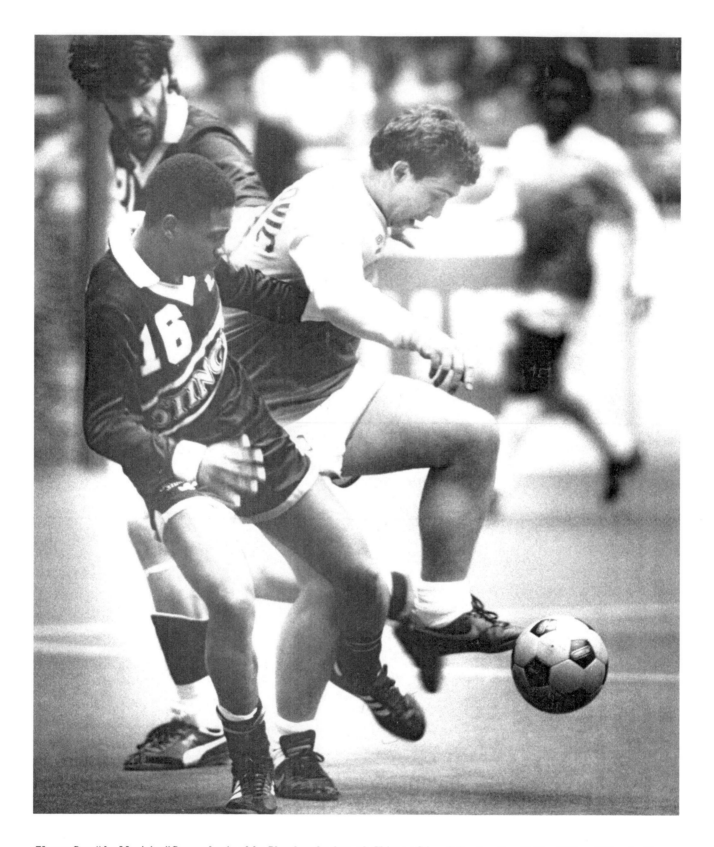

Above: Stan "the Magician" Stamenkovic of the Blast breaks through Chicago Sting defenders Ben Collins (16) and Ricardo Alonso in 1986. Stamenkovic helped Baltimore to the MISL title in 1984. *Photo by Gene Sweeney Jr.* BDE-550-BS
Opposite top: Kevin Alexander of Canada challenges Hopkins Hall of Famer Jeff Cook of the U.S. team during the World Lacrosse Championship in Baltimore in 1982. The U.S. beat Australia, 22-14, to win the title. *Photo by Walter M. McCardell* AAQ-214-BS
Opposite bottom: Carole Kennedy of the Towson YMCA accepts the Olympic flame from Jerry Elson of New York. The relay passed through Baltimore on its way to the 1984 Summer Games in Los Angeles. *Photo by Lloyd Pearson* BCK-062-BS

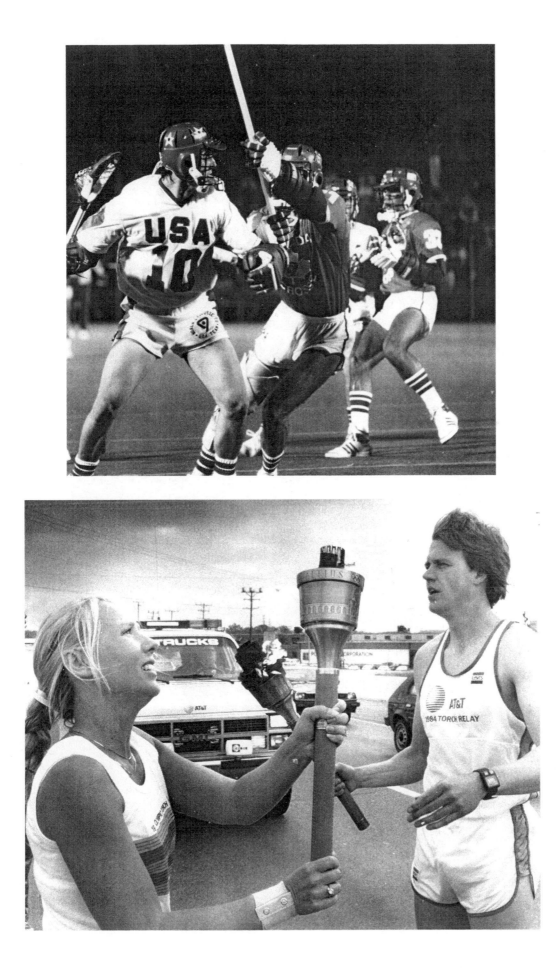

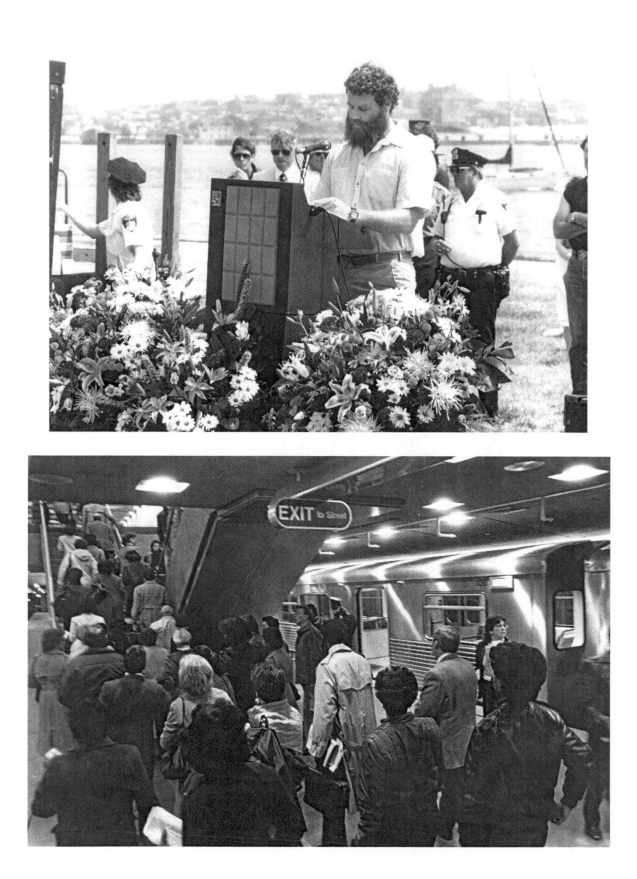

Top: John Flanagan, first mate of the Pride of Baltimore, addressed a crowd gathered at Fort McHenry on June 2, 1986, to mourn the loss of the vessel and four of its crew May 14 in a freak storm. *Photo by Paul M. Hutchins* BDJ-724-BS

Above: The art of subway strap-hanging arrived in Baltimore with the opening of the Metro's eight-mile line from Owings Mills to the crowded Charles Center station on November 21, 1983. *Photo by George H. Cook* AEI-608-BS

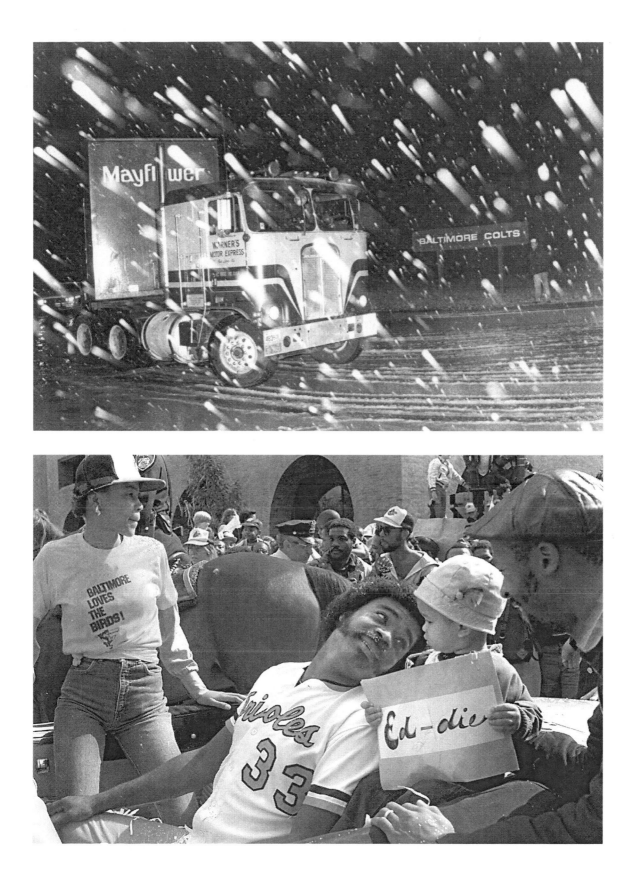

Top: When the Baltimore Colts slipped out of town on March 29, 1984, bound for Indianapolis aboard a fleet of Mayflower moving vans, it broke a city's heart. *Photo by Lloyd Pearson* 97011
Above: First baseman Eddie Murray takes it all in from the back seat of a convertible during the victory parade after the Orioles beat the Philadelphia Phillies four games to one in "The I-95 Series" in 1983. *Baltimore Sun photo* 120298

The Nineties

A stadium that set the mark, Ripken's streak for the ages and a new team in town

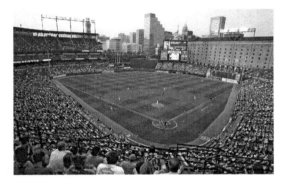

In 1990, the space shuttle Discovery carried the Hubble Space Telescope into orbit, Baltimore's population was 736,014, trade-union activist Lech Walesa was elected president of Poland and Soviet President Mikhail Gorbachev was awarded the Nobel Peace Prize.

In January 1991, U.S. and allied forces launched an attack to drive Iraqi troops from Kuwait in the first Persian Gulf war. That fall, the Orioles would end their final season at old Memorial Stadium, their home since 1954. In 1992, they opened Oriole Park at Camden Yards, a "new-old" stadium that would be the model for a wave of baseball-only, retro-style ballparks.

On September 7, 1995, The Sun's headline was "Immortal Cal" after Cal Ripken Jr. played in his 2,131st straight game for the Orioles, breaking the consecutive-games streak of Yankees ironman Lou Gehrig. On September 15, the last edition of The Evening Sun rolled off the presses at Port Covington. The 85-year-old newspaper bid farewell to Baltimore with the headline "Good Night, Hon."

NFL football returned to Baltimore after 13 years as the Ravens opened at Memorial Stadium in 1996. The Sun launched the website Sunspot.net that year and, in 2004, renamed it baltimoresun.com. The Sun's Lisa Pollak was awarded the Pulitzer Prize for feature writing in 1997 for her compelling portrait in 1996 of baseball umpire John Hirschbeck, who "endured the death of a son while knowing that another son suffers from the same deadly genetic disease." Gary Cohn and Will Englund would win another for investigative reporting a year later for a series describing the dangers posed to workers and the environment by the dismantling of U.S. Navy vessels from Baltimore to the shores of Alang, India. In December 1998, Sun "extras" reported the impeachment of President Bill Clinton on charges of perjury and obstruction of justice in the aftermath of his affair with White House intern Monica Lewinsky.

Above: Oriole Park at Camden Yards glittered for its first night game, on April 8, 1992. The ballpark, called "the jewel" in Baltimore's redevelopment and a model for retro stadiums, remains fresh as it celebrates its 20th anniversary. *Photo by Jed Kirschbaum* 120626

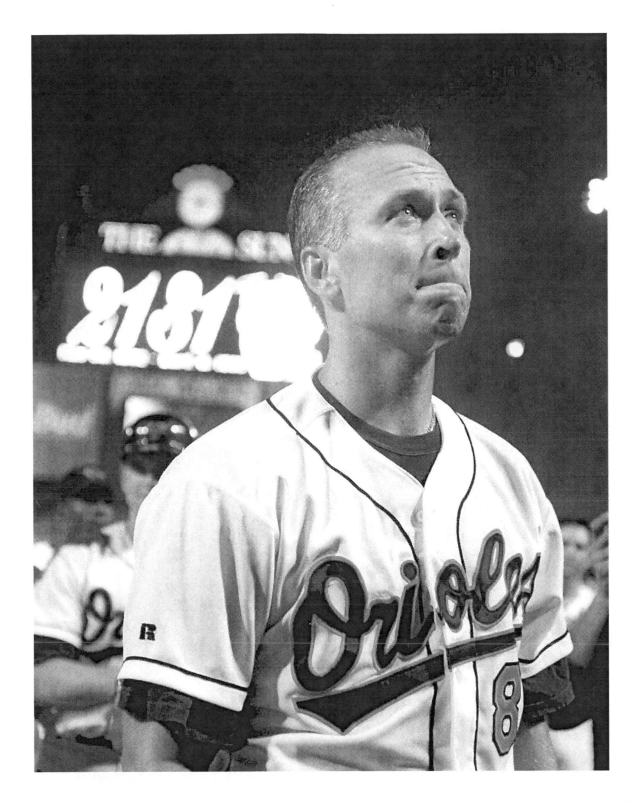

Above: Cal Ripken Jr. shows the emotions of the moment on September 6, 1995, after he broke Lou Gehrig's record streak of 2,130 consecutive games. Ripken would make an impromptu lap of the field at Camden Yards, shaking hands and high-fiving fans. *Photo by Karl Merton Ferron* 108934
Opposite top: Lou Forte Jr. holds up a sign expressing the feelings of many as the Orioles played their final game at Memorial Stadium in October 1991. The team would open the 1992 season at Camden Yards. *Photo by Karl Merton Ferron* 68380
Opposite bottom: Crystal Lee Hindla, 5, and her brother, Howard, 6, were among those who moved away from Wagner's Point in 1999 when the city, state and federal governments and two Baltimore chemical companies agreed to relocate residents concerned about foul odors, high cancer rates and industrial accidents there. The last two residents would leave in December 2000. *Photo by Algerina Perna* 119709

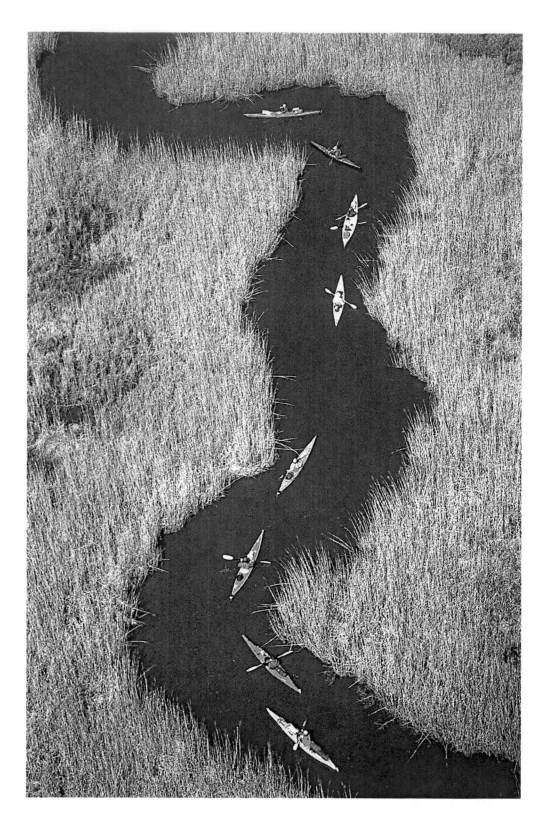

Above: A flotilla of kayaks makes a slow parade through a tidal marsh near Blackwater National Wildlife Refuge in April 1997. *Photo by Perry Thorsvik* 108958

Opposite top: Colin Mann and Kendyll Long, both 4, examine their catch of crayfish from Big Pipe Creek near Union Mills on a perfect fall day in 1997. *Photo by Chiaki Kawajiri* 108940

Opposite bottom: The Woman's Industrial Exchange, its waitresses and the menu never seemed to change, and that's the way Baltimoreans liked it. From left, Trish Hall, Loretta Tarbert, Marguerite Schertle, Charlotte Zimernack, Carrie Geraghty and Margaret Brogna in 1995. *Photo by Amy Davis* 60040

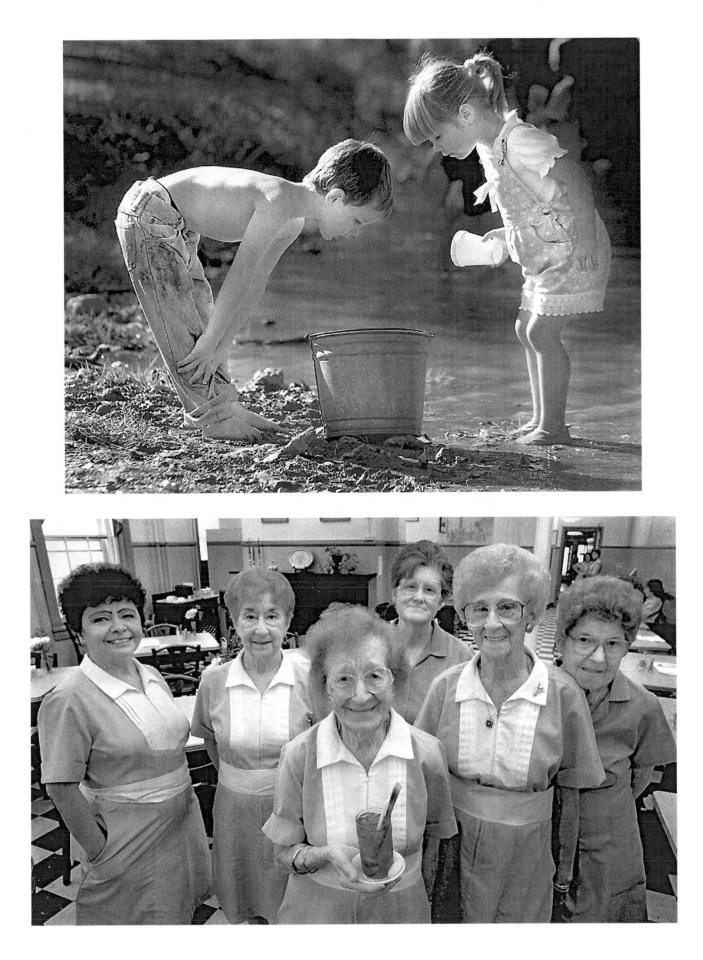

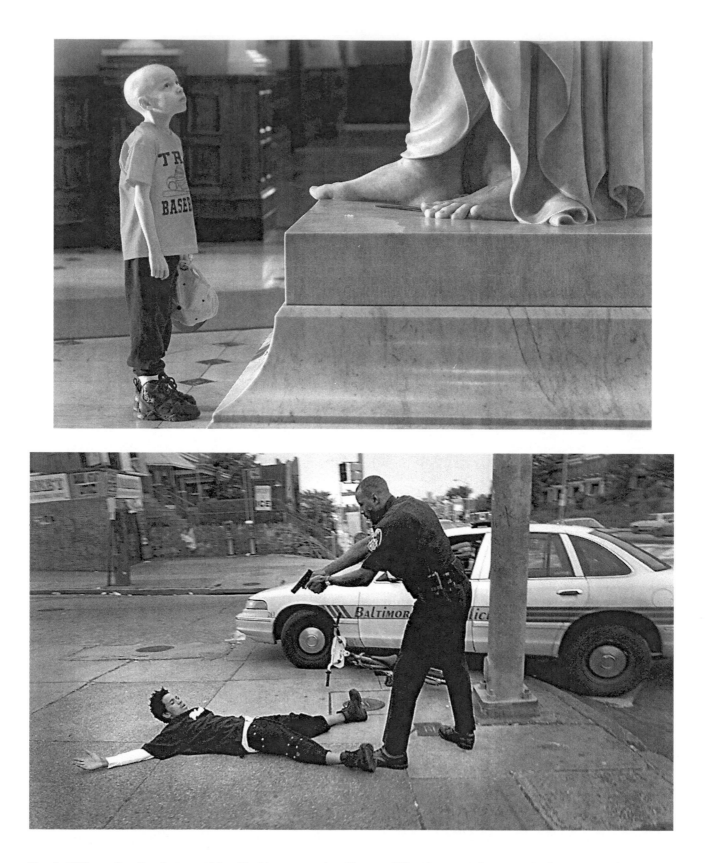

Top: In 1996, months after doctors at Johns Hopkins operated on Grayson Gilbert's pancreatic cancer, the 6-year-old left a note before the statue of "Christ the Divine Healer" seeking help for others. Fifteen years later, the boy who was thought unlikely to live was a student at Towson University. *Photo by Jed Kirschbaum* 108950

Above: Officer Ray Cook detains a suspect at gunpoint on Edmondson Avenue in 1997. The youth was wanted on a warrant for armed carjacking. *Photo by André F. Chung* 119706

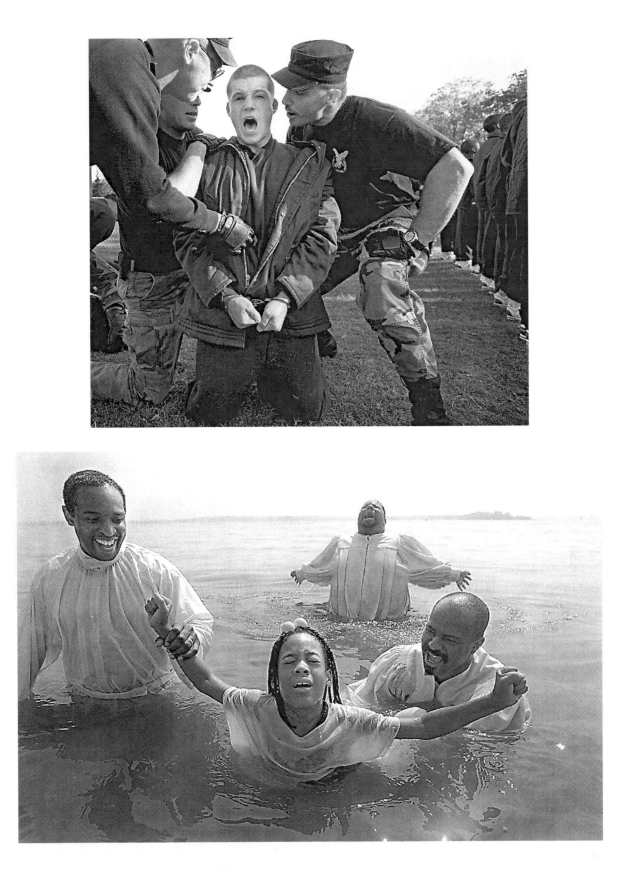

Top: Tactical officers teach 17-year-old James Phelps the importance of saying "sir" on the first day of boot camp for juveniles at the Savage Mountain Youth Center in Western Maryland. *Photo by André F. Chung* 119708

Above: Called by the spirit, three churches hold a mass baptism through immersion in the waters of Big Gunpowder Falls in August 1996. *Photo by Linda Coan* 118136

Above: Eric Kammeyer removes the "dixie cup" cap from the Herndon Monument, a 21-foot greased obelisk at the Naval Academy in Annapolis, in 1997. Tradition holds that the plebe who replaces the cap with a midshipman's hat will be the first from his class to attain the rank of admiral. *Photo by John Makely* 108971

Opposite top: Bugler Joe Kelly sounds the traditional call to the post for the Preakness at Pimlico in 1994. The successful Chicago jazz artist was known for jazzing up his racing gigs. *Photo by Chien-Chi Chiang* 108933

Opposite bottom: In 1999, Johnny Unitas visited Memorial Stadium, where he played for the Colts from 1956 to 1972. The stadium was razed from 2001 to 2002. A heart attack felled Unitas in September 2002. *Photo by Algerina Perna* AAT-579-BS

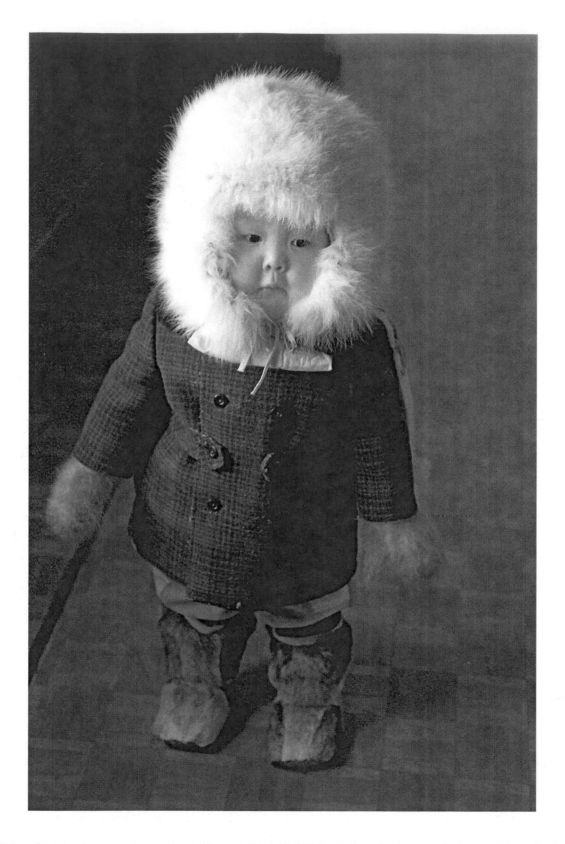

Above: A Sun photographer on assignment met this rosy-cheeked child in reindeer skin boots and a hat made from Arctic fox fur in a grocery store in a tiny Siberian village in 1996. *Photo by Barbara Haddock Taylor* 108978

Opposite top: Sun columnist Kevin Cowherd views the 2,000-horsepower electric fan that creates the wind in the Glenn L. Martin Wind Tunnel at the University of Maryland, College Park. *Photo by Jed Kirschbaum* 119711

Opposite bottom: The stripes of a Grevy's zebra, also known as the imperial zebra, appear as a form of nature's art. The species, now found mostly in northern Kenya, is considered endangered. *Photo by Jeffrey F. Bill* 119710

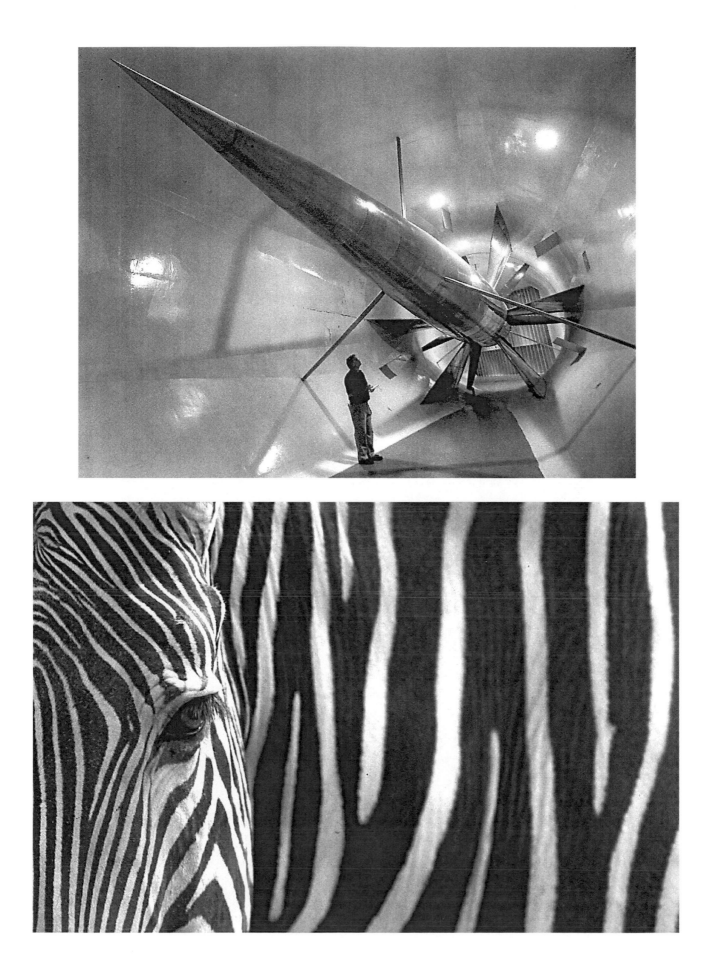

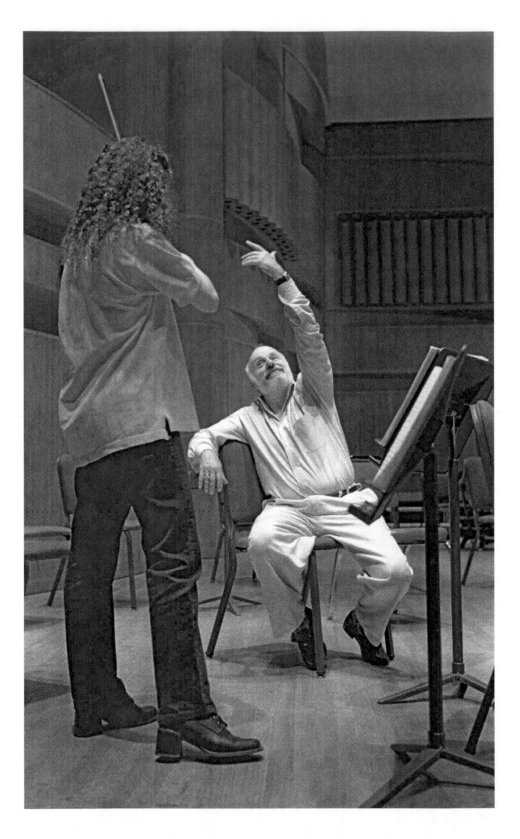

Above: David Zinman, then-musical director of the Baltimore Symphony Orchestra, works with violinist Hilary Hahn in 1998. Hahn, who took her first lesson at age 3, has won two Grammies. *Photo by Perry Thorsvik* 16248
Opposite top: From left, Twedell Bell, Damond Wallace, Ernest Robinson and Raymond Wallace were singing as they cooled off in an Inner Harbor fountain during a spell of 100-degree days in 1993. *Photo by Michael Lutzky* 108948
Opposite bottom: Pope John Paul II prays at the Basilica of the Assumption during a visit to Baltimore in 1995. America's first cathedral was designed by Benjamin H. Latrobe, the architect of the U. S. Capitol. *Photo by Chiaki Kawajiri* 108973

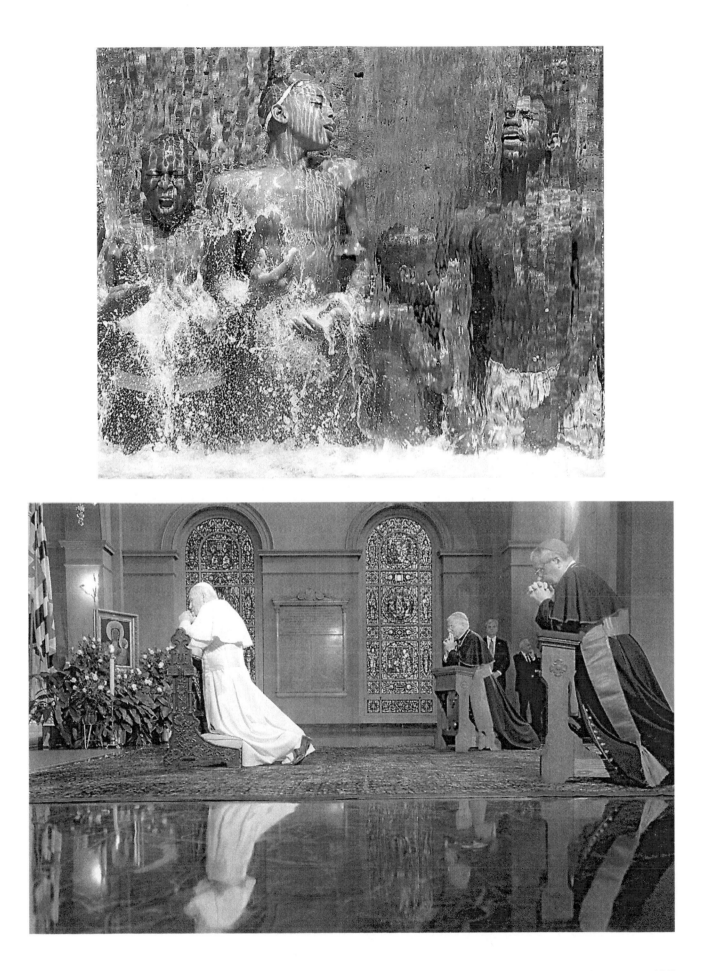

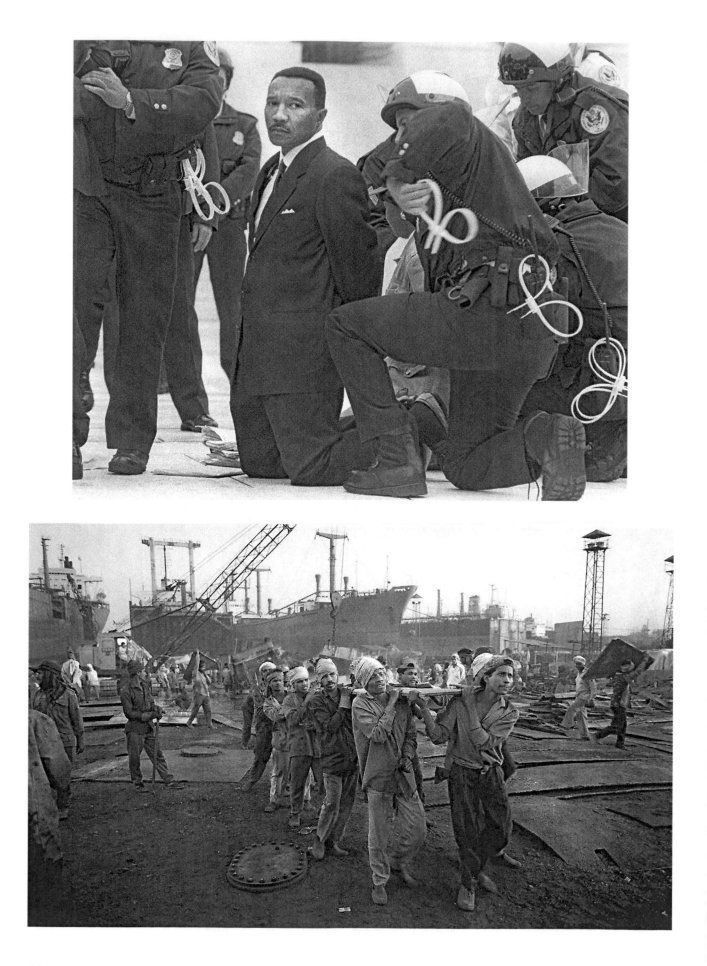

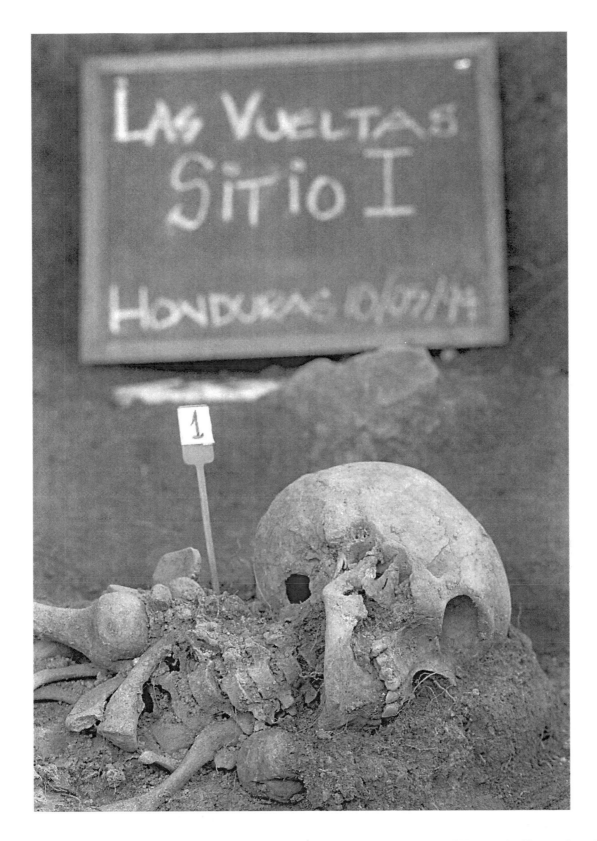

Above: A forensics expert marked remains found in 1994 in a mass grave in Honduras, where a CIA-trained military unit made opponents of the rightist Honduran government "disappear" in the 1980s. *Photo by Kenneth K. Lam* 119712
Opposite top: As head of the NAACP, Kweisi Mfume, a former Baltimore city councilman and U.S. representative, was among those arrested during a protest of discriminatory hiring practices at the Supreme Court in 1998. *Photo by Elizabeth Malby* 108965
Opposite bottom: Workers carry heavy sheets of steel as they break up obsolete U.S. warships on the shores of Alang, India, in 1997, at considerable risk to laborers and the environment. *Photo by Perry Thorsvik* 12997

The New Century

A war on terror, the Phelps phenomenon and the Blizzards of Baltimore

In 2000, Montgomery Ward announced its closing after 128 years, Ariel Sharon's visit to a Jerusalem site holy to both Jews and Muslims touched off a Palestinian uprising, and Republican George W. Bush defeated Democrat Al Gore in an election that ultimately was decided by the Supreme Court.

On March 13, Tribune Co. of Chicago reached a deal to acquire Times Mirror for about $6.5 billion and assumption of $1.8 billion in debt, forming a media giant with 11 daily newspapers, 22 TV stations, four radio stations and the Chicago Cubs baseball team. The Baltimore Sun changed hands again.

The Baltimore Ravens defeated the New York Giants, 34-7, to win Super Bowl XXXV on January 28, 2001, after finishing the 2000 regular season with seven straight victories and entering the NFL playoffs as a wild-card team. Linebacker Ray Lewis, the leader of the Ravens' ferocious defense, was selected as the game's Most Valuable Player.

On September 11, 2001, terrorists linked to al-Qaida hijacked four U.S. airliners and crashed two into the World Trade Center in New York and a third into the Pentagon. The fourth, headed toward Washington, went down near Shanksville, Pa., after passengers attempted to retake the jet. Nearly 3,000 people died in the attacks. The Sun's one-word headline the next day: "Devastation."

U.S. and allied forces invaded Afghanistan on October 7 in Operation Enduring Freedom, with the goals of driving al-Qaida from the country and deposing the Taliban regime. Despite initial successes, U.S. troops remain in Afghanistan in 2012, in what has become America's longest war.

In March 2003, U.S.-led forces invaded Iraq and unleashed a campaign of "shock and awe" designed to knock out command and control units and destroy enemy will. Operation Iraqi Freedom was intended to eradicate Saddam Hussein's supposed weapons of mass destruction, topple the dictator and liberate

Above: Hasim Rahman, a Baltimore native, takes a punch from his 4-year-old son Sharif. "The Rock," a 20-to-1 underdog, knocked out champion Lennox Louis in 2001 to win the heavyweight title. *Photo by Jed Kirschbaum* 108974

the Iraqi people. In April, The Sun's Diana K. Sugg won the Pulitzer Prize for beat reporting "for her absorbing, often poignant stories that illuminated complex medical issues through the lives of people." On May 1, aboard the aircraft carrier USS Abraham Lincoln, President Bush declared major combat in Iraq at an end against the backdrop of a banner that proclaimed "Mission Accomplished." In fact, bloody guerrilla warfare would go on for years, and the last U.S. troops would leave in December 2011.

In 2004, Michael Phelps, a swimmer from Baltimore, won six gold medals and two bronze at the Summer Olympics in Athens, Greece. He would win eight gold medals in Beijing in 2008, a record for a single Games. His 14 gold medals is an all-time Olympic record.

On December 26, 2004, a magnitude-9.1 earthquake in the Indian Ocean devastated Indonesia, triggered huge tsunamis and killed more than 230,000 people in 14 countries. In August 2005, Hurricane Katrina killed over 1,800 people, flooded New Orleans and caused an estimated $81 billion damage.

In January 2010, the Navy hospital ship Comfort sailed from Baltimore after a deadly earthquake struck Haiti. Sun staff members were aboard to report on its mission to the hemisphere's poorest country. Back-to-back blizzards that February blanketed Maryland in more than 40 inches of snow and brought much of the East Coast to a standstill. It was the snowiest winter on record in Baltimore with 77 inches. On April 20, an explosion on BP's Deepwater Horizon rig killed 11 and spilled an estimated 4.9 million barrels of crude oil into the Gulf of Mexico, fouling beaches and endangering wildlife.

On April 18, 2011, an era came to a close with the passing of former Governor William Donald Schaefer, 89, who as Baltimore mayor brought historic change to the city as the champion of Harborplace, the National Aquarium and Oriole Park at Camden Yards.

In May 2011, Navy SEALs killed al-Qaida leader Osama bin Laden, wanted "dead or alive" for the terrorist attacks of September 11, 2001, in a top-secret operation in Abbottabad, Pakistan.

In February 2012, Queen Elizabeth II celebrated her 60th year on the British throne. In March, Encyclopaedia Britannica discontinued its print edition after 244 years. And on May 17, The Sun marked the 175th anniversary of its founding in Baltimore.

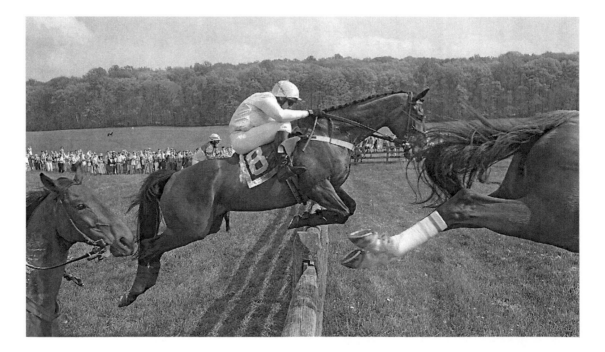

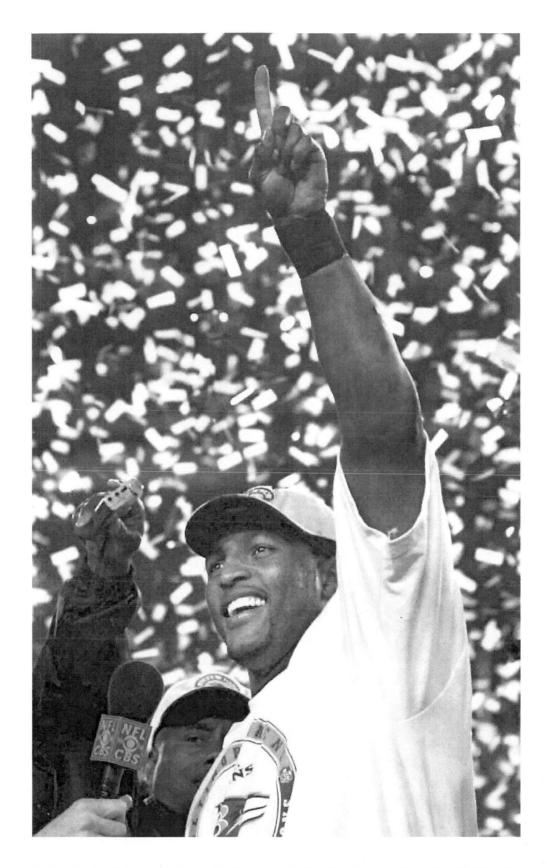

Above: Linebacker Ray Lewis celebrates the Ravens' 34-7 win over the New York Giants in Super Bowl XXXV on January 28, 2001. The leader of the defense was the game's Most Valuable Player. *Photo by Gene Sweeney Jr.* 108981

Opposite: Foiled Again, with Shane Burke aboard, clears a jump during the 112th running of the Maryland Hunt Cup steeplechase in Glyndon in April 2008. *Photo by Doug Kapustin* 120163

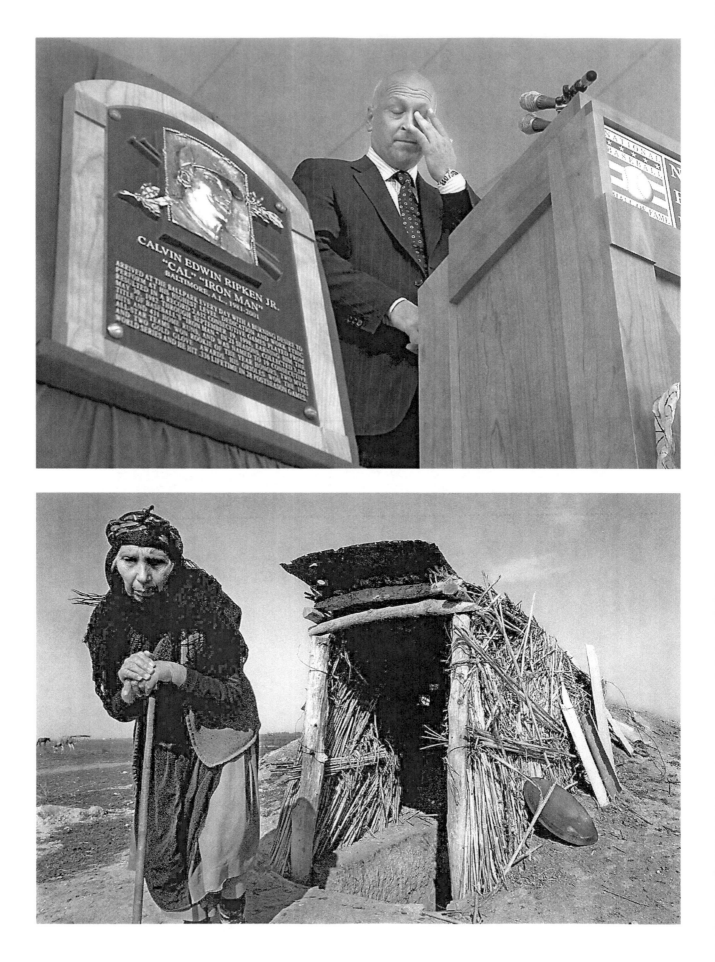

Above: Marilyn Johnson, 10, knew the victims of the arson that killed Angela and Carnell Dawson and their five children in October 2002 in their home on East Preston Street. A 22-year-old drug dealer angry at their "snitching" pleaded guilty in 2003 and was sentenced to life in prison. *Photo by Amy Davis* 108944

Opposite top: Aberdeen native Cal Ripken Jr. sheds tears as he talks of his family during his Hall of Fame induction in Cooperstown, N.Y., in 2007. The Ironman played in 2,632 straight games for the Baltimore Orioles. *Photo by Lloyd Fox* 120164

Opposite bottom: Minavar Sariyeva, 80, was living underground with her daughter in a closet-size dugout in 2001. The Azerbaijanis fled their homes during the war with Armenia in 1992. *Photo by Algerina Perna* 108923

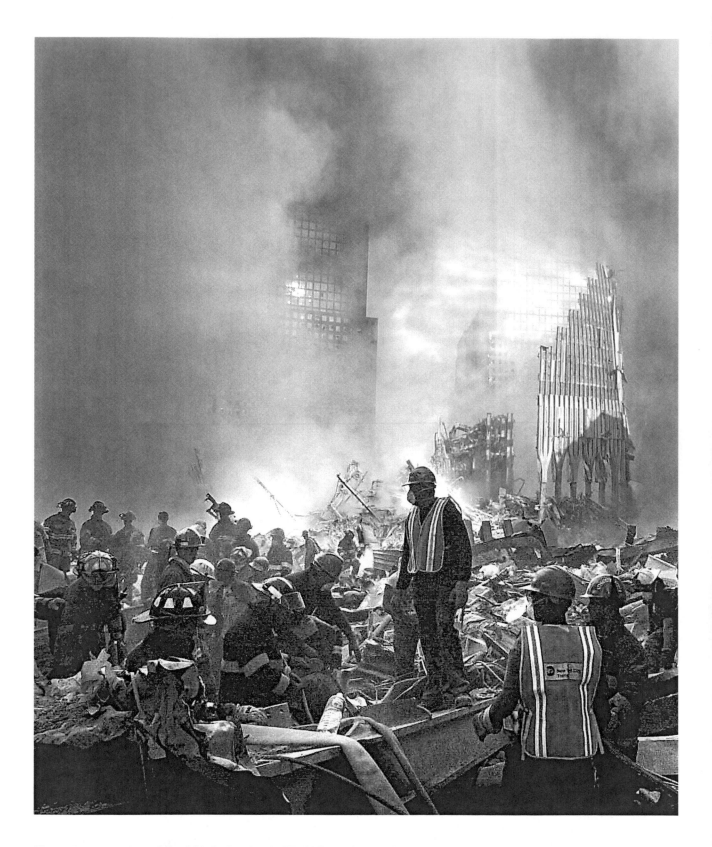

Above: Rescue workers shift rubble by hand at the World Trade Center site in New York the day after the terrorist attacks of September 11, 2001, in a search for survivors. *Photo by John Makely* 108986

Opposite top: A horse-drawn caisson bearing former President Ronald Reagan's flag-draped casket stops in front of the White House as the funeral procession makes its way to the Capitol in June 2004. *Photo by John Makely* 120165

Opposite bottom: Jacob Roberts, 5, salutes the coffin of his father, Allan Michael Roberts, a Baltimore firefighter killed while battling a rowhouse fire in October 2006. *Photo by Algerina Perna* 120166

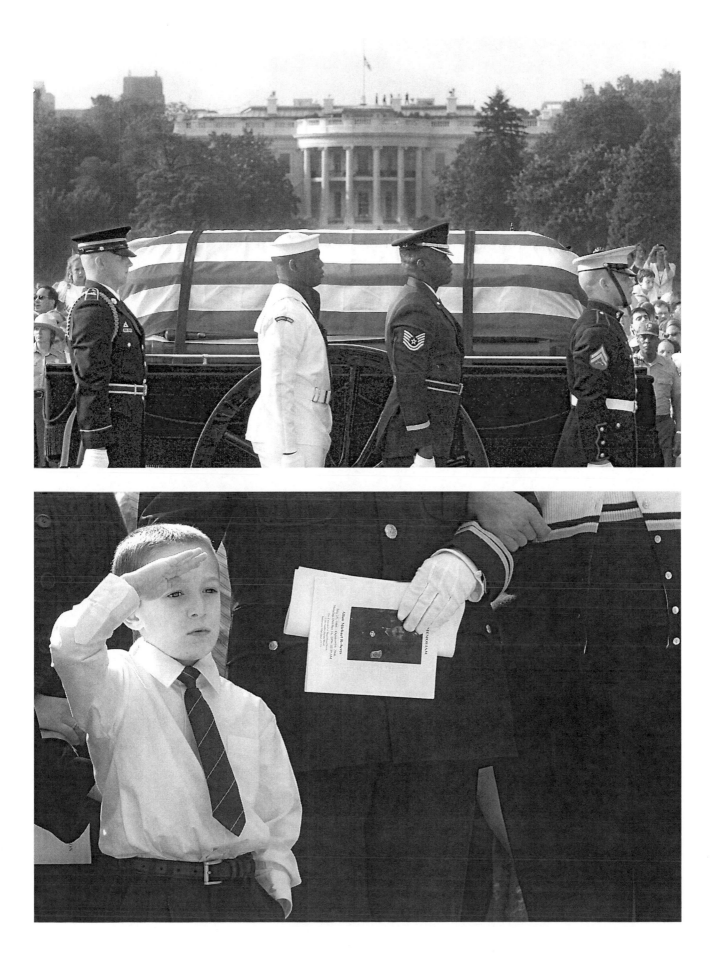

Above: An American Airlines jet hijacked by five terrorists plunged into the Pentagon on September 11, 2001, killing all aboard the plane and 125 people on the ground. *Photo by Amy Davis* 108967

Opposite top: Marine Lance Cpl. Marcco Ware of Los Angeles carries a wounded Iraqi soldier in the opening week of the Iraq war in March 2003. U.S.-led forces occupied Baghdad on April 9. *Photo by John Makely* 108956

Opposite bottom: In April 2008, Sophia Jones sheds tears of joy at the safe return of her son, Spc. Tony Jones of the Maryland Army National Guard, who had been deployed in Iraq. *Photo by Monica Lopossay* 120167

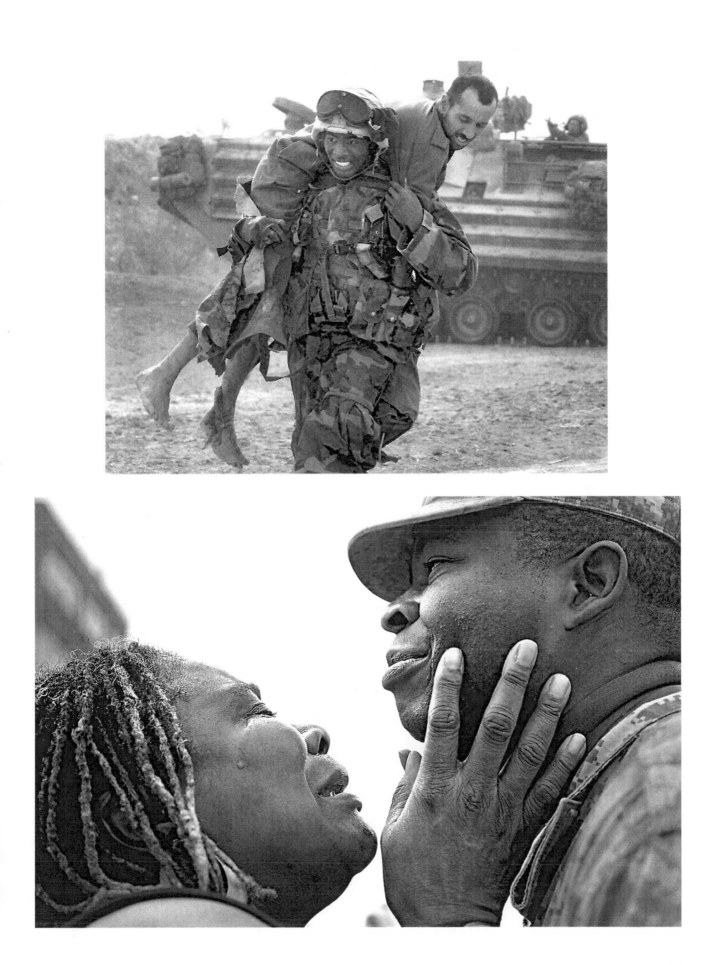

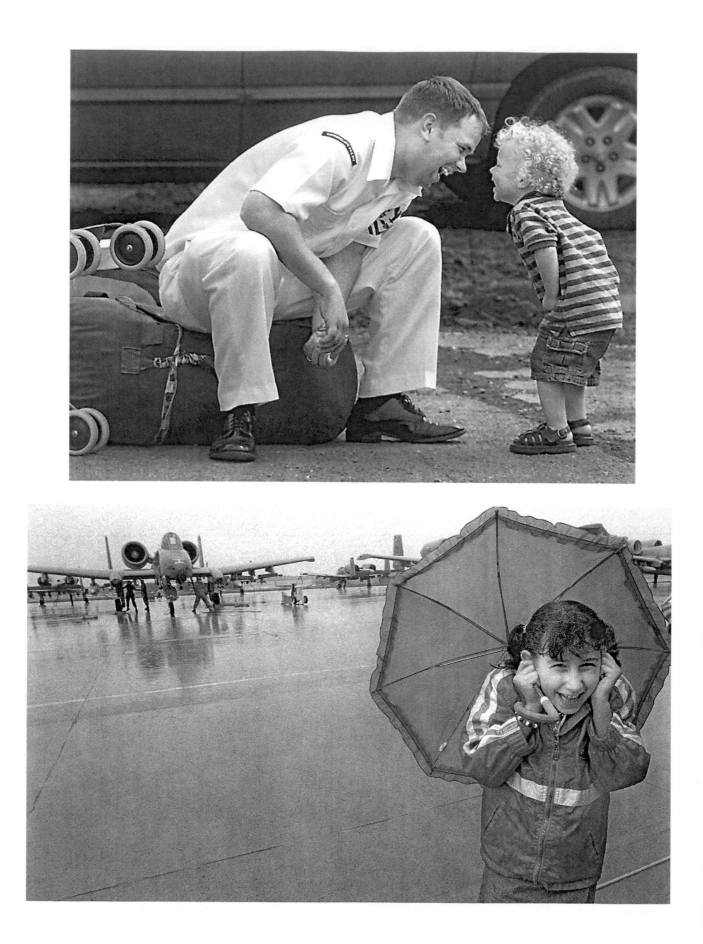

Above: At Running Brook Elementary in Columbia, fourth-grader Tashona Wilson, 9, watches on television and raises her right hand as Barack Obama is sworn in as president in January 2009. *Photo by Doug Kapustin* 120168

Opposite top: Petty Officer Josh Cackowski of Duluth, Minn., shares a moment with his 18-month-old son Jacob after the USNS Comfort returned to Baltimore from the Arabian Gulf during the Iraq war in 2003. *Photo by Jed Kirschbaum* 120170

Opposite bottom: Gloria Marino, 9, of Bel Air protects her ears from the screaming engines of her father's A-10. But she was glad Lt. Col. Dan Marino and the 104th Fighter Squadron were back from Afghanistan. *Photo by Jed Kirschbaum* 120169

Above: Coach John Harbaugh walks off the field with quarterback Joe Flacco after a dropped touchdown pass and missed "chip-shot" field goal brought a sudden end to the Ravens' 2011-12 season in the AFC championship against the New England Patriots. *Photo by Lloyd Fox* 120185

Opposite top: Summer Matthews and a less enthusiastic Dylan Henderson don hats for a picture in 2009 at the Flower Mart, a May tradition in Mount Vernon Place. *Photo by Jed Kirschbaum* 120171

Opposite bottom: Cold water did not scare Ed Griffin, a scantily clad Darth Vader from Reisterstown, during the relatively balmy Polar Bear Plunge into the Chesapeake Bay in January 2006. *Photo by David Hobby* 108955

Top: Nikki Miller of Cleveland frolics with a hula hoop at the Starscape Festival at Fort Armistead Park in June 2011. The 13th annual event featured live music, deejays and visual acts on five stages. *Photo by Brian Krista* 19793
Above: In 2011, Vikki Rowe, 19, of Frederick dressed as a "little sister" from the video game Bioshock 2 for Otakon, a Baltimore festival that celebrates anime, manga and Asian pop culture. *Photo by Gabe Dinsmore* 40152

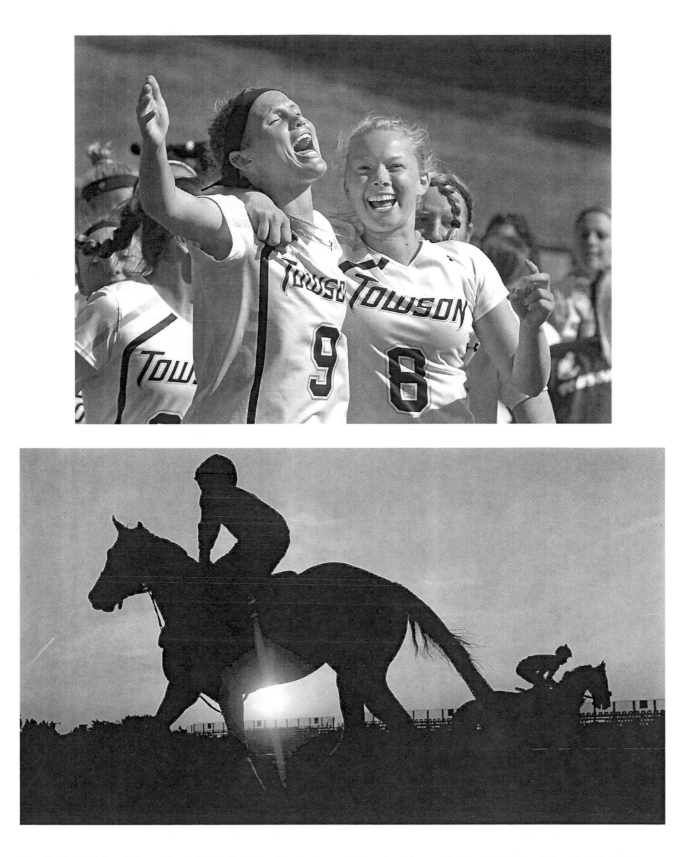

Top: Ashley Waldron, left, and Sarah Maloof rejoice after the Towson Tigers beat James Madison, 8-7, in the Colonial Athletic Association championship to earn a play-in berth in the 2012 NCAA lacrosse tournament. *Photo by Amy Davis* 120177

Above: Horses and riders are already on the track as the sun rises at Pimlico Race Course in May 2012. Kentucky Derby winner I'll Have Another would also win the Preakness, but an injury would keep the colt from pursuing the first Triple Crown since 1978 in the Belmont Stakes. *Photo by Kim Hairston* 120176

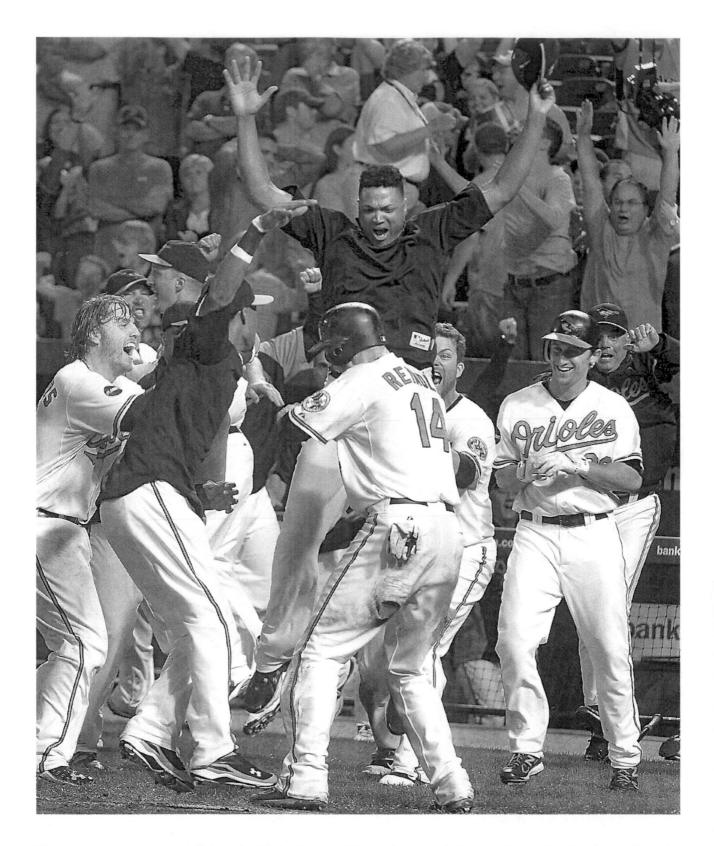

Above: Orioles teammates mob Nolan Reimold after he scored the winning run in the bottom of the ninth to beat the Red Sox, 4-3, on September 28, 2011. The loss, coupled with a Tampa Bay win, kept the Sox from the playoffs. *Photo by Gene Sweeney Jr.* 55730
Opposite top: The National Aquarium was the setting for the marriage of Caroline Trowbridge and Devon Minarik of Hunt Valley, who sealed their vows in 2011 with a kiss in front of smiling dolphins. *Photo by Kim Hairston* 108964
Opposite bottom: Mark Sanders as Edgar Allan Poe speaks to Halloween revelers at the Westminster Burying Ground in Baltimore, where the poet and mystery writer is spending eternity. *Photo by Algerina Perna* 108972

Above: The city's emblem is removed from the Memorial Stadium facade as demolition nears an end in 2002. Many wanted to save the wall that dedicated the facility to war veterans, but it too came down. *Photo by John Makely* 120624
Opposite top: Baltimore swimmer Michael Phelps won six gold medals and two bronze at the Summer Games in Athens, Greece, in 2004 and eight gold medals in Beijing in 2008. His 14 gold medals is an all-time Olympic record. *Photo by Karl Merton Ferron* 127626
Opposite bottom: Only two cemeteries remain as the rising waters of the Chesapeake Bay slowly reclaim Holland Island. A third cemetery already has submerged and the last house has fallen. *Photo by Kim Hairston* 66572

Top: Police comforted one another in January 2011 during a vigil for William Torbit Jr., who was killed by a fellow officer during a shootout outside the Select Lounge on Paca Street. *Photo by Kenneth K. Lam* 120174
Above: Police take up positions in a Baltimore alley during a drug raid on Lombard Street in 2011. Among those arrested was Felicia Pearson, who played "Snoop" on the TV series "The Wire." *Photo by Kim Hairston* 108946

Top: Park Avenue rooftops looked like icing on a cake after two major snowstorms on February 5-10, 2010. The storms dropped more than 40 inches and made it the snowiest month on record in Baltimore. *Photo by Jed Kirschbaum* 120175

Above: Supporters put hundreds of plastic flamingos outside City Hall in 2009 amid a permit dispute over a large flamingo sign at a Hampden restaurant. Many would later castigate Cafe Hon's owner for trademarking "hon," a local term of endearment. *Photo by Jed Kirschbaum* 25874

Above: Rob Holland of Nashua, N.H., pilots his Veteran Home Loans MX2 stunt plane 3,000 feet above Ocean City in June 2011 in preparation for the annual OC Air Show. *Photo by Karl Merton Ferron* 22238

Opposite top: Jerry Brown, the Monkey Man, with co-star Django, a capuchin, entertained at the Target Family Art Park during Artscape in 2008. The annual Baltimore event is billed as "America's largest free arts festival." *Photo by Monica Lopossay* 127625

Opposite bottom: Llewellyn Woolford Sr. kisses his wife, the Rev. Sadie Alston Woolford, after the couple renewed their vows on August 28, 2010, at Union Baptist Church on their 50th anniversary. *Photo by Karl Merton Ferron* 120173

Top: Chanel Jenkins holds 8-month-old granddaughter Jassira outside the Clarence Mitchell Courthouse in Baltimore after a magnitude-5.8 earthquake rattled the East Coast on August 23, 2011. *Photo by Jed Kirschbaum* 45060
Above: In 2012, Anna Eileen Dilks crawls through a muddy trench in the Wet and Sandy Drill, part of a 14-hour physical and mental training course and leadership challenge for Naval Academy plebes. *Photo by Lloyd Fox* 112273

Top: Angie Coleman, left, and McKenzie Conner show their delight at Towson High's graduation ceremony at the Towson Center in June 2012. *Photo by Steve Ruark* 117927
Above: The shock was deep after a police car hit a fire engine on U.S. 40 in October 2010, killing Officer Tommy Portz, 32. He was the third Baltimore officer killed in less than a month. *Photo by Barbara Haddock Taylor* 108939

Above: Lonny Baxter, Juan Dixon and Tahj Holden celebrate Maryland's 64-52 victory over Indiana and first NCAA men's basketball championship in 2002. *Photo by Kenneth K. Lam* 120172

Opposite top: Maryland's Sarah Mollison goes on the attack against Amanda Macaluso of Northwestern in the 2010 NCAA women's lacrosse final. The Terrapins defeated the Wildcats, 13-11. *Photo by Algerina Perna* 127796

Opposite bottom: After winning the Kentucky Derby, Barbaro shattered his hind leg in the Preakness at Pimlico in 2006. After a months-long struggle that riveted public attention, the horse was euthanized. *Photo by Doug Kapustin* 108925

Top: Big-time auto racing arrived for Labor Day weekend in 2011 as Danica Patrick and other IndyCar stars roared through the streets near the Inner Harbor in the Baltimore Grand Prix. *Photo by Gene Sweeney Jr.* 48560

Above: Joseph James and Alexis Keffer help Santa count down to the lighting of the "Miracle on 34th Street" in 2011. Thousands view the elaborate Christmas display in Hampden each year. *Photo by Lloyd Fox* 68478

Top: Kindergarten pals Susej Bayton and Isaiah Foreman at St. Ambrose School in 2010. Amid declining enrollment, the Baltimore Archdiocese closed St. Ambrose at the end of the school year in 2012. *Photo by Jed Kirschbaum* 120178
Above: The Navy's precision Blue Angels fly low over Fort McHenry in June 2012 during Baltimore's Star-Spangled Sailabration marking the bicentennial of the War of 1812. *Photo by Jerry Jackson* 120623

With grateful acknowledgment to the staff and pages of The Sun, The Evening Sun and The Sunday Sun.

The Sunpapers of Baltimore by Gerald W. Johnson, Frank R. Kent, H.L. Mencken and Hamilton Owens
(Alfred A. Knopf, New York 1937)

The Baltimore Sun 1837-1987 by Harold A. Williams
(The Johns Hopkins University Press, Baltimore and London 1987)

Copy Editor: Mark B. Fleming
Photography Editor: Robert K. Hamilton
Design Editor: Marsha Miller
Archival & Photography Researchers: Zachary J. Dixon, Paul McCardell, Jacques Kelly and Fred Rasmussen
Project Manager: Zachary J. Dixon

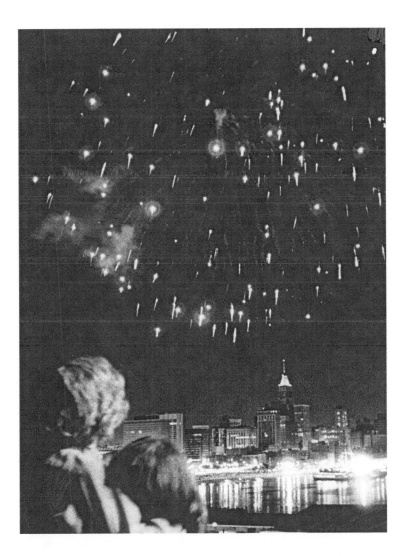

Above: Fireworks light the sky in September 1970 for the finale of the first Baltimore City Fair. The annual event celebrated the city, its neighborhoods, people and culture until the fair's end in 1991. Photo by Irving H. Phillips Jr. AHF-269-BS